DISCARD

The First Hundred Years
of Painting in California
1775-1875

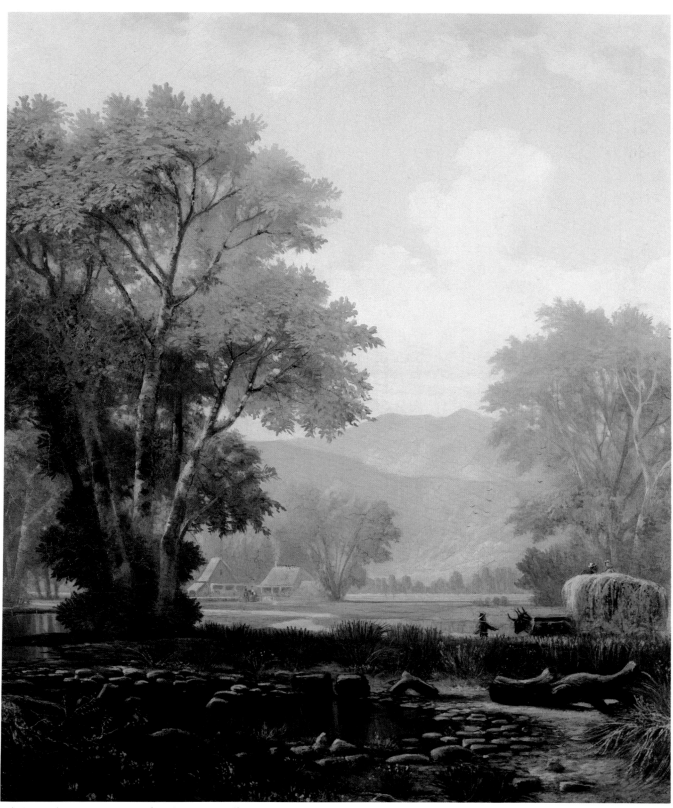

Edwin Deakin Farming in the Livermore Valley

The First Hundred Years
of Painting in California
1775-1875

With Biographical Information and References
Relating to the Artists

JEANNE VAN NOSTRAND

Foreword
ALFRED FRANKENSTEIN

JOHN HOWELL–BOOKS
San Francisco, California
1980

Library of Congress Catalog Card No. 80-50443

ISBN 0-910760-10-1

2500 COPIES

DESIGNED AND PRINTED BY LAWTON KENNEDY, SAN FRANCISCO

Color transparencies by George Knight

Color reproductions by Hooper Printing Company

For my sister
Bernice Kildow Skinner

Table of Contents

Foreword

The truly remarkable thing is how much of it is left.

Can you name a dozen painters of landscape or portraits or views of the sea active in California before 1875? There are dozens of them here in this wonderful book, which cannot help but be the genesis of an art-historical renaissance that will change the face and depth of things artistic from coast to coast.

When the art division of the present Oakland Museum opened, I wrote that a new state had been added to the artistic union. It had been there all the time but we hadn't noticed; once it was put together, everything changed. What the Oakland Museum has accomplished with the actual objects, Mrs. Van Nostrand has brought off in the verbal record. Now it's all complete.

And how much of the story we never knew until our author sank depth charges into libraries, historic collections, private assemblages of paintings, drawings, prints, illustrations in books of travel and adventure. The reproductions herewith provide the merest smattering sample. We must get together a big show of the originals when time, space, and funds permit.

This story is a little different from that of early art on the east coast. The draughtsmen who recorded Indian life in Virginia in the 17th century had heard about Indians with their feet on backwards, and some of their clientele rather liked the idea. By the time this book opens, all such moonshine has been dispelled. California is still a mysterious, fragmentary coast. Headlands, beaches, distant peaks are seen in disconnected glimpses, but they are seen, and are verifiable.

The gusto of the California adventure as recorded by soldiers, adventurers, traders, marauders comes through, and at times the lure of the land triumphs over the excitement of the adventure. Streets proliferate and run into towns. The Gold Rush creates its uproar of business, of unrestrained, cut-throat profit-taking, and politics. The overland adventure demanded its record, and got it. The overnight millionaires demanded their monuments, and got them. El Dorado brought men to match the mountains and art to match the men.

How much of it was forgotten and how much is coming back may be indicated by a little story.

About 35 years ago I wrote a book about American still life painting. In preparing this I had an interview with John I. H. Baur, then the director of the Brooklyn Museum. He showed me a still life of opulent, wet, silvery fish, signed "S. M. Brookes." He said no one knew or could find out anything about Brookes. (That was well before the establishment of the Archives of American Art at the Smithsonian Institution.) Baur said the records

showed that the picture had been given to the Brooklyn Museum by none other than Albert Bierstadt. When he turned the canvas over, I beheld something that meant nothing to Baur of Brooklyn but a good deal to me as a San Franciscan. It was a canvas maker's stamp on which one might clearly read "Kearny Street," the thoroughfare in San Francisco on which to this day dealers in artists' materials have their shops. This was the key to Samuel Marsden Brookes; and spreading out from him evaluations and insights into other Californians of his time—Edwin Deakin, Henry Alexander, and many others—were forthcoming.

Another wisp of a story. I organized a survey of American landscape for the Spokane World's Fair in 1974, and in connection with this I wanted to borrow some of the sketches of the U.S.-Canadian border country by James Madison Alden, an artist of whom many of you will have learned for the first time through the present book. These drawings were in the National Archives, and the National Archives cheerfully agreed to lend them if they were kept under armed guard and fully illuminated 24 hours a day.

It was soon apparent that the armed guard was superfluous, but the lights are still there, in every important sense, and this book makes them brighter. It would be difficult to make them more searching.

<div align="right">Alfred Frankenstein</div>

Illustrations

"California Rancho Scene" (retrospective) 1849 Plate 15.
Artist: Alfred Sully
Medium: watercolor
Size: 8″ x 11″ (sight)
Location of original: Oakland Museum, Oakland, California
(Reproduced by permission of the Oakland Museum)

"Monterey, California" (retrospective) 1849 Plate 16.
Artist: Alfred Sully
Medium: watercolor
Size: 8″ x 11″ (sight)
Location of original: Thomas Gilcrease Institute of American History and Art, Tulsa,
 Oklahoma
(Reproduced by permission of the Thomas Gilcrease Institute of American History and
 Art)

III. *Painting in Eldorado* 1849-1859

"Panning Gold, California" (Alternate title: "Scene on the Tuolumne") 1849 Plate 17.
Artist: William McIlvaine
Medium: watercolor over pencil
Size: 18-5/8″ x 27-1/2″
Location of original: M. & M. Karolik Collection of American Water Colors & Drawings:
 1800-1875, Museum of Fine Arts, Boston
(Reproduced by permission of the Museum of Fine Arts, Boston)

"New Almaden" 1851 Plate 18.
Artist: Bayard Taylor
Medium: watercolor
Size: 8-3/16″ x 10-7/8″
Location of original: California Historical Society, San Francisco
(Reproduced by permission of the California Historical Society)

"San Francisco Fire of September 17, 1850" 1850 Plate 19.
Artist: Francis Samuel Marryat
Medium: watercolor
Size: 9-3/8″ x 13-1/2″
Location of original: Oakland Museum, Oakland, California
(Reproduced by permission of the Oakland Museum)

"Saint Francis Hotel, San Francisco" 1849 Plate 20.
Artist: Harrison Eastman
Medium: watercolor
Size: 9-3/4" x 9-1/2"
Location of original: California Historical Society, San Francisco
(Reproduced by permission of the California Historical Society)

"Saturday Night in the Mines" 1856 Plate 21.
Artist: Charles Christian Nahl in collaboration with Hugo Wilhelm Arthur Nahl
Medium: oil on canvas
Size: 120" x 192"
Location of original: Stanford University Art Gallery, Stanford, California
(Reproduced by permission of the Stanford University Art Gallery)

"Sonoro from the South: Morning 1853" 1853 Plate 22.
Artist: Thomas Almond Ayres
Medium: black and white chalk
Size: 17-1/2" x 25-1/2"
Location of original: Society of California Pioneers, San Francisco
(Reproduced by permission of the Society of California Pioneers)

"Hock Farm" 1852 Plate 23.
Artist: William Smith Jewett
Medium: oil on canvas
Size: 29" x 40"
Location of original: Sacramento Area State Parks, West Sacramento, California
(Reproduced by permission of the California Department of Parks and Recreation, Sacra-
 mento, California)

"View of Benicia, California, from the Frigate Savannah" 1850 Plate 24.
Artist: Henry S. Stellwagon
Medium: watercolor
Size: 8-3/8" x 28"
Location of original: Privately owned
(Reproduced by permission of the Frick Art Reference Library, New York City)

"Haying in Marin County" 1873 Plate 30.
Artist: William Keith
Medium: oil on canvas
Size: 18-3/8" x 36-3/8"
Location of original: California Historical Society, San Francisco
(Reproduced by permission of the California Historical Society)

"Redwood Trees" ca. 1865 Plate 31.
Artist: Albert Bierstadt
Medium: oil on paper mounted on cardboard
Size: 30" x 21-1/2"
Location of original: Los Angeles County Museum of Art, Los Angeles
(Reproduced by permission of the Los Angeles County Museum of Art)

"Along the Mariposa Trail" 1863 Plate 32.
Artist: Virgil Williams
Medium: oil on canvas
Size: 41-1/2" x 35-1/2" (sight)
Location of original: California Historical Society, San Francisco
(Reproduced by permission of the California Historical Society)

"Hay Scow on San Francisco Bay" 1871 Plate 33.
Artist: Gideon Jacques Denny
Medium: oil on canvas
Size: 24" x 42"
Location of original: National Maritime Museum, San Francisco
(Reproduced by permission of the National Maritime Museum)

"Valley of San Mateo Taken from Howard's Hill" 1870-1872 Plate 34.
Artist: Henry Cheever Pratt
Medium: oil on canvas
Size: 23" x 41"
Location of original: Privately owned
(Reproduced by permission of the owner)

"Sacramento Railroad Station" ca. 1874 Plate 35.
Artist: William Hahn
Medium: oil on canvas
Size: 53-3/4" x 87-3/4"
Location of original: Fine Arts Museums of San Francisco, San Francisco
(Reproduced by permission of the Fine Arts Museums of San Francisco)

"Cascades of Vernal Falls" 1872 Plate 36.
Artist: Thomas Moran
Medium: pencil and wash on paper
Size: 10-5/8" x 7-3/8" (sight)
Location of original: Jefferson National Expansion Memorial Site, St. Louis, Missouri
(Reproduced by permission of the Jefferson National Memorial Site)

"Moss Landing at Castroville" ca. 1873 Plate 37.
Artist: Leon Trousset
Medium: oil on canvas
Size: 52" x 72"
Location of original: Our Lady of Refuge Church, Castroville, California
(Reproduced by permission of Our Lady of Refuge Church)

"Farming in the Livermore Valley" 1874 Frontispiece
Artist: Edwin Deakin
Medium: oil on canvas
Size: 24" x 20"
Location of original: California Historical Society, San Francisco
(Reproduced by permission of the California Historical Society)

"Mount Shasta" ca. 1868 Plate 38.
Artist: Juan Buckingham Wandesforde
Medium: watercolor
Size: 15" x 25"
Location of original: Oakland Museum, Oakland
(Reproduced by permission of the Oakland Museum)

"Lone Mountain" June 10, 1871 Plate 39.
Artist: Thomas Ross
Medium: oil on cardboard
Size: 12" x 15"
Location of original: California Historical Society, San Francisco
(Reproduced by permission of the California Historical Society)

"Washerwoman's Lagoon" 1866 Plate 40.
Artist: Hiram Reynolds Bloomer
Medium: oil on canvas
Size: 16" x 22"
Location of original: Society of California Pioneers, San Francisco
(Reproduced by permission of the Society of California Pioneers)

"View of San Francisco Bay from Oakland" 1870 Plate 41.
Artist: Frederick Whymper
Medium: watercolor
Size: 19" x 36"
Location of original: California Historical Society, San Francisco
(Reproduced by permission of the California Historical Society)

"View of San Francisco from the Bay" September, 1862 Plate 42.
Artist: Edward Vischer
Medium: pencil on paper
Size: 8¼" x 16¼"
Location of original: The Bancroft Collection, Bancroft Library,
 University of California, Berkeley
(Reproduced by permission of The Bancroft Library)

The publisher gratefully acknowledges the use of the color plates for Illustrations Plate numbers 5, 6, 8, 10, 19, 27, 28, 39, and 40 provided by the Book Club of California, San Francisco, from their 1975 publication of Jeanne Van Nostrand's *San Francisco, 1806–1906*.

The publisher gratefully acknowledges the efforts of Éditions Robert Laffont in procuring the color transparency for Illustrations Plate 11.

List of Artists

PART I

Apocryphal Beginnings, 1775

Painting in California does not reach back, as it might have, to Juan Rodríguez Cabrillo's voyage of discovery in 1542, or to the infrequent voyages of exploration that followed in the next two hundred years. As far as is known, no on-the-spot depiction of a California scene resulted from the sixteenth and seventeenth century venturings of white men along the uncharted coast of what is now the State of California. It is not until the closing quarter of the eighteenth century that we find on record a painting that may represent a California scene. It is a full-length portrait of a shaven monk standing on the grassy shore of a bay; he holds a cross in his raised right hand and a violin and lilies in his left. In the background another monk is baptizing Indian children, a group of buildings is faintly visible, and a sailing ship is at anchor in the bay.

In 1865 an old painting fitting this description and reputed to be a portrait of Junípero Serra, Founding Father of the California missions, was given to the Society of California Pioneers in San Francisco.[1] Visitors to Pioneer Hall questioned the age and authenticity of the relic until the following notice appeared July 10, 1865 in the *Alta California*:

"Portrait of Junipero Serra.—The painting has no special merit artistically speaking, but it is one of much historic interest nevertheless. It represents the missionary Junipero Serra. The friar who is baptizing the Indians . . . is Buenaventura Sitjar, the buildings are those of the Mission San Carlos . . . This picture was painted by Don Cristobal Dia (sic) on the day of the completion of the mission in August 1770 . . ."

The numerous errors of fact in the *Alta California* story have since been corrected by Fr. Maynard Geiger, eminent biographer of Father Serra. Fr. Geiger identifies the portrait figure as that of Saint Francis Solanus, apostle of Tucúman and Peru, always represented with lilies and a violin;[2] Buenaventura Sitjar did not come to California until May, 1771 and therefore could not have been present at the founding of the mission; furthermore, the painting could not have been the work of Don Cristobal Díaz, a secular priest from Peru and chaplain of the *San Carlos*, as Díaz was not at Monterey or Carmel in 1770.[3]

Although Fr. Geiger has set the record straight on the subject of the painting, there still remains the tantalizing possibility that this large oil (which burned in the 1906 San Francisco fire) may have been the earliest painting executed in California by a white man, perhaps a mission padre.[4]

A claim of 'earliest' might also be made for the six paintings listed in an inventory of mission furnishings compiled by Father Junípero Serra at Monterey dated February 5, 1775: three large portraits of saints, two religious conceptions ("the work of a good painter, as

are also the others"), and a smaller canvas depicting the death of Saint Joseph.[5] But until further research establishes these six paintings and the so-called Junípero Serra portrait as art works of California origin, they may appropriately be termed apocryphal.

NOTES

Apocryphal Beginnings

1. Society of California Pioneers, San Francisco. Accession record.

2. The 'Serra' portrait follows the eighteenth-century practice of including background objects closely related to the subject figure.

3. Geiger, Maynard. *Representations of Father Junípero Serra in Painting and Woodcut. Their History and Evaluation.* Santa Barbara: Old Mission, 1958, p. 32.

4. The padres at Mission San Carlos Borromeo may have brought artist's materials with them from Mexico. It is known that in 1771 the missionaries at San Gabriel Mission requisitioned a dozen artist's brushes and a book, *Painting Without a Teacher*, for their own use or for instructing the neophytes in the art of church decoration. (Webb, Edith. *Indian Life at the Old Missions.* Los Angeles: Warren F. Lewis, 1952.)

5. Tibesar, Antoine, ed. *Writings of Junípero Serra.* Washington, D.C.: Academy of American Franciscan History, 1956.

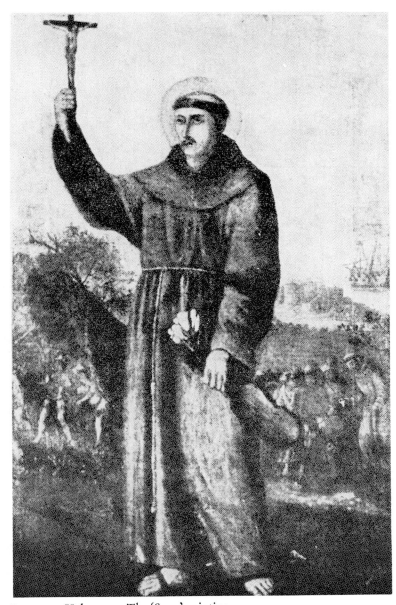

PLATE I Unknown The 'Serra' painting

Painting in Hispanic California, 1775–1845

The earliest known images of California were executed by artists attached to exploring expeditions sent out by France, Spain, England, and Russia in the late eighteenth and early nineteenth centuries. In those pre-camera eras it was customary for an expedition to include a professional artist, an artist-naturalist, or a competent draughtsman upon whom the sponsoring government could depend for factual delineations of the native life and customs, flora and fauna, and geographical features of the lands visited. Usually the artist made his preliminary sketches on land and worked them up into finished drawings or paintings at sea while the expedition was en route to another destination. The use of various media—pencil, pen and ink, ink wash, water color, singly or in combination—gave variety to the finished product, the quality of which depended upon the artist's skill. At the conclusion of the voyage the pictorial records became the basis for lithographic or engraved reproductions in the official publications. The 'finishers' who prepared the original drawings and paintings for publication often added details of their own or omitted certain features of the artist's conception; not infrequently derivative copies of the reproductions appeared in still more variant form in later books of travel and adventure.

Expeditionary art in Hispanic California was in the ambiance of the missions founded by Spanish missionaries between 1769 and 1822 along El Camino Real, California's first 'highway.' Until the 1830's these Spanish-Colonial outposts, spaced a day's journey apart from San Diego to San Rafael, were the only indication of the white man's presence in California. To their hospitable doors came explorers, whalers, traders, and chance travelers from the outside world. Among the infrequent callers of that by-gone mission era were certain gifted individuals who painted the earliest visual images we have of Hispanic California.

Gaspard Duché De Vancy

The first expeditionary artist known to have visited California was Gaspard Duché De Vancy, a French painter whose work had won wide acclaim in Europe. Duché De Vancy arrived at Monterey in the fall of 1786 as official artist of the French round-the-world expedition commanded by Comte Jean François Galaup de Lapérouse. In view of the fact that Spain and France were at that time on friendly terms, the long-standing ban on foreign visitors to California was set aside for the distinguished French explorer.

While at Monterey, Lapérouse's party was entertained for a day at Mission San Carlos Borromeo in Carmel Valley. The resident padres greeted the visitors in the mission court-yard where they had stationed in review a double file of Indian neophytes—men, women,

and children. Duché De Vancy depicted the welcoming scene in a small painting which he left with the padres, perhaps as a token of appreciation for their hospitality. This first documented California painting is the only art work Duché De Vancy is known to have executed in California.[1]

Tomás de Suría and José Cardero

In September, 1791, five years after Lapérouse's stopover in California, a Spanish round-the-world tour of exploration and scientific investigation under the command of Alejandro Malaspina called at Monterey. Malaspina, keenly aware of the unique contribution that art could make to scientific research, had put special emphasis on having a competent art corps included in the personnel. Several artists had been engaged at the start, but clashes of personalities and illnesses had necessitated certain removals and replacements. When the Malaspina expedition arrived at Monterey, the art corps consisted of Tomás de Suría, an artist-engraver on leave of absence from the Casa de Moneda in Mexico City, and José Cardero, a self-taught sailor-artist from Cadiz, Spain. At Monterey, Suría and Cardero industriously executed in pencil, pen and ink, ink wash, and water color at least nineteen carefully detailed drawings of colonists, soldiers, Indians, birds, plants, and other natural history subjects as well as views of the Presidio of Monterey and Mission San Carlos Borromeo at Carmel, the earliest known depictions of those establishments. Suría is believed also to have executed one of the three known pen and ink copies of Duché De Vancy's "Reception of LaPérouse."[2] The identity of the artist or artists of the other two copies has not been established.

John Sykes and Harry Humphreys

Following close upon Malaspina's California visit came that of Captain George Vancouver, commander of an English round-the-world expedition. Although Captain Vancouver well understood the importance of graphic records to supplement the written reports that would be made, he did not engage professional artists at the start as Lapérouse and Malaspina had done. He relied instead upon the latent talent he expected to find among members of his crew. Soon after setting out from England in 1791 this expectation was realized. "It was with infinite satisfaction," he wrote, "that I saw amongst the young gentlemen of the quarter-deck, some who, with little instruction, would be enabled to construct charts, take plans of bays and harbours, draw landscapes, and make faithful representations of the several headlands, coasts, and countries which we might discover."[3]

The Vancouver expedition spent three summers in the North Pacific Ocean. At the approach of winter each season the explorers sailed south to the warmer waters of California. On the first southward voyage Captain Vancouver may well have expected the Spanish authorities to apply the usual ban against foreign visitors, but when he arrived in the late

fall of 1792 he was fortunate in finding friendly commandantes at San Francisco and Monterey who treated him with proverbial Spanish hospitality. A brief initial call at San Francisco was followed by two full months at Monterey where members of the expedition were permitted complete freedom of movement ashore. Later, when the governor of California who had been absent at the time learned that English visitors had been allowed to observe the weakness of the country's defenses, the genial commandantes received a scalding reprimand for their open-handedness. As a result, when Vancouver arrived again in the fall of 1793 he received such a cold reception from the chastened commandantes that he sailed away as soon as his ships were reprovisioned. Nevertheless, he returned to California for a third time the following winter, hoping for a friendlier reception. He was not disappointed. Commandante José Darío Argüello, his hospitable host of the first visit, and a jovial new governor, Diego de Borica, extended every courtesy to the Englishmen. Among the pleasant occasions provided by the Spaniards was an excursion toward the Salinas Valley. It was the first time foreigners had been allowed inland.

Three of Vancouver's 'young men of the quarter-deck' whose naval education had included instruction in drawing became the artists of the expedition. They were Thomas Heddington, of whom nothing is presently on record except that he was a fifteen-year-old midshipman, Harry Humphreys[4] of the Royal Navy who signed on as master's mate of the *Discovery*, and John Sykes, a seventeen-year-old master's mate who became the chief artist. None of Heddington's California art work (if, indeed, he actually produced any) has been located, but five original Monterey views by Sykes and two by Humphreys are known. One of these, Sykes's "Point Conception on the Coast of California," dating from Vancouver's first visit is believed to be the oldest watercolor of California now in the United States.[5]

The pictorial records produced by the artists of the Vancouver expedition conformed strictly to the eighteenth-century tradition of topographic drawing. The artistic objective —to depict actual prospects as realistically as possible—was achieved; features of the terrain were represented undiminished and unblurred by distance. In the view, "Inland from Monterey," John Sykes drew every crag and crevice of a crenelated sandstone mountain as though viewed at a distance of ten feet, when in fact an extensive meadow lay between artist and subject. Two or three of the wash drawings and watercolors of Monterey scenes, however, perhaps because of the media, are softer in outline and do convey a sense of the lonely remoteness of the Spanish settlement. But taken as a whole, the California sketches, drawings, and watercolors that emanated from the Vancouver visits are the usual factual images of specific prospects.

Georg Heinrich von Langsdorff

The visits of French, Spanish, and English expeditionary artists to California in the late eighteenth century were followed early in the new century by two artist-naturalists of Russian affiliation. The first one to arrive was Georg Heinrich von Langsdorff, a surgeon-naturalist of German parentage, who came into the Pacific area in 1805 with the expedition commanded by Captain A. J. Krusenstern. From the Russian settlement at Sitka, Langsdorff accompanied Count Nikolai Petrovitch Rezanov to San Francisco on the *Juno* to exchange a cargo of manufactured goods for raw food stuffs badly needed by the Russian colonies in the Far North. The *Juno* reached San Francisco Bay on April 5, 1806.[6]

The sight of a foreign ship entering the Bay for an unknown and perhaps hostile purpose raised a general alarm at the San Francisco Presidio, but after some hallooing back and forth from shore to ship, the Russian party was allowed to land. Rezanov did not speak Spanish; the Spaniards knew no Russian. The impasse was solved when Langsdorff acted as interpreter, conversing in Latin with the padres from Mission San Francisco de Asís.

While Rezanov was negotiating with the commandante during the next six weeks Langsdorff collected and sketched objects of interest to a naturalist. At the invitation of the padres he visited Mission San José, the first foreigner to be allowed that far inland, and while there was entertained with ceremonial dances performed by a group of costumed Indians. After nearly two months Rezanov succeeded in obtaining a full cargo of provisions and on May 19,[7] the *Juno* sailed for the Far North.

Two California scenes by Langsdorff are known: a brush drawing of San Francisco Presidio, the earliest recorded representation of any part of San Francisco, and a brush drawing of the Indian dancers at Mission San José.[8] Langsdorff's training in scientific observation is evident in both drawings in his meticulous attention to detail. In the foreground of the presidio view, taken from offshore, four Indians are paddling a reed canoe, the construction of which is carefully delineated. In the background the presidio buildings, the wooded path leading to the beach, and the two hills now known as Twin Peaks are drawn with topographical exactness. In the portrait group of the Indian dancers the designs painted (or tattooed?) on bodies and faces are those of local tribes; the headdresses and loin cloths are individually styled and the body poses indicate various dance steps. The background represents the actual setting of the mission—near a river, with hills in the distance.

Louis Choris

An expedition commissioned by the Czar to explore the South Pacific and to search for a passage to the Atlantic Ocean north of Alaska, and perhaps to estimate the strength of Spain's hold on California, brought the second artist of Russian affiliation to California.

Louis Choris—possibly the most talented of the early documentary artists—came to San Francisco on October 2, 1816 in the *Rurik* as artist for Otto von Kotzebue, a lieutenant in the Russian navy.[9] Russian encroachment on the California coast had materialized four years earlier with the establishment of Fort Ross as a base for Russian sealing operations. The garrison at San Francisco, never of any real military consequence, lacked the force to drive the intruders away, and for the same reason when the *Rurik* arrived the Spanish commandante was powerless to muster resistance. The Russian party took advantage of the situation to spend a full month documenting the condition of the Spanish outpost, the physical characteristics of the natives and their customs, and the local flora and fauna, ostensibly in the pursuit of scientific, geographical, and natural history researches.

Nothing escaped the eye of the artist Louis Choris. In water colors he carefully depicted the San Francisco Presidio, the natives, their costumes,[10] and the wild life. He drew objects as they met his eye, and in the two books he wrote about his travels the lithographic illustrations, which he did himself, retain a remarkable life-like freshness.

Choris's paintings and drawings are the last known to have been made while Spain ruled California.

When Mexico won independence from Spain in 1822 California became a province of Mexico. The country's most notable heritages carried over from the Spanish-Colonial period (1769-1822) were four presidios, three pueblos, and twenty missions[11] established by Spanish soldiers, missionaries, and colonists between San Diego and San Rafael. Of the three institutions the missions dominated; all else revolved around them. In fact, California history from the beginning of Spanish colonization through the early years of the Mexican regime is in reality the history of the missions. Yet it appears that no colonist, padre, soldier, trader, or casual visitor produced any paintings or drawings of those remarkable establishments between 1800 and 1825, the period of their greatest development. (Choris shows only the façade of Mission San Francisco de Asís in his "Danse des Californiens.") The earliest known inclusive view of a mission complex was painted in the winter of 1826-27 during Captain Frederick William Beechey's first visit to Monterey and San Francisco on the *Blossom*.

Captain Beechey had been sent out by the British government in May, 1825 on a voyage of exploration to the Far North Pacific and Bering Strait. At the end of the arctic summer of 1826 he sailed the *Blossom* south to winter in the warmer waters of California; the following October he again stopped over at Monterey and San Francisco before sailing home to England.

The old Spanish law prohibiting foreigners to anchor in California ports except when in need of provisions or ship repairs was no longer in force in Mexican California, and on both visits Captain Beechey received a most hospitable welcome. Among other courtesies ex-

9

tended to him was permission to survey the bay, the only proviso being that a copy of the survey map be given to the Mexican authorities.[12] When the survey was completed on December 28, 1826, the *Blossom* sailed for Monterey where she remained until January 5, 1827; the October, 1827 visit was somewhat longer in duration.

One of the midshipmen aboard the *Blossom* was the captain's younger brother, Richard Brydges Beechey. Captain Beechey and Midshipman Beechey had inherited considerable artistic talent from their distinguished father Sir William Beechey, the English portraitist. Captain Beechey is not known to have used his artistic ability to produce any pictorial records of California, but Richard combined naval duties with those of artist. The official artist of the expedition, however, was Master's Mate William Smyth.

Richard Brydges Beechey and William Smyth

Young Beechey and William Smyth painted a number of watercolors depicting California subjects, frequently working from the same viewpoint, but with markedly dissimilar results. Beechey's paintings are in the English romantic style: the grass is thicker and greener than ever grew in the poor soil of the Monterey mesa; the trees are gracefully heavy with foliage in defiance of winter; the tile roofs are bright red instead of dull terra-cotta which they actually were; the rotund cows are English 'Constable' creatures, not bony Spanish stock; the draped female figures are reminiscent of Biblical times. Only occasionally does Beechey touch solid ground as in his "View Taken Near Monterey,"[13] in which he depicts a horseback rider in sombrero and poncho, the everyday costume of a *Californio*. It is always sunny noontime in Beechey's works, the turquoise sky without a trace of fog, the land serenely peaceful. Here, the artist seems to say, one may enjoy a pleasant existence in an idyllic setting, far from the troubled world.

In contrast to Richard Beechey's romantic approach to his subjects William Smyth's art reflects a preoccupation with exact reproduction of the prospect before him. In his "Bay of Monterey Upper California"[14] taken from the same spot as Beechey's "View Near Monterey" the foreground is sparsely covered with the dead grasses of early winter, a dull sky shows through the thin branches of a weathered tree; all colors are muted as on a typically overcast day. Both artists include the *Blossom* in Monterey Bay, but Smyth also includes the masts of a Russian brig and a Yankee trading vessel that were then in port. Beechey confined his art activity to depictions of scenery; Smyth, as official artist of the expedition, executed not only topographic views of the Monterey and San Francisco areas, but also drew with scientific accuracy birds, plants, and small animals, and in a number of sketches portrayed the life and customs of the Indians.[15]

The art works of Captain Beechey's two artists are the first expeditionary paintings to possess aesthetic as well as documentary value.

California was just as remote geographically under Mexican rule as it had been during the Spanish regime, but the new government opened the ports to foreigners and the outside world came closer. With the restrictions on foreign trade removed, the hide and tallow business flourished. During the 1830's and 1840's an increasing number of traders dropped anchor in the once-empty California ports to exchange cargoes of manufactured goods for bundles of hides and botas of tallow. A goodly number of these early callers found the country so much to their liking that they never left. Meanwhile the covered wagons of emigrant settlers were rumbling westward across the desert and over the Sierra Nevada into California. This period of coast and inland settlement during which California first stirred with a life of its own saw the rise of the great ranchos, 'the days of the Dons,' celebrated by historians as the Golden Age of California.

Incredible as it seems in a later art-conscious day, life in that Golden Age apparently passed unrecorded pictorially by any Spanish-Mexican *Californio* or pioneer settler. Except for views executed by two early traders, Alfred Robinson and Jean Jacques Vioget, who later became residents, painting in California in the 1830's and 1840's was limited (as from the beginning) to the art activities of transient outsiders.[16] The total known collection for the period is not so extensive that we need omit from this narrative any of the contributing personalities.

Auguste Bernard Duhaut-Cilly

The first known graphic representations of settlements outside the San Francisco and Monterey areas were produced in 1827 and 1828 by Auguste Bernard Duhaut-Cilly,[17] an artistically-inclined navigator. Duhaut-Cilly came to California in command of *L'Héros*, a vessel owned by Laval and Lafitte, a French firm interested in establishing trade with the Hawaiian Islands and California. The ship made stops at San Francisco, Santa Cruz, San Diego, Fort Ross, and Bodega; from those points Captain Duhaut-Cilly visited settlements in the San Francisco Bay Area and southward along El Camino Real. He was intelligent and observant as well as artistic and his *Voyage Autour du monde* (1834), is one of the most interesting and informative narratives of the period. The volume contains three engravings of California scenes based on wash drawings by Duhaut-Cilly: "Mission San Luis Rey,"[18] "View of the Russian Establishment at Bodega" (Fort Ross), and "Monterey."[19] Although the Monterey view was taken from some distance out in the bay the architectural features of the church, presidio, and fort are clearly presented in miniature. The detailed nearer views of Mission San Luis Rey and the Russian settlement eventually served as models in the restoration of those establishments.

Ferdinand Deppe

Before Duhaut-Cilly departed California in October, 1828, he may have met another trader, Ferdinand Deppe, who also found the missions along El Camino Real worthy of pictorial representation. Ferdinand Deppe was a German supercargo in the employ of Heinrich Virmond, a German merchant engaged in the hide and tallow business with headquarters at Mexico City. Between 1828 and 1836 Deppe made at least six trips to California on business for Virmond. He traveled up and down the country from mission to mission, rancho to rancho, stopping at night with the friendly padres or the hospitable rancheros, among whom he had many friends.

Deppe was an amateur artist of more than average skill. From his brush came the earliest known views of Mission Santa Barbara and Mission San Gabriel[20] painted in 1832, the latter from a drawing made by Deppe in 1828. Both paintings are remarkably accurate in all details. In view of the many visits and pleasant contacts Ferdinand Deppe enjoyed in California over a period of eight years and the evidence of his talent in the two mission pictures it may reasonably be supposed that there are other paintings by him not yet located.

Alfred Robinson

During his journeying from one settlement to another in the early 1830's Ferdinand Deppe frequently fell in with young Alfred Robinson of Boston who was in California as clerk for Bryant and Sturgis, hide and tallow traders. Occasionally Deppe and Robinson chanced to ride along El Camino Real together in the interests of their employers, soliciting orders for manufactured goods in exchange for cargoes of hides and tallow. Robinson also had an artist's awareness of paintable subjects and one may imagine that the two travelers shared an appreciation of the pastoral countryside and the picturesque missions.

Robinson recorded his early impressions of California in six known views of missions, pueblos, and presidios[21] and also drew a panoramic landfall sketch of Monterey Bay,[22] taken from offshore. His work is of no aesthetic value, at least not as transferred to stone by F. Swinton for reproduction in Robinson's *Life in California* (1846), but this minor artist's painstakingly accurate draughtsmanship endows the pieces with a high degree of historical value. They are also of interest as the earliest known views by one who became a long-term resident of the state.

Jean Jacques Vioget

Early on a clear morning in July, 1837, Captain Jean Jacques Vioget, a trader who was something of an artist, sailed the bark *Delmira* into San Francisco Bay and dropped anchor in Yerba Buena Cove. From the *Delmira*'s anchorage[23] the captain had a panoramic view across the gentle cove to the western hills destined one day to be the site of the City of San Fran-

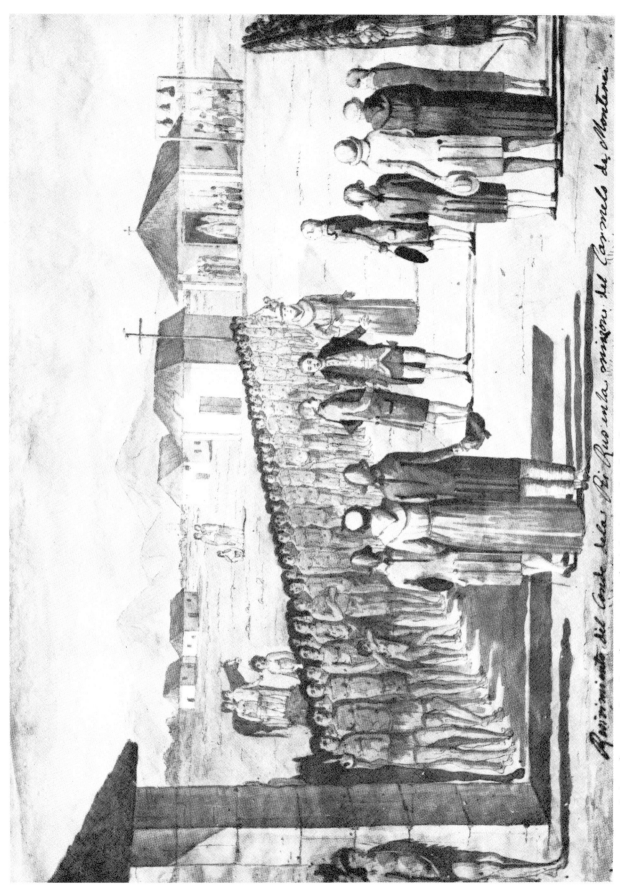

PLATE 2 Tomás de Suría Reception of La Pérouse at Carmel Mission in 1786 (attributed)

cisco. At the crest of the first slope beyond the narrow beach Vioget could see two build-ings,[24] apparently the only structures in the settlement then known as Yerba Buena. Except for a lumber schooner and another trading vessel near the *Delmira* and one or two small boats close to shore, the seemingly endless reaches of the smiling cove and bay were empty of sail. Transported by the beauty and solitude all around him Captain Vioget broke out his brushes and paints as soon as business ashore permitted to reproduce the tranquil scene in water color. When the *Delmira* sailed away that August the little painting now known by the title "Yerba Buena (San Francisco) in the Spring of 1837,"[25] swung on the cabin wall, possibly alongside other port scenes painted by the far-roving captain.[26]

For the next two years Captain Vioget was in and out of West Coast ports after which he more or less gave up seafaring to make his home in Yerba Buena, where he built a com-bination dwelling and tavern. The watercolor of Yerba Buena painted on that clear day in 1837 adorned the tavern wall and as time passed became an object of much historical interest as the earliest pictorial representation of San Francisco.[27] It is believed to be the only sur-viving California painting by Captain Jean Jacques Vioget. There are on record, however, a San Mateo scene[28] and some sketches that Vioget gave to Edward Vischer, a fellow-trader and merchant.[29]

François Edmond Pâris

Foreign interest in California's ultimate destiny brought in a greater number of quasi-scouting expeditions in the last ten years of Mexican rule than had come to California since the Spanish occupation. Whatever the underlying motives of the various governments, expeditions of any size sent out in the 1830's and 1840's included scientists and experts whose specific assignment was to record the flora and fauna, geographical features, the customs of the inhabitants of the territory explored, and to supplement written reports with visual images.

Well-equipped to accomplish the latter objective was the French expedition com-manded by Captain Cyrille Pierre Thèodore Laplace that brought the watercolorist Fran-çois Edmond Pâris to the West Coast in August, 1839, on the *Artèmise*.

Captain Laplace's exploratory assignments included a hydrographic survey of the north-western coast of North America; in connection with that section of his work Laplace put in at Bodega Bay, San Francisco, Santa Cruz, and Monterey. While at Monterey the French visitors rode over the hills to Mission San Carlos Borromeo in Carmel Valley. They found the padres still in nominal charge but the gradual secularization of the missions, culminating in the Secularization Act of 1834, had brought the mission's prosperous days to a sad end. The Indian laborers had nearly all departed; the weaving looms stood silent, the baking ovens were cold, gardens and orchards were overgrown with weeds, and in places winter

rains had washed down the neglected adobe walls. Lieutenant Pârís's depiction of the mission as it was on that autumn day movingly conveys to the viewer an air of solitude, of grandeur-that-was. The tilted cross, the roofless outbuildings, and the broken adobe walls subtly carry the artist's message that this great institution, the burial place of the founding father, Junípero Serra, already belonged to California's past. "Mission de N-D Carmel aux Environs de San Carlos de Monterey Californie,"[30] is one of the few extant art works of pastoral California of aesthetic as well as historic value. It is the only known California view by this talented artist.[31]

Titian Ramsay Peale, Joseph Drayton, and Alfred Thomas Agate

Spying out the land was not limited to the great powers of Europe. During the years leading up to the war with Mexico the United States government kept a close watch on California. In 1841 the United States South Seas Surveying and Exploring Expedition under the command of Lieutenant Charles Wilkes, U.S.N., arrived on the West Coast ostensibly in the interests of commerce and navigation. In America in the 1840's art and science were not as mutually exclusive as in our day; the artist-naturalist and artist-draughtsman were considered indispensable for the advancement of world knowledge. For that reason the roster of the Wilkes expedition included such distinguished men of science and art as Titian Ramsay Peale, the eminent Philadelphia artist-naturalist, Joseph Drayton, portraitist and illustrator (regarded by Wilkes as the country's most experienced artist in those fields), and Alfred Thomas Agate, a professional miniaturist and portraitist of New York.

Wilkes's instructions included separate surveys of San Francisco and the Northwest Coast. One of the vessels sent north from San Francisco was the *Peacock*. The total loss of that vessel at the mouth of the Columbia River necessitated major changes in transporting the company back to San Francisco Bay where the squadron was to reassemble for the homeward voyage to New York. Seventeen stranded members of the expedition, including the artists Titian Ramsay Peale and Alfred Thomas Agate, were detailed to make the return journey over old trails from Oregon to the final rendezvous at San Francisco. Joseph Drayton, the third artist, made the return from Oregon by ship.

The land party started south on September 1, 1841, and reached the northern entrance to the Sacramento Valley in mid-October. Agate's views of the "South Branch of the Clamet [Klamath]," "Shasty Peak," and "An Encampment on the Upper Sacramento River,"[32] are the earliest known representations of that part of the country by a professional American artist. Agate used a camera lucida, the new tool of the documentary artist, which gave his delineations a high degree of accuracy.

At Sutter's Fort the company divided. A launch from the *Vincennes* carried a group that included Agate down the river to San Francisco Bay; Peale and the others continued the

journey by land. On the way around the southern end of the bay Peale's party stopped over at Mission San José where the artist noted in his diary there were "several good oil paintings" and walls "rather neatly painted in distemper by a wandering Italian."[33]

Peale sailed with the assembled squadron from San Francisco on October 31, 1842. Except for a sepia wash drawing of the *Vincennes* on the San Francisco bar (a vignette in Peale's diary) there are no known California paintings by this artist.[34] Possibly there were drawings and paintings in the saddlebags that were lost on the way south from Oregon when Peale's horse stumbled on a mountain trail and the bags pitched into an inaccessible canyon.

William Henry Meyers

During the late 1830's vessels of the United States Pacific Squadron were constantly cruising in Pacific waters pending the anticipated outbreak of hostilities between Mexico and the United States. On October 19, 1842, an over-eager American commodore, Thomas ap Catesby Jones, believing that war had already been declared, sailed the *Cyane* and the *United States* into Monterey Bay. The next morning Commodore Jones took possession of the town, an embarrassing premature action that he diplomatically retracted within twenty-four hours. The episode provided an irrepressible amateur painter, William Henry Meyers, a young gunner on the *Cyane*, with a subject for California's first known narrative painting, "The Taking of Monterey, October 20, 1842."[35] In spirited style Meyers depicted the United States marines storming the Mexican fort, cutlasses waving and bayonets pointed. An unmanned cannon prominently featured in the foreground indicates the marines encountered no resistance. Meyers used a sheet of stationery for the lively watercolor and sent it to a friend, William Hancock, with some acrid comments on Commodore Jones's blunder.

The *Cyane* remained peacefully on the California coast for more than a year. Meyers kept a day-by-day journal during the cruise which he illustrated with water color paintings.[36] In addition to ten views of settlements between San Francisco and San Diego the journal contains four watercolors especially illustrative of life in California: "Hunting the Grizzly Bear," "Hide Houses at San Diego," "Indians Gambling," and "Hunting at San Francisco."

Emmanuel Sandelius, The "King's Orphan"

Among the interested spectators watching the international incident known ever after as "Commodore Jones's War" was Emmanuel Sandelius, a Swedish visitor traveling under the name Gustave M. Waseurtz af Sandels or Dr. Sandels who called himself the "King's Orphan."[37] In the course of his world travels Sandelius arrived at Monterey from Mexico just previous to the Commodore Jones incident; during the next twelve months he became well-known up and down the country as a gentleman, a scholar, a mineralogist, a physician

15

(possibly without a medical degree), and an artist-of-sorts. As he journeyed about he produced numerous pencil, pen and ink, and watercolors of various settlements, missions, and scenes illustrative of life in California. Although not above amateur level, his portfolio of views[38] is a welcome addition to the limited number of extant visual images of California executed in the years immediately preceding the American conquest.

NOTES

I. *Painting in Hispanic California, 1775–1845*

1. No California views are known to have been included in the packets of documents sent by Lapérouse to France from later ports of call. His two vessels and all aboard were lost in the South Pacific in 1788. The Duché De Vancy painting survived several changes of ownership in California, but finally disappeared in the 1830's. (See Henry R. Wagner, "Four Early Sketches of Monterey Scenes," California Historical Society *Quarterly*, vol. 15, September 1936, pp. 213–215.)

2. The California scenes painted by Tomás de Suría and José Cardero remained virtually unknown until outsiders were given limited access to the Spanish archives in the 1920's. Suría's copy of the Duché De Vancy painting, "Reception of LaPérouse at Carmel Mission in 1786," and Cardero's "Vista del Convento Yglecia, y Rancherias de la Mision del Carmelo" are in the Museo Naval, Madrid. Cardero's "Mision del Carmelo de Monterey," "Vista del Presidio de Monte Rey," and "Plaza del Presidio de Monte-Rey," are in The Bancroft Library, University of California, Berkeley, California.

3. Vancouver, George. *A Voyage of Discovery to the North Pacific Ocean and around the World . . . Performed in the Years 1790, 1791, 1792, 1793, 1794, and 1795.* 3 vols. London: Printed for G. G. & J. Robinson & J. Edwards, 1798, vol. 1, p. xiv.

4. The signature "W. Humphries" on certain works by this artist is in a different hand. Humphrey's original California drawings in the Hydrographer's Office of the Admiralty, Taunton, are signed "H. Humphreys," as is his manuscript journal, "Proceedings of H. M. S. Discovery," in the Public Records Office, London.

5. Six of the seven known California paintings emanating from Vancouver's visit to Monterey in 1792 are in the Hydrographer's Office of the Admiralty: "View of Monterey," "Mission of San Carlos near Monterey," "A View Inland from Monterey," and "The Presidio of Monterey," by John Sykes; "A View of the Land about Monterey," and "Serra's Reef," by Harry Humphreys. The seventh painting, "Point Conception," by Sykes, is in The Bancroft Library.

6. Langsdorff's date: March 28, 1806.

7. Langsdorff's date: May 10, 1806.

8. Original in The Bancroft Library. Reproduced in Langsdorff, Georg Heinrich. *Bemerkungen auf einer Reise um die Welt.* Frankfurt: Fredrich Williams, 1812, vol. 2, p. 132.

9. Historians disagree as to whether or not Otto von Kotzebue was a Russian secret agent sent to spy on the military strength of the Spanish outposts in California.

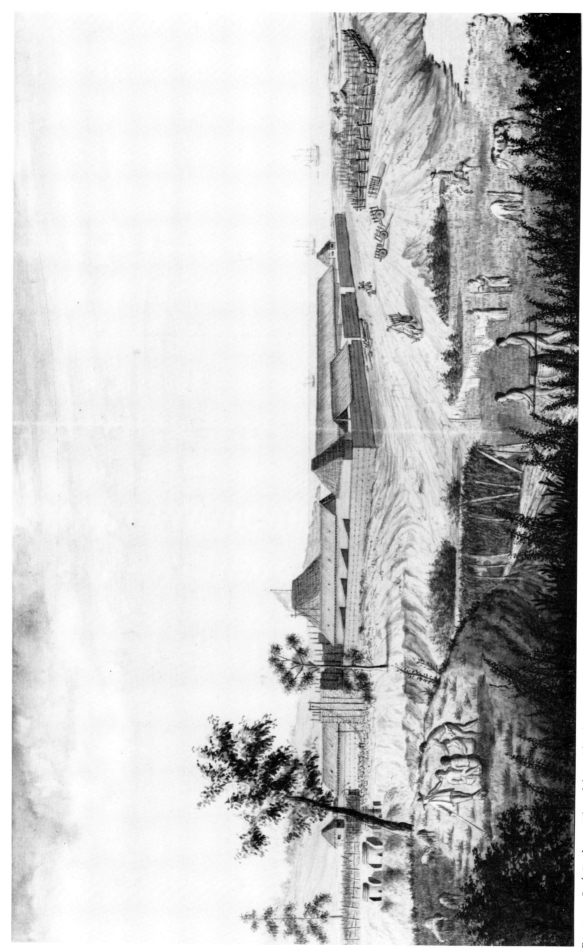

PLATE 3 José Cardero Vista del Presidio de Monte Rey

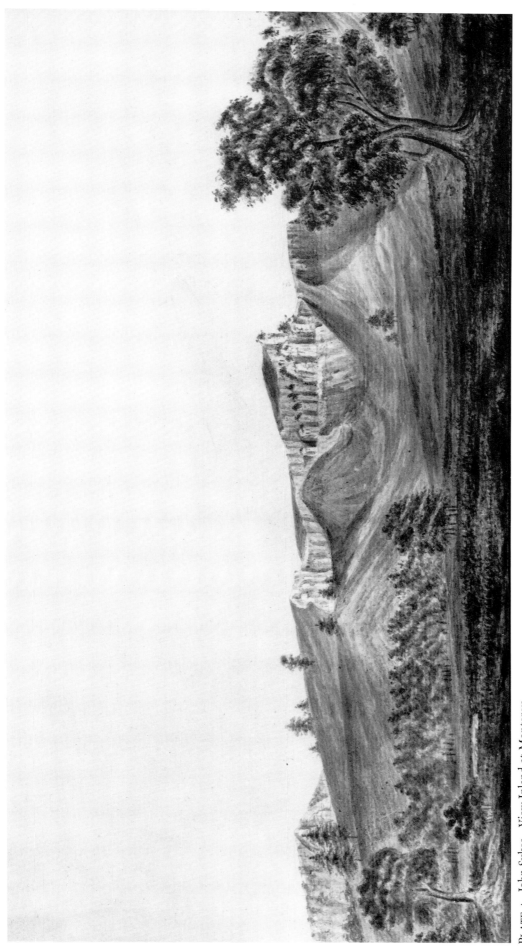

PLATE 4 John Sykes View Inland at Monterey

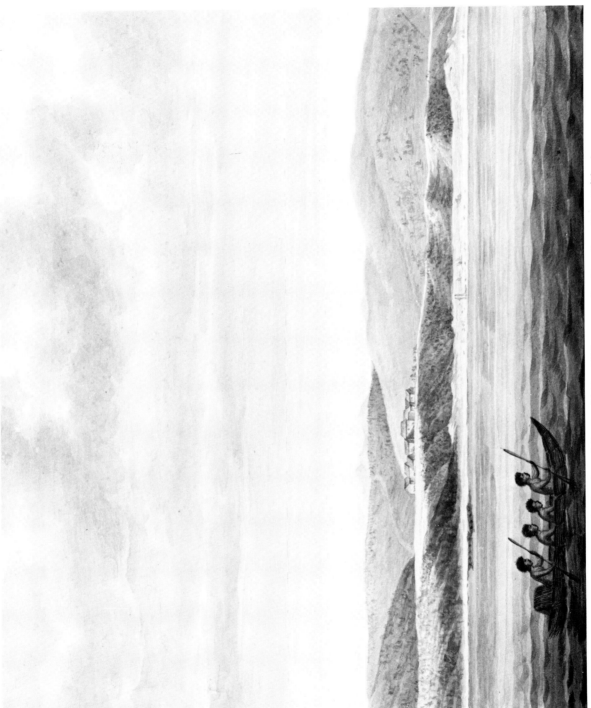

PLATE 5 George Heinrich von Langsdorff View of the Spanish Establishments at San Francisco, New California

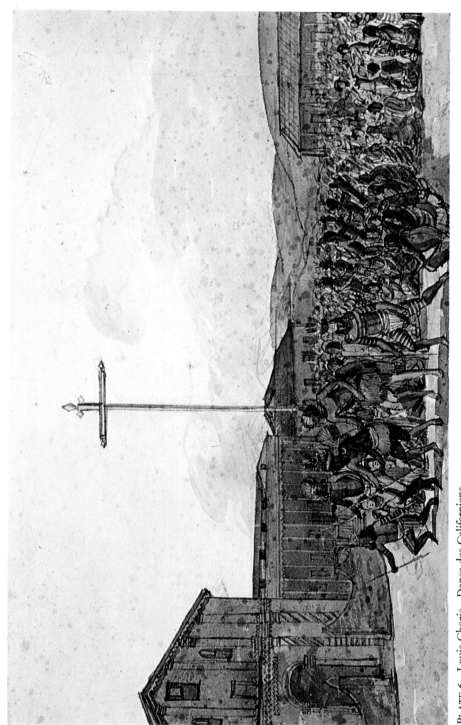

PLATE 6 Louis Choris Danse des Californiens

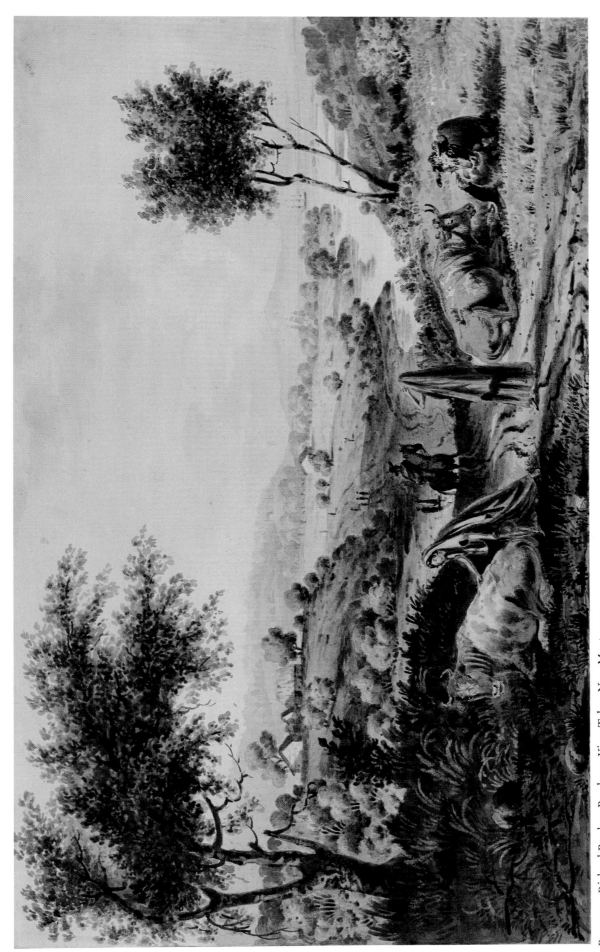

PLATE 7 Richard Brydges Beechey View Taken Near Monterrey

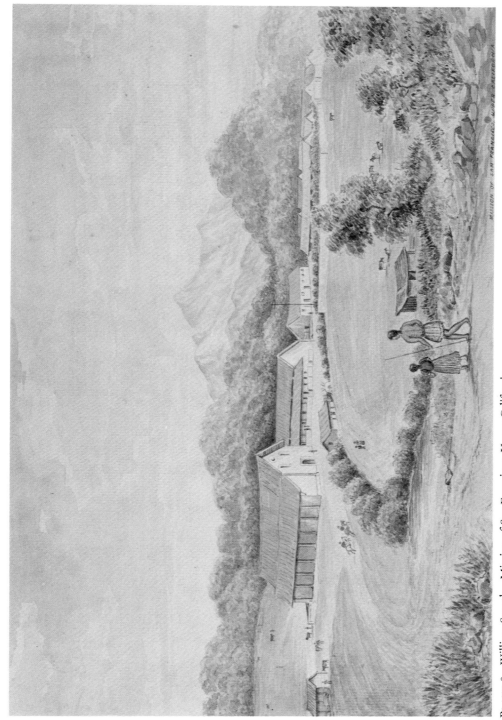

PLATE 8 William Smyth Mission of San Francisco, Upper California

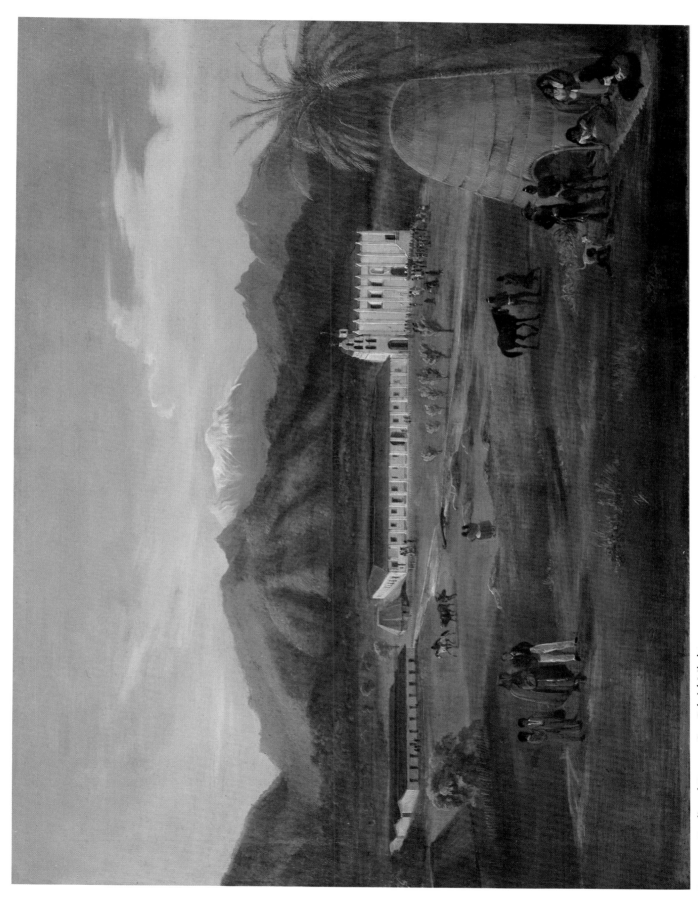

PLATE 9 Ferdinand Deppe San Gabriel Mission

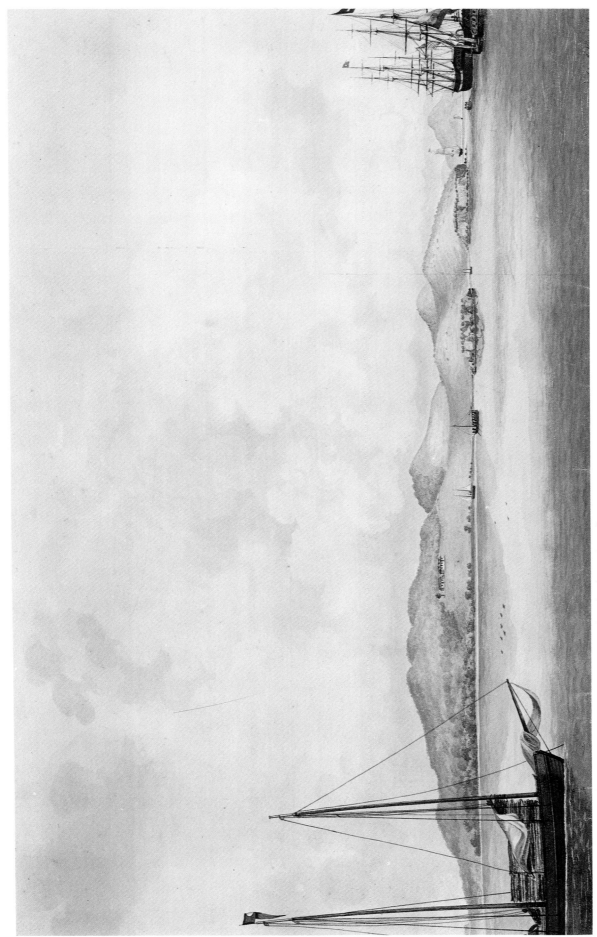

PLATE 10 Jean Jacques Vioget Yerba Buena, Now San Francisco, in the Spring of 1837

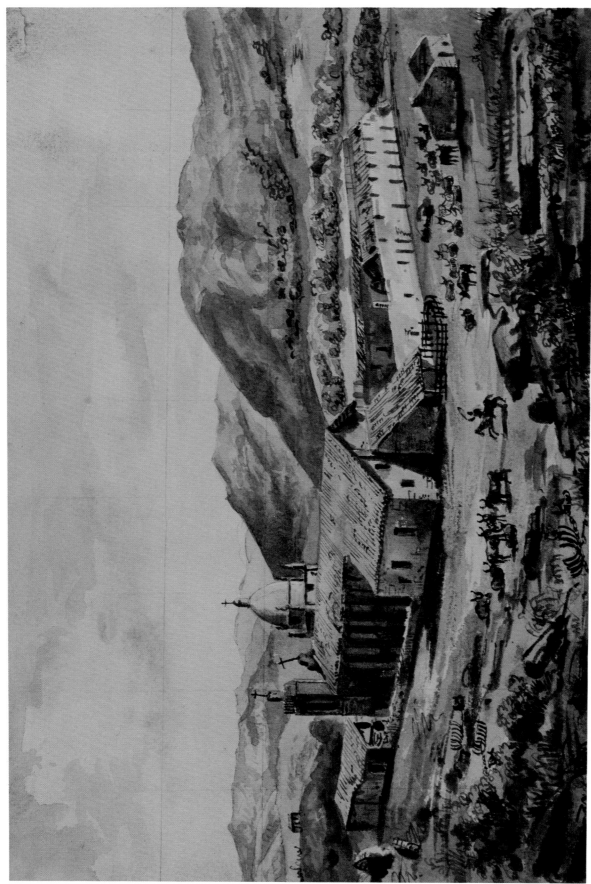

PLATE 11 François Edmond Pâris Mission De N-D Carmel Aux Environs De San Carlos de Monterey Californie

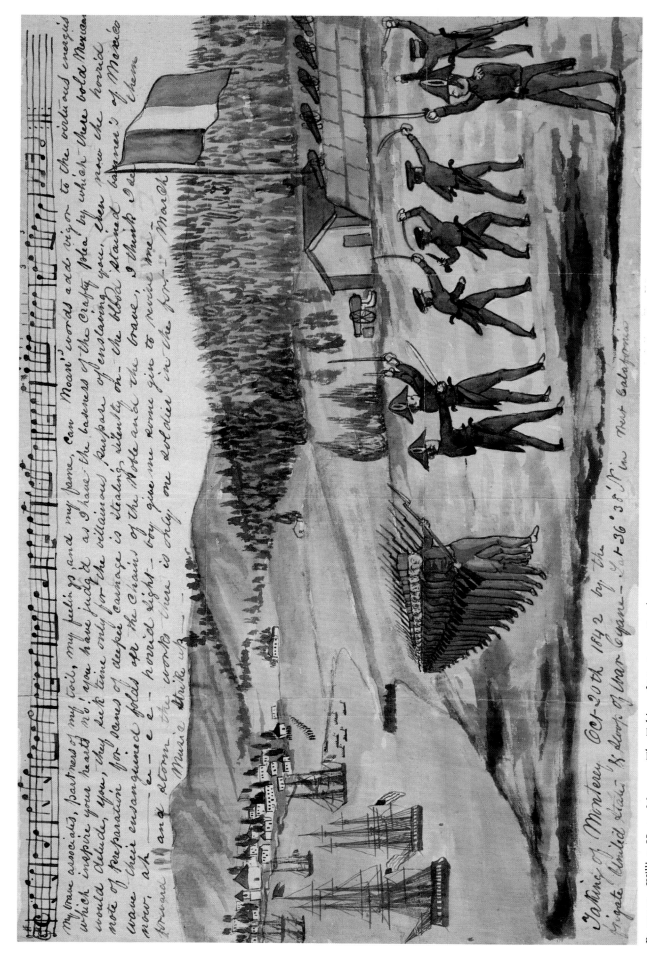

PLATE 12 · William Henry Meyers · *The Taking of Monterey, October 20, 1842*

10. The mission façade shown in the background of Choris's "Danse des Californiens" is the earliest known image of any part of Mission San Francisco de Asís.

11. The 21st mission, San Francisco Solano (Sonoma), the last in the chain, was founded on July 4, 1823, under Mexican auspices.

12. A manuscript map inscribed "The Harbour of San Francisco, Nueva California," by Captain F. W. Beechey, is in the Record of Deeds, Contra Costa County Recorder's Office, Martinez, California. There is also a manuscript "Plan of the Harbour of San Francisco, New Albion," by F. W. Beechey in the Hydrographer's Office of the Admiralty. It is believed that the Martinez map is a copy of the one in Taunton.

13. In The Bancroft Library.

14. In The Bancroft Library.

15. Approximately 65 original sketches by William Smyth are in The Bancroft Library. A Smyth sketchbook in the Mitchell Library, Melbourne, Australia, contains six sketches of California scenes including one of Mission San José from which the artist may have made a finished painting.

Although William Smyth was the official artist aboard the *Blossom* only one of his California paintings, "Californians Throwing the Lasso," appeared in F. W. Beechey's published report of the voyage, *A Narrative of a Voyage to the Pacific and Beering's Strait . . . 1825–1828*, London: Henry Colburn and Richard Bentley, 1831. Reproductions of Smyth's California paintings have appeared in later books of travel and adventure. The earliest, Alexander Forbes's *California: A History of Upper and Lower California*. London: Smith, Elder & Co., 1839, contains eight California scenes based on Smyth's sketches and paintings. Four originals are known: "Presidio and Pueblo of Monterey, Upper California," and "Bay of Monterey—Upper California," in The Bancroft Library; "The Mission of San Carlos, Upper California," in the David I. Bushnell Collection, Peabody Museum, Harvard University; "The Mission of San Francisco Upper California," in the Donald Angus Collection, Honolulu, Hawaii.

16. This is not to say that certain unsigned undated portraits of early *Californios* may not one day be identified as the work of artist-residents of Hispanic California.

17. Duhaut-Cilly was in California and along the West Coast from January to October, 1827, and from May to October, 1828.

18. In the foreground of the mission view Duhaut-Cilly depicts a rider at full gallop about to snatch up a half-buried rooster, a favorite sport of the *Californios*.

19. No original California paintings by Duhaut-Cilly have been located. A reproduction of the Monterey view with minor changes appeared in Paolo Emilio Botta's translation of Duhaut-Cilly's *Voyage Autour du Monde* (Turin, Italy, 1841).

20. The San Gabriel view is believed to have belonged in 1850 to Nicolas Augustus Den of Santa Barbara and later to his townsman Daniel Antonio Hill. Hill may have written the description of the painting in the Los Angeles *Star*, December 24, 1859:

"A Real California Painting:—It represents the entire mission on a feast day in the spring of the year under a cloudless sky, with a religious procession leaving the church and buildings, in complete order, with Californians, Indians, huts, trees, hedges and animals, and the river flowing by; all according to the times. Old Friar Sanchez is in the foreground in his Franciscan habit, attended by

his two Indian boys in their red dresses, speaking to a foreign trader, and a number of Indians male and female are introduced dressed in the fashion of the mission period—the women in their bayetas of red flannel, and the men conforming to custom and nature.

"The execution of the work is exceedingly creditable to the artist—the sketch was made with the best judgment and taste by the draughtsman, who must have been highly competent and *au fait*, with all his perceptive faculties alive. In the background Mount San Bernardino rears his snow-capped summit and wooded green sides, and the neighboring hills are covered with a lively California verdure of emerald, flushed with the glowing tinge of an afternoon sun. The painting measures 38″ x 28″ and is valued not only as a work of art, but as representing a magnificent California landscape, with historical accessories now buried forever in the grave of the past. It is the only *proper painting* ever made of one of the missions during their flourescence (sic), and with its intrinsic merits is worthy of careful preservation . . ."

The original paintings of San Gabriel and Santa Barbara missions by Ferdinand Deppe are in the Santa Barbara Mission archives, Santa Barbara, California.

21. "Town of Santa Barbara," "Mission San Luis Rey," "Mission San Gabriel," "Presidio of Santa Barbara," "Mission of Santa Barbara," and "Mission of San Buenaventura." (The originals have not been located.)

22. Original ink-and-pencil in the California Historical Society, San Francisco, California.

23. Yerba Buena Cove was completely filled in during the early years of the American occupation. The *Delmira*'s anchorage in 1837 would be at approximately the present intersection of Drumm and Sacramento streets.

24. Built by William A. Richardson and Jacob P. Leese, the first settlers at Yerba Buena.

25. Privately owned.

26. Several watercolors of South American ports by Jean Jacques Vioget, dated 1834, came into the American art market in the 1960's.

27. The verso of the frame is covered with depositions by early pioneers verifying the historical accuracy of the painting.

28. *History of the Coast Counties of Central California.* Chicago: Lewis Publishing Co., 1893, p. 196.

29. Gudde, Erwin Gustav, ed. "Edward Vischer's First Visit to California," California Historical Society *Quarterly*, vol. 19, September 1940, pp. 193–216.

30. The view is taken from the rear of the church near the present corner of Santa Lucia and Francisco streets, looking east to the hills bordering Carmel Valley. In the Musée de la Marine, Paris.

31. Laplace's *Campagne de circumnavigation de la frégate l'Artémise pendant les années 1837, 1838, 1839 et 1840* . . . Paris: Arthus Bertrand, 1841–1854, is illustrated with 14 engravings, 10 of which were engraved by Laplace from watercolors by Pâris.

32. The Klamath River view is an original watercolor in The Bancroft Library. The other two views are reproduced in Wilkes, Charles. *Narrative of the United States South Seas Surveying & Exploring Expedition During the Years 1838, 1839, 1840, 1841, 1842.* Philadelphia: Printed by C. Sherman, 1844, 5 vols. and Atlas.

33. The Italian painter Leonardo Barbieri is known to have been painting in California by the 1840's, but there is no conclusive evidence that he was the artist of the church decorations.

34. The written and pictorial records produced by members of the Wilkes expedition became government property and were deposited in the National Institution for the Promotion of Science, forerunner of the Smithsonian Institution. Specimens collected by the botanists and naturalists are in the Smithsonian Institution, but except for Agate's "South Branch of the Clamet," no original drawings, paintings, or sketches of California subjects by Wilkes's expeditionary artists have been located in the National Archives, the Smithsonian, or elsewhere.

35. In The Bancroft Library.

36. In The Bancroft Library.

37. Sandelius also used the name Edelyertha. (See Gudde, Erwin G., ed. "Edward Vischer's First Trip to California," California Historical Society *Quarterly*, vol. 19, September, 1940, pp. 214–216.)

38. In the Society of California Pioneers, San Francisco, California.

Chapter Two

Painting in California During the Conquest,
1846 – 1848

With the heavy influx of Americans into Mexican California during the 1830's and the first years of the 1840's, it became evident to men of perception that California would inevitably fall to the United States, either by peaceful negotiation or by war with Mexico. The long-anticipated event became an actuality when on May 13, 1846, the United States declared war on Mexico. The occupation of California by American forces quickly materialized. On July 7 Commodore John Drake Sloat, commander of the Pacific Squadron, took possession of Monterey; two days later Captain William Mervine captured the port of San Francisco; a week later Sonoma and Sutter's Fort were occupied; and early in September Southern California was temporarily subdued. These stirring events became the subjects of first-hand —if not first-class—paintings and drawings depicting the Yankee conquest and occupation of California.

Edward Meyer Kern

Edward Meyer Kern, artist-naturalist, came into California with Colonel John Charles Frémont in the spring of 1846 and was in the Sacramento Valley with Frémont at the time of the Bear Flag Revolt. When the war with Mexico abruptly terminated that uprising of disgruntled settlers, Frémont's party was quickly mustered into the regular United States Army. Edward Meyer Kern, invested with the rank of lieutenant in the California Battalion of Volunteers, was posted to Sutter's Fort. This talented artist could have vastly enriched the annals of California painting, but his time at the fort was fully occupied with keeping accounts, recruiting men and horses, protecting settlers from hostile Indian forays, and requisitioning supplies from San Francisco. To these time-consuming duties was added in February, 1847 the outfitting of relief parties to rescue the Donner party trapped in the snow-covered Sierra Nevada.

Following the termination of his military assignment in the fall of 1847 Kern departed California without, as far as is known, having executed any finished paintings or drawings of the historic events he had witnessed. To date the record of his artistic activity in California rests on doubtful attribution of certain plates in Frémont's *Memoirs of My Life*[1] and a few rough sketches in his diary, journals, and letters. Among these is a hasty sketch of the lowering of the bear Flag.[2]

John Mix Stanley

Of the artists swept into California by the war with Mexico perhaps the most talented was John Mix Stanley, now remembered chiefly for his Indian portraits. In the late summer of 1846 while on a painting tour in the Southwest, Stanley fell in with General Stephen Watts Kearny at Santa Fé and on September 1 left for California with Kearny's Army of the West as staff artist of the Topographical Engineers Corps. After a long and wearisome march the company entered California near San Diego and at San Pasqual engaged a force of mounted *Californios* in battle. In that near-rout of the Americans, Stanley lost his baggage, but saved his sketches. From San Diego he sailed to San Francisco where he made finished paintings from his sketches. The paintings came to the attention of Edwin Bryant who later wrote the following description of them: "A more truthful, interesting and valuable series of paintings, delineating mountain scenery, the floral exhibitions on the route, the savage tribes between Santa Fé and California, combined with camp life and marches through the desert and wilderness, has never been and probably never will be exhibited."[3]

At San Francisco Stanley hired guides and purchased equipment for a six-month round-trip journey by horseback to the Oregon country to paint portraits of northern Indians. On August 1, 1847, he left from San Francisco for the East Coast, going by way of Hawaii, and was not again in California.

At present the only known original California painting by John Mix Stanley is a delicate watercolor of San Francisco Bay.[4] Among the missing California views by this artist is "San Diego from the Old Fort," one of the earliest recorded views of that city.[5]

Joseph Warren Revere

Lieutenant Joseph Warren Revere who later attained some reputation as an artist and muralist was an officer on the *Portsmouth* in San Francisco Bay when hostilities with Mexico commenced in July, 1846. Revere was the first to raise the American flag at Sonoma, and for awhile served as commander of that garrison. In the final flareup of disturbances in Southern California the *Portsmouth* was dispatched to San Diego and Revere may have participated in the battles of San Gabriel and La Mesa.

Lieutenant Revere executed a number of California sketches and paintings of which six appeared as lithographs in his *A Tour of Duty in California*.[6] The original drawings and paintings have disappeared; the last known location of his "Mount Diablo from the Sacramento River" was the Revere family home at Morristown, New Jersey, in 1880. The loss of Lieutenant Revere's images of California during the conquest is of minor importance artistically speaking, but it typifies the fate that overtook much of the first-hand art produced in that disturbed period.

William Henry Meyers

William Henry Meyers, previously noticed here as the artist of "The Taking of Monterey on October 20, 1842," was on a second tour of duty in California as gunner on the *Dale* during the final battles of the war with Mexico. He depicted the decisive engagements at San Pasqual, San Gabriel, and La Mesa in a series of spirited watercolors with a concluding view of the United States Naval Squadron peacefully at anchor in Monterey Bay. Meyers was a participant in some of the actions he delineated; for others he drew upon eye-witness accounts. The resulting series of twenty-eight paintings,[7] which also includes scenes of naval engagements off the coast of Mexico, illustrates the unsophisticated tactics of land and naval warfare in that day.[8]

Meyers was not a trained artist, but he had a fine sense of the dramatic and an unusual degree of natural artistic ability. His water color representations of specific places and events, infused with his flare for the dramatic, are an important addition to the limited number of narrative paintings produced in California prior to the American take-over.

William Rich Hutton

Victory over Mexico brought California under United States military rule. Former Mexican authorities were promptly replaced with American army and navy personnel or civilians in government employ. One of the latter, William Rich Hutton, proved to be the most prolific delineator of California scenes yet to visit California.

William Rich Hutton came to Monterey in April, 1847, as clerk to his uncle William Rich, a paymaster of the United States volunteer troops. Hutton was in California until March, 1853 in government employ or engaged in civil projects of surveying, drafting, or clerical work. During his six years in California Hutton traveled up and down the coast between San Francisco and Los Angeles, visited Sutter's Fort and Sutter's Mill on the American River, and briefly toured the mining region. During his travels he produced at least seventy-five pencil sketches and water color paintings of missions, towns, churches, camps, and scenes of California life.[9] In the 1847 views of the Monterey area he worked in pencil or pen and ink, perhaps because brushes and paints were scarce during the first months of the occupation. Two of his watercolors painted in 1848 are closely related to the hide and tallow business: "Trying out Tallow, Monterey," depicting Indian workers stirring botas of tallow over fires, and "Matanza, Monterey," a view of a bone-littered slaughter ground with hides strung out on a fence to dry. The accuracy of Hutton's draughtsmanship proved useful a hundred years later when his view of the custom house at Monterey enabled archeologists to locate the rock cairn that had held the original flagpole.

Remarkably, the Hutton collection of more than one hundred original drawings and watercolors has been preserved intact.[10]

Alfred Sully

Yankee domination made itself felt from the moment the United States flag took the breeze atop the old flagpole at Monterey. In the occupied towns along El Camino Real Yankee rule and Yankee ways pushed aside the leisurely pace and pattern of Spanish-Mexican life. Out in the cattle country, however, in the old adobe ranch houses the change-over made little difference in established routines. The annual roundups and matanzas, frequent picnics, gay weddings, happy christenings (numerous, indeed, among a people that welcomed a family of twenty or so children), feast days, and funerals (also sadly numerous because of the high rate of infant mortality) continued to fill the lives of the *Californios*.

Nostalgic images of the days before the 'gringos' came are found in scenes painted by Lieutenant Alfred Sully, son of the American portraitist Thomas Sully, and an artist in his own right. Although Lieutenant Sully did not arrive in California until April, 1849, he is brought into our narrative at this point because he caught on canvas the lingering flavor of an earlier day.

As chief quartermaster of the United States troops stationed at Monterey, young Sully had ample leisure time for socializing with other officers and with the leading families of the old capital and to paint the scenes and customs of a land and culture alien to him. There being no regular officers' mess Sully boarded with the hospitable Doña Angustias Jimeno and soon fell in love with Manuela, her fifteen-year-old daughter. They were married in 1850, and for a time Sully considered settling in California, but Manuela's death a year later, followed by the death of their son soon afterwards, caused the grief-stricken lieutenant to long for transfer to another post. The transfer came in 1853 and Sully gladly said farewell to California.

Lieutenant Sully had been drawing and painting since childhood, an activity that he continued during his entire adult life. Although he had not reached the peak of his artistic ability before coming to California his charming sketches and watercolors of life on a California rancho[11] and his appealing depictions of towns, missions, and churches surpass artistically all others known for the period. The rancho scenes, believed to represent the outlying Jimeno rancho, were painted before the great 'days of the Dons' passed into hisory and before the oncoming Gold Rush flooded the country with the manners and mores of the outside world. In Lieutenant Sully's depictions we have a rare visual record of California at the close of the Hispanic era.

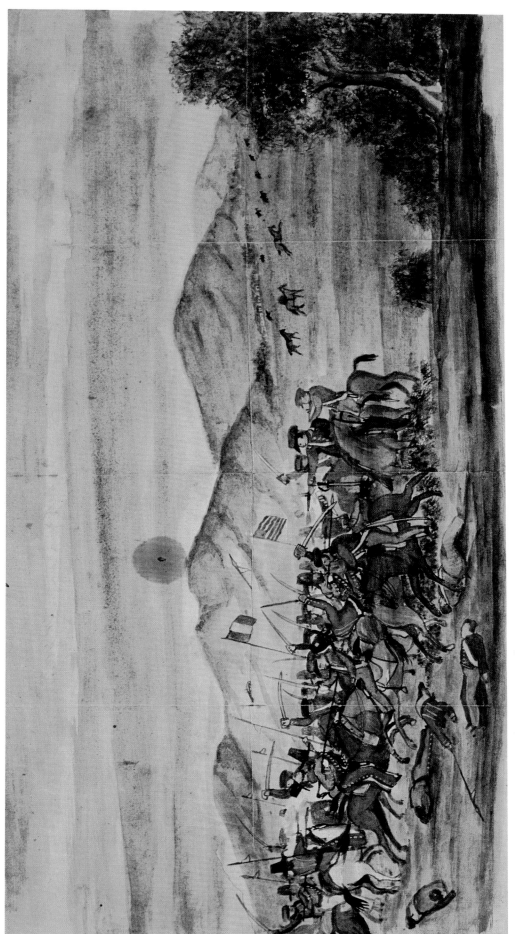

PLATE 13 William Henry Meyers Fight at San Pasqual

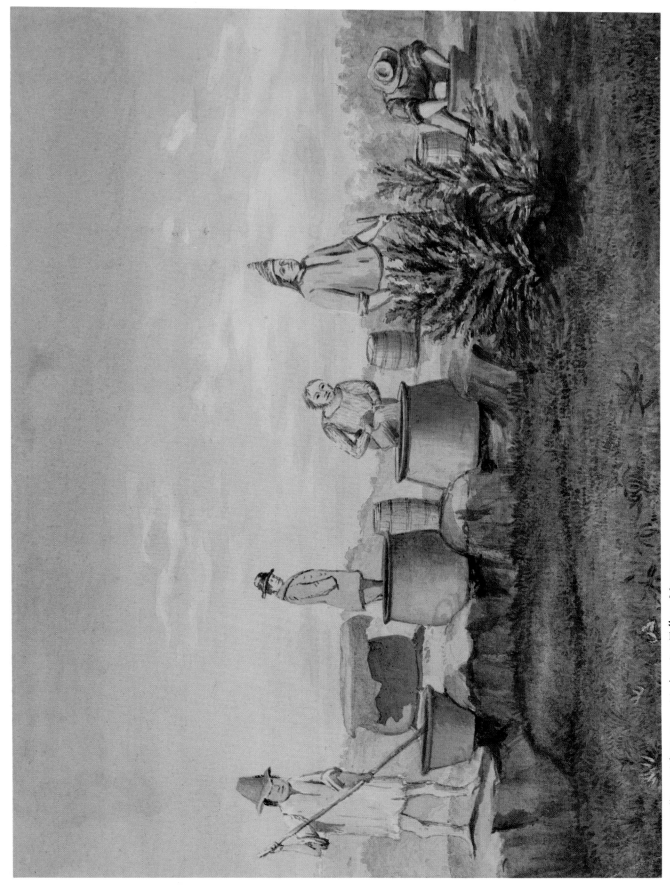

PLATE 14 William Rich Hutton Trying Out Tallow, Monterey

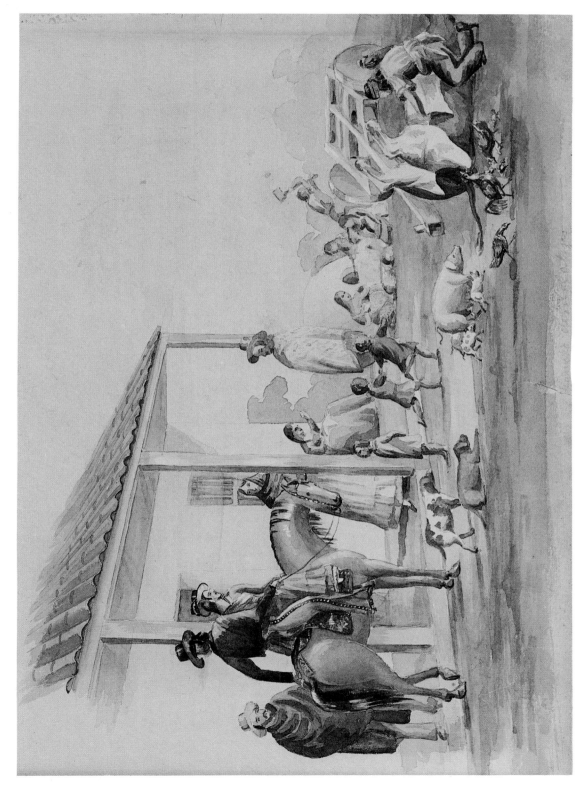

PLATE 15 Alfred Sully California Rancho Scene

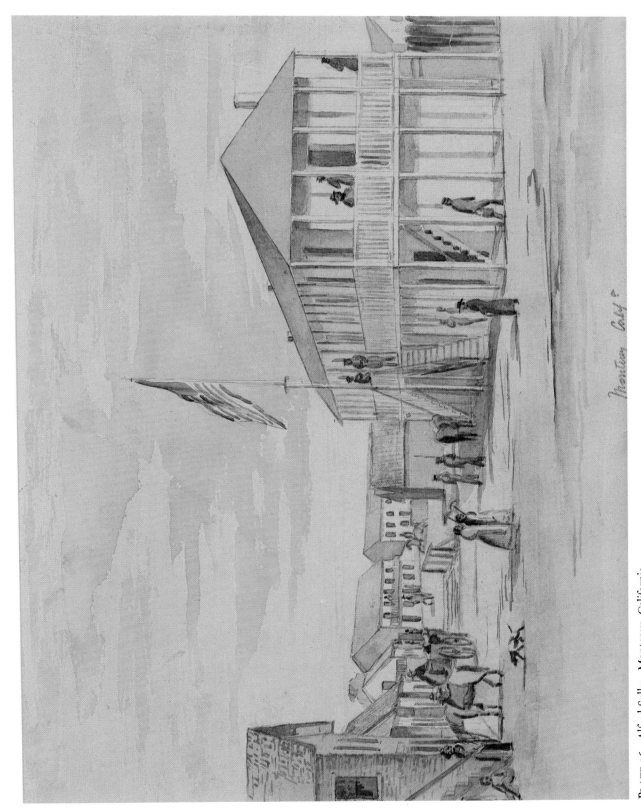

Monterey Calif.

PLATE 16 Alfred Sully Monterey, California

NOTES

II. *Painting in California During the Conquest, 1846–1848*

 1. Frémont, John Charles. *Memoirs of My Life, by John Charles Frémont. Including in the Narrative Five Journeys of Western Exploration, During the Years 1842, 1843–4, 1845–6—7, 1848–9, 1853–4 . . .* Chicago and New York: Belford, Clark & Co., 1887.

 2. In The Henry E. Huntington Library and Art Gallery, San Marino, California.

 3. Bryant, Edwin. *What I Saw in California.* New York: Appleton, 1848, p. 435.

 4. Privately owned.

 5. Reproduced in William H. Emory, *Notes of a Military Reconnaissance from Ft. Leavenworth, in Missouri, to San Diego, in California . . .* Washington, D.C.: Wendell and Van Benthuysen, 1848.

 6. Revere, Joseph Warren. *A Tour of Duty in California . . .* edited by Joseph N. Balestier . . . New York: C. S. Francis & Co., Boston: J. H. Francis, 1849.

 7. In The Franklin Delano Roosevelt Library, Hyde Park, New York.

 8. After the battle of La Mesa on January 9, 1847, Dr. John S. Griffin, assistant surgeon with Kearny's army, wrote in his diary: "Some artist among the Californians drew a picture of the action on the 9th—which represented us in square, three deep, and our cattle and baggage in the centre. Under it was written, "The infernal Yankee Coral." "A Doctor Comes to California. The Diary of John S. Griffin . . ." Edited by George Walcott Ames, Jr. California Historical Society *Quarterly*, vol. 22, March, 1943, p. 44.

 9. In The Henry E. Huntington Library and Art Gallery.

 10. In The Henry E. Huntington Library and Art Gallery.

 11. Several California scenes by Lieutenant Alfred Sully are in The Oakland Museum, Oakland, California, but the major portion of his California paintings and sketches are privately owned.

Chapter Three

Painting in Eldorado, 1849—1859

Gold on the American!

The shout that echoed around the world in January, 1848, touched off a migration such as had never been known before. Hordes of gold-seekers from the very ends of the earth set out post-haste for California; by the spring of 1849 men of every race and creed from all walks of life were converging upon San Francisco by the thousands, bound for the golden foothills of the Sierra Nevada. That human avalanche, destined to change the course of California history—indeed, the course of world history—included scores of amateur and professional painters. Although most of the artists and would-be artists had come for gold, and gold only, many interrupted that mad pursuit long enough to sketch indescribable San Francisco, the roaring port of entry; Sacramento and Stockton, the jumping-off places for the northern and southern mines; the sawmill at Coloma where the first flakes of gold were found; the legendary figures of John Augustus Sutter, owner of the historic mill, and his foreman, James Wilson Marshall, who made the astonishing discovery (but who was destined never to profit from his find); Sutter's Fort where the first nugget was tested; and the rough mining camps along the banks of California's wild rivers.

Professional artists there were among the crowds pouring into San Francisco, but it was the obscure amateurs whose names are not to be found in the scanty art annals of the period who produced the major portion of the extant Gold Rush images: John Hovey, Daniel W. Nason, John Henry Dunnell, A. W. Grippen, John S. Eagan, George Coffin, W. Henry Bringhurst, Charles L. Parrish, Antoine Claveau—to mention but a few—amateurs who earnestly attempted to record the passing scene to the best of their limited ability. They produced no works of art but many of their blunt pencil sketches, crude drawings, and garish paintings possess a high degree of historical accuracy and no small amount of naïve charm. Counter-balancing the voluminous amateur output of the period is a limited but extraordinarily impressive collection of colorful, vigorous paintings and drawings by fine professional painters who took temporary or permanent leaves-of-absences from established art careers at home to seek their fortunes in the world-famous Eldorado. Also, there came into the country during the 1850's a corps of competent reconnaissance artists who painted the California scene as they passed through on tours-of-duty. Drawing upon that immeasurable influx of artistic talent we document the progress of painting in California during the Gold Rush decade in terms of some two score representative artists and near-artists who worked in California for varying lengths of time between 1849 and 1859.

27

First to engage our attention (in order of their arrival) are six artist-authors who wrote and illustrated popular narratives of their experiences in Gold Rush California: William Redmond Ryan, an obscure English artist and New York journalist; William McIlvaine, a socially prominent artist of Philadelphia; Bayard Taylor, lecturer, poet, and writer of travel books; George Victor Cooper and John M. Letts, perfectly matched artist-author collaborators from the East; Francis Samuel Marryat, adventurous English sportsman, writer, and world traveler; and John David Borthwick, Royal Academician astray from the London art world. On-the-scene representations by this disparate sextet contributed significantly to the origin of the Gold Rush image of California.

William Redmond Ryan

The war with Mexico gave William Redmond Ryan, an obscure English artist unbearably bored with newspaper reporting in New York City, an opportunity "to obtain relief from the monotony of civilized life, in a more congenial and adventurous existence amidst the wilds and mountains of California"[1] by enlisting in Colonel Jonathan D. Stevenson's California-bound First New York Volunteers.

Colonel Stevenson's recruits, "stout daring young fellows from the lower ranks of society,"[2] arrived in California some months after the war was over. In October, 1848 they found themselves being mustered out at Monterey, only two hundred miles from the beckoning gold country. Almost to a man the ex-soldiers took the trail north. Ryan held back for a time hoping to receive the one hundred and sixty acres that had been promised the Volunteers at the outset. When it became clear that the promise was not to be kept Ryan and four comrades banded together as the United Mining Company[3] and started for the mines. The United Mining Company lasted as far as San José, a matter of seventy miles, where it disbanded. Ryan, with one companion, went on.

As a miner Ryan seems not to have been "a stout daring young fellow" at all. Accustomed to a more sedentary life, the back-breaking pick-and-pan labor under a burning sun in the rocky gorges of the Stanislaus River proved almost beyond his endurance. Fellow-prospectors might find sizeable nuggets but not Ryan. His average take for a day's hard labor was only four or five dollars; after weeks of hardships he still had scarcely any gold in his poke. What Ryan did have, however, was a collection of on-the-spot sketches of camps, mining operations, frontier towns, scenes on the trail, and his faithfully-kept daily journal.

Discouraged with mining but not yet through with California, Ryan next tried to earn a living painting houses in Monterey. He soon discovered that Indian servants kept the adobe houses in that old town spotlessly whitewashed inside and out. Moving on to San Francisco with its wooden buildings Ryan fared somewhat better as a house and ship painter.[4] Affluent for the moment with two hundred and sixty dollars earned by painting

the Panama Mail Steamship *California*, Ryan rented an office in the rear of a house. He had scarcely settled in when the owner raised the rent and Ryan was obliged to move. He found a tent in Happy Valley, a mis-named, dismal area of sand dunes on the outskirts of San Francisco. In that 'suburban' location little work came his way. He passed the time huddled in the tent, writing in his journal, or painting. When he exhausted his stock of painting materials—nothing of the sort was to be had in San Francisco—he rowed about in the crowded harbor garnering ship paints and brushes from sympathetic captains. As the days and weeks passed, San Francisco's cold summer winds and damp fogs blowing through the flimsy shelter caused Ryan's health to fail alarmingly. By August, 1849, after only ten months he had had enough of "the wilds of California" and left for home, a self-styled "frame-shaken man" of twenty-seven years.

Some months later Ryan's relatives in London received twenty-three of the sick man's California paintings and drawings and his journal.[5] The collection was published in 1850 under the title *Personal Adventures in Upper and Lower California 1848-1849*, and was advertised as "the only original work on California hitherto published in a collective form in England... The illustrations bear the impression of truth, and have a certain rude vigor and freshness."[6] Several English and two Dutch editions appeared while the Gold Rush was at its height. The illustrations in this early 'best seller' are the only known California Gold Rush images produced by the sickly artist-author whose death occurred in 1855 at New Orleans.[7]

William McIlvaine

Our second artist-author, William McIlvaine, more forehanded than the unfortunate William Redmond Ryan, providently brought with him to California good health, a supply of artists' materials, and sufficient funds to insulate himself against privation. Taking temporary leave of absence from a career as a landscape artist in Philadelphia, he arrived on June 1, 1849 at San Francisco. From that chaotic entrepôt he hurried on by steamer and horseback to the mining regions.

All that summer and even through the early fall the heat in the mountain gorges was almost unbearable and McIlvaine found it far more pleasant to loll in the shade painting than to toil in the sun with pick and pan. What luck he had prospecting is not known, but when he started back to San Francisco in October he had a wealth of California drawings and paintings in his portfolio—scenes of miners at work and views of the mushrooming towns he passed on his way. Apparently totally uninterested in what was already a world renowned city McIlvaine departed San Francisco by the first available steamer, the *California* (freshly painted by Ryan!). And as so often would be the case in years to come the artist carried his California sketches and paintings East with him. The next year sixteen lithographs which McIlvaine had made from his paintings appeared in his *Sketches of Scenery and Notes of Personal*

Adventures in California and Mexico (1850).[8] Ten of the sixteen plates were California views.

From time to time during the next ten years the Pennsylvania Academy of Fine Arts and the National Academy of Design[9] exhibited McIlvaine's "Prairie, California," "Panning for Gold," and "Sacramento River, California."[10] Also emanating from McIlvaine's California visit but virtually unknown until 1949 are "Canon (sic.) of the South Fork above Sutter's Mills," "Wood's Diggings," "Scene on the Tuolumne," and "The Miner,"[11] one of the earliest California genre paintings of record.

McIlvaine's sensitively painted landscapes of California subjects are not only the first true works of art executed in the state after the American occupation, but may also have been the earliest to attract general attention to the compelling beauty of California's mountain scenery. It may be taken for granted that the haunting images of California produced by this talented artist influenced fellow landscapists to seek 'that wilder image' in California.

Bayard Taylor

Bayard Taylor, once internationally known as a world traveler, lecturer, poet, author, and artist is no longer a name in literature or art, but his *Eldorado, or Adventures in the Path of Empire...*, published in 1850, with illustrations from his own brush, endures as an important primary source of information on California in the first year of the Gold Rush.

Bayard Taylor was writing for the New York *Tribune* when the news of the gold discovery broke. *Tribune* editor Horace Greeley realized the advantage of having a roving reporter on the scene and in June, 1849, sent Taylor out on assignment. Taylor arrived at San Francisco in August and remained in the country until the end of September. In that short time he 'covered' the southern and northern mining districts, visited the principal towns as far south as Santa Barbara, and attended the Constitutional Convention at Monterey (where he waltzed with Captain John A. Sutter at the closing ball).[12] The thorough-going reporter returned to New York on January 1, 1850 by way of Mazatlan, Mexico.

While in California Taylor did not try his luck at the mines or speculate in real estate, the two most absorbing local pursuits of the day. He remained strictly a reporter, a looker-on at the incredible sights around him; he saw everything, and in a lively engaging style reported on everything he saw. His letters to the *Tribune* were among the most informative of any being published in eastern journals; his first-hand account of the Constitutional Convention is possibly the best we have in printed form. The letters were incorporated into Taylor's account of his California visit, *Eldorado...*, which contains eight beautifully tinted lithographs. Seven are reproductions of the author's own watercolors: "Monterey," "San Francisco in November, 1849," "Lower Bar," "Mokelumne River," "The Volcano Diggings," "Sacramento City," "Portsmouth Square," and "Mazatlan."[13] The originals of

these views have not been located, but three additional watercolors of California scenes executed by Taylor are known: "Ranche in the Valley of San José," "New Almaden," and "Yerba Buena Island from San Francisco."[14]

George Victor Cooper

The role of the artist in Gold Rush literature is perfectly illustrated in the sketches and paintings of George Victor Cooper, a New York artist, sculptor, cameo-cutter, and lithographer who accompanied John M. Letts, a New York friend, on a gold-seeking journey to California in the spring of 1849. This author-artist team left New York on the bark *Marietta* for Panama, crossed the Isthmus by canoe and horseback, and on the Pacific side took passage on the *Niantic* for San Francisco, arriving there on July 4. In the mining region Cooper and Letts hopefully moved from one mining camp to another along the middle fork of the American River. Although the area was one of the richest in gold deposits, Letts and Cooper often found no more than a dollar's worth of the shining flakes, or nothing, at the end of a long day's labor. By late fall the disillusioned friends gave up all hope of striking it rich at the diggings and ventured into storekeeping at Mormon Bar. That enterprise was even more unprofitable and in December Letts went home. Cooper is believed to have remained in California another year or two.

While in California Letts kept a daily journal and Cooper sketched and painted fifty or more California subjects. In 1852 forty-eight of Cooper's pictorial record of his California experiences appeared in Lett's *California Illustrated, Including a Description of the Panama & Nicaragua Routes.* . . . The historically important (if not aesthetically pleasing) illustrations include early views of Mormon Bar (now inundated by Folsom Lake), Placerville, San Francisco, Santa Barbara, and a portrait of John Augustus Sutter. In the preface Letts describes Cooper's delineations as "truthful and to be relied upon as faithfully portraying the scenes they are designed to represent. They were drawn upon the spot and in order to preserve characteristics, even the attitudes of the individuals represented are truthfully given."

Cooper also painted a bird's eye view of "Sacramento City from the foot of J Street, Showing I, J, and K streets with the Sierra Nevada in the Distance," which was first published as a separate lithograph in 1850; since then it has been frequently reissued and is considered one of the most important early printed views of Sacramento.

Francis Samuel Marryat

Gold was certainly the prime magnet that attracted men to California in 1849, but one of our artist-authors came for a quite different reason: to hunt game.

For a good many years after the American occupation California was a hunter's paradise. Seemingly unlimited flocks of ducks, geese, pheasants, and other wild fowl hovered in

clouds over the marshes bordering much of San Francisco, San Pablo, and Suisun bays; grizzly and brown bears foraged in the nearby foothills; herds of deer and antelope grazed the fertile Russian and Napa valleys. The killing of the plentiful game for food had always been a necessary part of life for the *Californios*; under the American regime hunting became an unrestrained slaughter. Undoubtedly, any number of eager sportsmen made the long trip to California expressly to indulge in the pastime. The only artist-author known to have done so was Francis Samuel Marryat, the adventurous youngest son of the English novelist Captain Frederick Marryat.

Captain Marryat died in August, 1848, and soon afterward Francis used part of the inheritance from his father's estate to outfit himself for a hunting trip to California's Russian River Valley. For this adventure he took along his man Barnes, an ex-poacher and game-keeper and three hunting dogs. The party arrived at San Francisco on June 14, 1850 at the height of one of the city's frequent fires. In the general excitement and confusion Marryat could not find transportation across the Bay for his long-legged dogs. While detained for a time by that difficulty Marryat executed water color paintings of Mission Dolores,[15] the Fremont Hotel, Sansome Street from the southwest corner of California Street, Blay (Bay?) Place, an overall view of San Francisco and the Bay,[16] and several vividly colored scenes depicting volunteer bucket brigades battling roaring conflagrations.[17]

Marryat, Barnes, and the dogs eventually reached their destination, and until late in December hunted deer and antelope in the Russian River Valley. Upon returning to the Bay Area Marryat made San Francisco his headquarters between visits to Sacramento, Stockton, and the mining region. He became involved in various ventures among which were a costly scheme for quartz mining and the construction of an iron hotel at Vallejo. He happened to be in Vallejo in June, 1851 when another tremendous fire burnt large sections of San Francisco. In that holocaust Marryat lost his entire wardrobe, his collected notes on California commercial, political, and social affairs, and a number of sketches and paintings. He went home to England in May, 1852, but that fall brought his wife to San Francisco for a visit of several months. Home again in 1853 Marryat wrote and illustrated *Mountains and Molehills . . .* (1855), an amusing narrative of his California experiences. In the preface he stated that inasmuch as his sketches had been destroyed by fire he had been unable to illustrate the scenery of California but had endeavored "to be faithful to the characteristics of the people." The lost landscapes are more than compensated for by the twenty-six illustrations, in themselves a kindly searchlight into the vicissitudes of life in California as Marryat observed them. Although Marryat sent some of his drawings and paintings to England for publication[18] and took others with him when he departed California he is one of the few Gold Rush artists to leave behind a representative collection of his work.

Marryat's vivid watercolors and his book, *Mountains and Molehills*, constitute an impor-

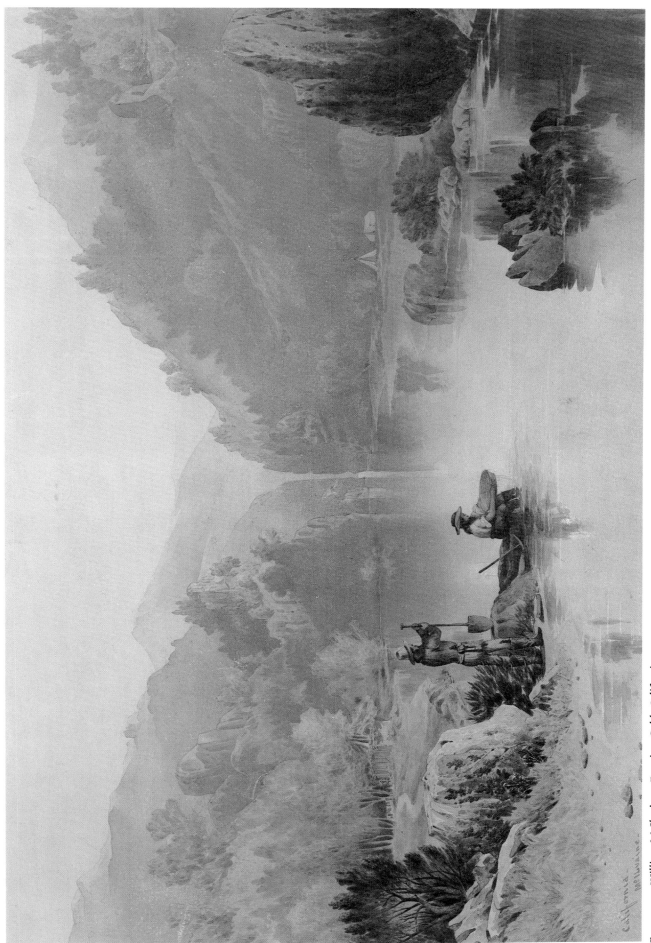

PLATE 17 William McIlvaine Panning Gold, California

tant contribution to the art and literature of the Gold Rush.[19] The paintings are distinguished by expert draughtsmanship and accuracy of detail; many of them are the earliest known visual images of the subjects portrayed. Among those of marked historical interest is a depiction of California's first Admission Day celebration.[20]

John David Borthwick

Suddenly "seized with the California fever" in May, 1851 while on a visit to America, John David Borthwick, Royal Academician, set out immediately from New York City for the California gold fields.[21] After a grueling journey by the Panama route Borthwick arrived in September at San Francisco, "the city of rats, fleas, and empty bottles."[22] The English visitor not only had a gift for perceiving, but also for portraying the significant features of that bustling port. He spent a number of weeks in the city observing the habits, morality, and manners of the people before going by river steamer to Sacramento and on by stagecoach to Hangtown (present-day Placerville). For a time he roughed it stoically in the foothills as a miner, but not finding much gold he soon "broke out in a fresh place altogether," specifically, with the inspiration to put his artistic talent to commercial use. "I had always been in the habit of amusing myself by sketching in my leisure moments," he later wrote, "especially in the middle of the day for an hour or so after dinner, when all hands were taking a rest, 'nooning' as the miners call it, lying in the shade. . . . My sketches were much sought after and on Sundays I was beset by men begging me to do something for them. Every man wanted a sketch of his claim, or his cabin, or some spot with which he identified himself, and as they offered to pay very handsomely, I was satisfied that I could make paper and pencil more profitable tools than with pick and shovel. My new pursuit had the additional attraction of affording me an opportunity of gratifying the desire which I had long felt of wandering over the mines, and seeing all the various kinds of diggings and the strange specimens of human nature to be found in them.

"I sent to Sacramento for a fresh supply of drawing paper for which I had to pay the moderate sum of $2.50 (ten shillings sterling) a sheet; and finding my old brother miners very liberal patrons of fine arts, I remained some time in the neighborhood actively engaged with my pencil."[23]

Borthwick occasionally sent a drawing or painting from California to the *Illustrated London News* for publication. A view of Kanaka Bar, a mining location on the south fork of the American River, appeared in the January 24, 1852 issue with the comment: "Of the many illustrations of this new Gold Field which the obliging intelligence of Correspondents has enabled us, from time to time, to present to the readers . . . the large view upon the preceding page presents the most practical picture. It has been sketched by Mr. John Borthwick, a clever watercolour painter, who first visited the locality as a gold-seeker but is now

33

settled in the neighbourhood, and is actively engaged in his profession, by taking portraits of successful adventurers, chiefly to be sent to their friends at a distance . . ."[24]

When the portrait business slacked off in his immediate vicinity Borthwick shouldered his pack and moved to a new location. He spent a pleasant interlude on Weaver Creek in Trinity County in the welcome company of a congenial fellow-artist and journalist James Mason Hutchings.[25] At Grass Valley Borthwick obliged three clients with crayon portraits. Of this art-form the artist wrote; "I did not take many portraits in the mines; but from the little experience I had I invariably found that the men of a lower class wanted to be shown in the ordinary costume of the nineteenth century, that is to say, in a coat, waistcoat, white shirt, and neckcloth; while gentlemen miners were anxious to appear in character, in the most ragged style of dress."[26]

Borthwick traveled leisurely and profitably about in California from 1851 to 1854 observing and recording in notes and paintings the early days of mining, the polyglot inhabitants—Chinese, French, Italian, Irish, Indian, Chilean—and life in the fast-growing settlements. Eight of his California paintings appeared as illustrations in his *Three Years in California*, published at Edinburgh in 1857.[27] By that date the conditions described by Borthwick no longer generally prevailed, as book reviewers were quick to point out.[28] Nevertheless, as an historical and pictorial record of California in the years 1851 to 1854 the book is of lasting value.

The six artist-authors presented in the foregoing pages were like hundreds of other talented goldseekers who contributed significantly to the shaping of the California image but who did little or nothing toward implanting or nurturing the profession of painting in California. They did not stay long enough for that. After a brief fling at mining and a taste of rough life in Gold Rush California they left the country to resume art careers in more congenial surroundings. However, side by side with those transient artists were the 'stickers,' tenacious, undaunted painters who, once cured of the gold fever, remained in California for a stretch of years or for life to pursue art careers; to them we are indebted for the birth, growth, and flowering of painting as a profession in California.

Settler-artists must have realized from the start that theirs would be a diet of crumbs if not actual starvation (not unknown) in the cultural desert of mid-nineteenth century California unless they found gainful employment in art-related lines or completely outside their profession. Fortunately for them (and for the future of art in California) there was at all levels more work than workers in the newly opened country. In the crowded ports and inland towns everything 'Yankee' was under construction or had so recently been completed that the finishing touches of the artisan were still to be applied. Consequently it was possible for an industrious artist to eke out a living in a multitude of related fields; by hum-

bly painting murals for the gaudy river boats,[29] lettering ornamental signs for business houses, designing membership certificates and banners for fraternal, social, and charitable organizations, filling orders for fancy calling cards and invitations, painting stagecoaches, fire wagons, theatre curtains and scenery,[30] frescoing the ceilings of public buildings,[31] or executing gigantic scenes on canvas for the ever-popular panoramas—to name but a few of the near-art openings. Then, too, in addition to bottom-rung art forms which required only a scant measure of artistic ability there were loftier opportunities in woodcut, lithography, and engraving in the proliferating publishing offices.

It was by these many back-stair approaches to art that the majority of California's first resident artists made their laborious way into full-time painting careers in their adopted state. Among those whose hard-won careers shed considerable light on the ground floor beginnings of art in pioneer California were George Holbrook Baker, Harrison Eastman, and Charles Christian Nahl.[32]

George Holbrook Baker

Twenty-two-year-old George Holbrook Baker was soberly completing art courses at the National Academy of Design and somewhat gloomily contemplating a future in the fiercely competitive art world of New York City when in 1849 the news of the gold discovery electrified the country. Newspaper reports of gold nuggets as big as hen eggs and of fortunes being made overnight at San Francisco in merchandising, shipping, freighting, and real estate so fired the young art student's imagination that he promptly laid down his brushes and made plans to emigrate to golden California. If fortune failed him at the mines, he reasoned, he would go into merchandising with a shipment of goods sent on ahead, or—and this was the heart of his resolve—begin an art career on the unfettered Pacific Coast.[33]

With all preparations completed by February 6, 1849, Baker and twelve eager young friends set out for California, going by way of Mexico. After literally fighting their way from the Gulf coast to the Pacific shore and enduring a tedious voyage up the West Coast the travelers finally arrived on May 29 at San Francisco. Baker's immediate reaction upon beholding the magnificent harbor was to paint a view of it. Before going on to Sacramento and the mines he sent his "Port of San Francisco"[34] to the New York *Tribune* for publication. The view appeared in the August 28, 1849 issue with Baker's descriptive note. "About 200 vessels were then detained here, their crews leaving for the mines on arrival in port. Only a portion of these can be shown here. The view is from Rincon Hill looking Northwest showing San Francisco Bay, Mt. Tamalpais, Angel Island and the hills of Marin in the extreme distance. In the mean distance lies the embryo city flanked by Telegraph and Russian Hills. Population estimated at 2000 all adults with very few women. Many living in tents."[35]

Panning for gold in the icy waters of the American River proved to be blistering work with small reward and city-bred Baker soon left the mines to open a store in Sacramento. He filled the intervals between customers and after store hours with painting and on July 6 noted in his diary: "I have made ten sketches since I arrived in California. This afternoon I am to make a view of this place from the opposite side, having the offer of some artistic materials for my trouble[36] . . . I yet hope to be able to pursue my original intention of illustrating California in a manner it deserves."[37]

Not finding storekeeping much to his liking Baker next engaged in a series of commercial ventures; to his pleasure some of his business activities required extensive journeys throughout the mining regions and visits to the San Francisco Bay Area. After five years of journeying about, casually sketching and painting at odd moments,[38] Baker returned to his original objective of establishing himself in California as a full-time artist. He had developed a high degree of artistic ability in portraiture and landscape painting, but commissions in those fields were too infrequent to provide an unknown artist with a steady income. However, he was willing to begin further down the art scale as an illustrator.

The times were propitious. In the mid-1850's the number of illustrated periodicals, pamphlets, newspapers, letter-sheets, and even full-length books being published at San Francisco and Sacramento was proliferating at a great rate. Publishers needed artists not only to provide original designs, but to transpose them into wood-cuts, lithographs, or engravings. Skilled in those art forms Baker soon found employment as an associate of Edward L. Barber, a Sacramento wood engraver and publisher, and for some time Baker illustrated the publications issued under the firm name of Barber and Baker.[39] In 1855 Baker, independently, began publication of *The Granite Journal*, illustrating it with his own drawings, and from December 6, 1855 to June, 1856, he illustrated and published *The Spirit of the Age*.[40] His illustrations for these publications and others met the general demand for views of mining operations, camps and towns, streets and buildings in San Francisco, Sacramento, and San José, and local events, all subjects that would show the folks back home what life was like in Gold Rush California. The wide dissemination of his timely representations contributed substantially to the shaping of the national image of Gold Rush California.

Toward the end of the 1850's the so-called 'bird's-eye' views became especially popular. Baker demonstrated his remarkable skill in that type of perspective drawing in an India ink view of Sacramento as seen from the height of the ordinary flight of a bird in which he depicted the entire city, the broad adjacent valley, the distant Sierra Nevada, a tule fire, and the nearer flanks of the Coast Range. The vessels tied up on the river front were represented in minute detail, as were the buildings lining the streets; the vignettes around the border included Baker's 1849 view of Sacramento, Sutter's Fort, and twenty-six commercial, municipal, and church buildings, all carefully drawn in detail. Baker offered the finished draw-

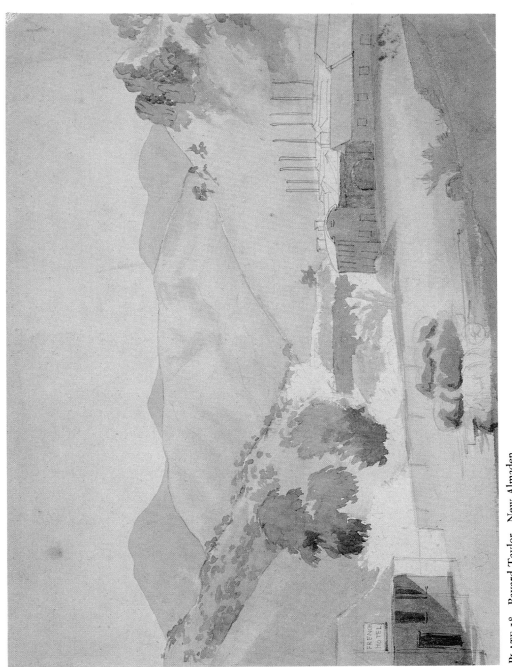

PLATE 18 Bayard Taylor New Almaden

ing for sale in the spring of 1857 on a five-dollar subscription basis. The piece proved to be a money maker; two editions quickly sold out.[41]

Perhaps it was the Sacramento tour-de-force more than any other single piece that established Baker's reputation as a leading California lithographer. Thereafter the business of lithography dominated his lifelong art career to the near eclipse of his considerable talent as a portraitist and landscape painter.

Harrison Eastman

A striking resemblance is seen between George Holbrook Baker's art career and that of another Down East Yankee, Harrison Eastman, an adventurous goldseeker who became one of California's most industrious resident-artists.

We must assume that Eastman's adventures at the mines were of short duration, for soon after arriving at San Francisco on February 16, 1849, he began clerking in the post office. From the post office window he had a wide-angle view of everything going on in what was then the fastest growing community on the Pacific Coast. With a perceptive eye he singled out the significant features of his chaotic surroundings as subjects for his first California sketches and paintings, among them the post office,[42] hub of the town's social and commercial activities, the St. Francis Hotel,[43] the fashionable hostelry of the day in spite of its thin hear-through walls, and the one-room schoolhouse[44] at the southwest corner of the Plaza where was enrolled half of the sixty school-age population. When not on duty at the post office Eastman supplemented his salary with fees earned as a wood engraver and lithographer for the publishers of San Francisco's numerous illustrated periodicals and from free lance commissions. These included in 1850 the design for the seal of the City of Sacramento, the emblem of the New England Society of San Francisco, and the masthead of the Sacramento *Transcript*. In less than two years Eastman's expertise as a lithographer became generally known and as early as January 29, 1852 the editor of the *Alta California* referred to the engraver-lithographer as "the successful artist of Pollard and Britton's lithograph of San Francisco . . . a view from the head of Sacramento Street . . . altogether one of the most accurate and excellent sketches that has yet been published." Soon after this 'puff' Eastman opened a studio[45] where he worked industriously on commissions for wood engravings to illustrate books and periodicals issuing from the city's busy presses and on separate lithographs, much in demand as parlor decorations for San Francisco's first permanent homes. Important commissions in the mid-1850's included illustrations for *The Annals of San Francisco* (1854) and the 1855-56 holiday issue of the Sacramento *Union*.[46] From time to time he collaborated with the best woodcutters, illustrators, and artists then in California[47] and became a close friend of Charles Christian Nahl, California's well known pioneer artist. With Charles's half-brother, Hugo Wilhelm Arthur Nahl, Eastman reproduced on stone a

remarkably detailed view of the Lombard, North Point, and Greenwich docks with the ships *Great Republic, Hurricane,* and *Zenobia* discharging.[48]

Eastman's broad range of media and subjects is indicated in his full-page advertisement in the 1856 San Francisco City Directory; "Harrison Eastman. Designer and engraver on wood, all kinds of book illustrations, views of buildings, machinery, landscapes, marine views, mining scenes, portraits, animals, birds, labels, billheads; illustrations for printing in colors; water color drawings, and India ink sketches of every kind executed in superb style."

Like many dedicated artists of pioneer California Eastman of necessity adapted his talent to the demands placed upon it, putting in what must have been long, tedious hours executing commercial assignments to make a living in a completely materialistic society. But evidently he found time to paint in water colors also, for in 1857 he exhibited views in that medium at the first Mechanics' Institute Fair, his "Scene on Montgomery Street, 1851,"[49] winning first prize. By 1859, having successfully weathered the first ten years of what was to be a lifelong art career in California, Eastman found himself with an enviable reputation as a fine engraver, lithographer, portraitist, and landscape painter. Today his paintings of everyday scenes and events, from his 1849 portrait of James Marshall, the hapless discoverer of the gold, to his 1858 view of San Francisco, graphically document the pertinent aspects of California's social, physical, and commercial development during that formative period.

Charles Christian Nahl

German-born, European trained Charles Christian Nahl, our most versatile and important pioneer artist, began his California art career as humbly as did George Baker, Harrison Eastman, and most other California-based artists—principally as an illustrator of newspapers and magazines.

The Gold Rush was at its height in May, 1851 when Charles Christian Nahl, a bachelor, arrived at San Francisco with five members of his family and an artist friend August Wenderoth, all of whom hoped to bolster their sagging fortunes by striking it rich at the mines. Wasting no time in San Francisco the Nahl party hastened by steamer to Marysville and from Marysville by camp wagon and horseback to the Yuba River mining district. The claim they bought near the mountain camp of Rough & Ready was a poor one and after months of strenuous labor, for which the city-bred Nahl men were totally unfit, Charles shepherded his party to Sacramento where he, his artistic half-brother Hugo Wilhelm Arthur Nahl, and Wenderoth hoped to establish themselves in their own profession.

Charles's pockets held little gold, but stored indelibly in his mind were vivid memories of the Isthmus crossing,[50] scenes and incidents of mining life,[51] and tales of overland journeys that were to provide him with paintable subjects for the rest of his life. Sacramento in the

fall of 1851 was an unpromising location to set up an easel. Everyone in that bustling entre-pôt seemed to be either going to or coming from the mines or was engaged in freighting, shipping, merchandising, saloon or hotel keeping; there appeared to be little interest in art.

Charles Nahl had never completely given up painting since coming to California and while he waited for art commissions in his studio-residence he continued to sketch and paint scenes, characters, and incidents he had witnessed since arriving. The family resources dwindled alarmingly during this trying period, but by chance two large canvases that Charles had placed in a barroom came to the attention of Paul Morrill of the Sacramento *Union*. "Emigrants Crossing the Plains,"[52] vividly depicted the all-too-familiar tragedy of a family brought to a halt on the desert by the exhaustion of one of their oxen; the second canvas depicted a scene in the mines, possibly a preliminary version of a later painting, "Saturday Night in the Mines."[53] Morrill thought the barroom paintings "rough but might good." "Nahl had hardly anything to do nor much money when I first struck him," Morrill wrote later, "but I could see that he was an artist just as soon as I saw his first work. I found him to be a very fine man besides being a good artist. We paid him a good deal of money. He did a good deal of work for us."[54] Partly as a result of Morrill's friendly interest Charles obtained employment as an illustrator for the Sacramento *Union* and for other illustrated Sacramento periodicals. His was a heavy work load, but as was his custom he filled every free moment painting on his own.

Charles Nahl's promising career at Sacramento was brought to a sudden halt in 1852 when a disastrous city fire burned his studio and its contents. Disheartened by this loss and frustrated by the general indifference to art in Sacramento the artist moved with his family to San Francisco. San Francisco in 1852 was a city in ferment, suffering from political graft, fires, and chaotic growth. But the Nahls found there was also a stable element in the community interested in personal and civic improvement and social amenities, and that there existed a flourishing market for illustrated books, periodicals, and letter-sheets as well as a lucrative demand for portraits. Charles Nahl quickly found employment as an illustrator and during his first years in San Francisco made hundreds of wood engravings that appeared in the city's illustrated publications. During this same early period he executed an amazing variety of allegorical mastheads for newspapers, membership certificates, the silver and bronze medals for the first Mechanics' Institute Fair of 1857, and the monument to James King of William. The drawing of the grizzly bear for the state seal of California[55] was from his hand, and with Wenderoth he submitted the winning design for the silver coins to be minted at San Francisco.

In addition to working as an illustrator and designer during the 1850's Charles Nahl went into the business of daguerreotyping with August Wenderoth. Hugo Wilhelm Arthur Nahl, commonly known as Arthur, joined the enterprise and in 1856 the Nahl brothers advertised

as daguerreotypists as well as "painters of miniatures on ivory, landscape and banner," ready to fill orders for "drawings of every kind, on stone, wood, etc."[56] Throughout this same period Charles Nahl painted numerous portraits (children were almost a specialty), still lifes, genre, and contemporary events. Outstanding in the latter class is the painting by Charles and Arthur, who often joined talents, "Fire in San Francisco Harbor,"[57] which depicts the burning of the *Manco* and the *Canonicus* on May 24, 1853. The work is noteworthy for accuracy of detail, especially since it was painted three years after the event from a boy's sketch on a box top and for its revelation of Charles's and Arthur's sensitivity to drama and history. Also dating from the Gold Rush period is the well known "Saturday Night in the Mines,"[58] on which the brothers collaborated in 1856, and "Emigrants Attacked by Indians,"[59] the latter a hair-raising composition in which Charles's meticulous attention to grisly details is all too evident. Two wash drawings, "The Hanging of Samuel Whitaker 1851," and "San Francisco Harbor 1851" are rare examples of Charles Nahl's work in that medium.[60]

Charles Nahl's most celebrated paintings, the ones that have led art historians to refer to him as *the* artist of the Gold Rush were actually painted long after the Gold Rush was over,[61] but we have brought him into our narrative at this point because it is in his sketches, drawings, and paintings executed in the 1850's that we find the very quintessence of California life in the exciting years of the Gold Rush.

E. Hall Martin

While certain fine painters were stoically plodding through the Gold Rush years toward eventually successful art careers in California, literally dozens of other equally talented artists were finding the going too rough. Many of the early newcomers soon became thoroughly discouraged with both mining and painting and left the country without a backward glance; a lesser number chose to hang on in their own profession until death or success overtook them. In the case of one E. Hall Martin death outdistanced success—if by success we mean recognition of a fine talent—by a hundred years. His tragic story follows a familiar pattern in the annals of Gold Rush art.

Poor and in wretched health, E. Hall Martin was painting marines and genre compositions in New York when news of the gold discovery sent him recklessly off to California.[62] Nothing is known of his mining experiences, but there has emerged from recent researches[63] a partial record of his brief and tragic career as a Gold Rush artist. During the cold wet winter of '49 he lay ill for weeks at a time in San Francisco, too sick to paint at all. In January, 1850, somewhat improved, he hopefully opened a studio and advertised his willingness to "paint portraits, make sketches in oil of a local character, paint landscapes and sea views or anything else"[64] in the line of his profession. Harrison Eastman generously engraved an attrac-

tive business card[65] for his brother-artist and the kindly editor of the *Alta California* alerted his readers to Martin's "very life-like paintings."[66] With friendly publicity and concerned friends Martin might have been one of the fortunate few to make a go of an art career in San Francisco, but the damp foggy climate proved intolerable and to escape it Martin moved to Sacramento, a community even less cultural-minded than San Francisco. In a modest studio-residence at Sacramento the artist painted whenever he was well enough, but a near-fatal attack of cholera made it impossible for him to complete the occasional commissions that trickled across his threshold. He fell behind in his rent, owed the grocer, and was in debt all around when Dr. John Franklin Morse of the Sacramento *Union* came to his rescue with money, provisions, and an art commission or two. By September, 1850, Martin had completed several paintings about which the publisher of the *Illustrated California News* wrote: "Let us mention that, among other works of art we have been especially pleased with some very spirited sketches in the studio of Mr. Martin at Sacramento City, one of which, "A Miner Prospecting," we shall request permission to reproduce in these columns."[67]

A few months later Martin was at his easel when J. Goldsborough Bruff, an overland emigrant with a little artistic ability himself, visited Martin's studio. Bruff recorded the visit in his diary: "Made the acquaintance of a very clever artist—Mr. Martin; he has several good pieces at his studio in Sacramento—one large piece represents two prospectors on a mountain, looking and pointing down into a deep valley."[68]

Drawings and paintings of mining scenes and views of towns and camps were much in demand for reproduction as illustrations in newspapers, magazines, books, lithographs, and lettersheets. In search of those popular subjects Martin set out in the fall of 1851 on a rugged trek through the northern mining region. That December at Onion Valley, a mountain camp fifteen miles northwest of Downieville, Martin fell seriously ill and died.[69] In Sacramento his friend Dr. Morse tried to arrange for an auction sale of Martin's paintings to pay the artist's debts, but nearly all his canvases had already been pledged to creditors and the rest unaccountably disappeared before the auction date. The one depicting two prospectors on a high rocky ledge that Bruff had seen in Martin's studio was unceremoniously removed from the Sacramento council chambers where it had been placed on display, by a young man who claimed it in payment of a forty-dollar debt. Martin's death and the disappearance of his paintings made little stir in a community totally engrossed in getting rich and he was soon forgotten.

The painting Bruff saw, the same one the young man made off with, was rediscovered a hundred years later and in 1975 sold for thirty thousand dollars, a price that would have stunned not only poor Martin but every artist in Gold Rush California. Art historians have pronounced "Mountain Jack & a Wandering Miner"[70] (the artist's title) "the most important and exciting mid-nineteenth century 'find' in recent years."[71] Certainly the two su-

perbly depicted subject figures dressed in rough mountain garb, loaded down with mining tools and camping gear, confirm in every respect the long-established image of the California goldseeker.[72]

Panoramic Painting

From the 1850's through the 1880's panoramas were an immensely popular form of entertainment in America. Several of these forerunners of the modern motion picture had long runs in California's first theatres. They were truly 'home products,' the scenes having first been sketched on-the-spot and then painted in gigantic dimensions on a continuous roll of canvas by California resident or visiting artists.

As early as 1850 William Cogswell,[73] a portraitist temporarily based in San Francisco, transferred his California-Panama sketches onto some forty thousand square feet of canvas. When shown in New York early in 1851 the *Literary World* described it as "the first opportunity ever offered to the public of seeing a correct and full representation of the cities, villages, valleys, missions, bays, rivers, mining regions; and together with the picturesque ruins, public buildings, religious processions, holiday fetes of the City of Panama, crossing the Isthmus, Chagres River, manners and customs of the people."[74]

In May, 1852, a panorama of the gold mining country almost a mile in length opened a long run at the Theatre of Varieties in San Francisco. It was the work of Paul Emmert, a New York painter visiting California for the second time. "Some of the views are singularly correct," reported the *Alta California*, "If the artist has failed at all it is in representing the rich woodland scenery of the foothills of the Sierra." Emmert's show was followed in September, 1853, by "Weaver's Grand Moving Panorama," which consisted of a sequence of thirty-one different scenes depicting the emigrant route across the plains, each scene covering 144 feet of canvas, all painted by "Mr. Weaver, a talented and experienced artist."[75]

Perhaps the most innovative California panorama of the 1850's was "California on Canvas," a sequence of forty-six oil paintings, panoramic in scope but not painted on one continuing roll of canvas. The paintings depicted scenes extending from the Golden Gate to the summit of the Sierra Nevada. Thomas Almond Ayres, a New Jersey artist who had come to California in August, 1849, made the sketches from nature; an unidentified artist, Thomas A. Smith, painted the scenes. The individual paintings, first displayed in D. L. Gunn's art store in San Francisco in 1854[76] and then exhibited at Musical Hall, were the talk of the town. Two years later Ayres put together a panorama of Yosemite views which had a long successful run at McNulty's Hall in Sacramento. In 1857 Ayres took his Yosemite sketches and possibly some of the "California on Canvas" paintings to New York to exhibit at the Art Union.

Thomas Almond Ayres was equally at home with pencil, black chalk, steel point, oils,

and water colors. His beautifully drawn pencil views of Yosemite, the first to make known the beauty of the valley, were a sensation. The artist was swamped with requests for copies, and Harper & Brothers sent him back to California to make drawings for a forthcoming series of articles about California. During February, March, and April, 1858, Ayres traveled about in Southern California taking sketches of the principal points of interest for the Harper assignment. At San Pedro he boarded the *Laura Bevan* for the return trip to San Francisco intending to continue with a sketching trip in the north. On the night of April 26 the ship was caught in a sudden storm and sank; all aboard were lost.

Ayres's untimely death at the age of forty removed from the art world then taking shape in San Francisco one of California's most promising artists. The twenty to thirty California views from his brush form an important chapter in the annals of Gold Rush art.

Portrait Painting

During the 1850's while a majority of California's resident artists were of necessity grubbing a livelihood from commercial art commissions a fortunate few of their brethren were having a much easier time: the portraitists.

Portraiture was the one branch of art in California (and in the more settled states as well) for which there was a ready market. Artists who could paint a representational likeness and who had no aversion for what was generally considered in nineteenth-century America a low form of art, found in the burgeoning cities of San Francisco, Sacramento, and San José a crust of prosperous merchants, well-to-do judges, Mexican war heroes, government officials, and over-night entrepreneurs whose vanity demanded a painted likeness. There were also members of the old Spanish-Mexican ranching nobility living around Monterey, Santa Barbara, Los Angeles, and San Diego who were proud to pose in the treasured laces and satins of a bygone day. Today, those early *Californios* stare solemnly down at us from cracked and varnished canvases in mute testimony of the heartlessly realistic style of mid-nineteenth century portraitists.

Samuel Stillman Osgood

One of the first professional artists to tap the latent portrait market in San Francisco was Samuel Stillman Osgood, an East Coast painter who had studied art in Boston and Europe. Early in 1849 Osgood took a leave of absence from his successful art career in New York to join the rush to California. After an unrewarding spell of digging for gold he decided he would fare better at his own profession in San Francisco. On the way he stopped over at Sutter's Fort in the Sacramento Valley where he made a sketch of the illustrious pioneer John Augustus Sutter.

Upon arriving at San Francisco, Osgood established himself in a studio, one of the city's

earliest, and began work on an oil portrait of Sutter. The portrait was completed in September, 1849,[77] and in December Osgood took it to New York City for John Sartain to engrave on steel. Sutter was nationally known for his part in the settlement of California and the Sartain engravings were widely distributed. When Osgood returned to San Francisco early in 1852 he found himself already well-known as the artist of the popular Sutter portrait. It was the touchstone of a busy but brief career in California. Until his departure in December, 1853, the artist was kept fully engaged in painting the likenesses of San Francisco's prominent citizens. His sitters, especially the very wealthy ones, usually preferred to be pictured in rough mining garb, to show how they looked when they made their 'pile.' One notable client was Edward Gilbert,[78] editor of the *Alta California*, to whom more than one struggling local artist was indebted for exuberant reviews of his works (whether meritorious or not), and to whom Osgood himself was grateful for endowing him with a national reputation considerably beyond reality: "S. S. Osgood:—This gentleman after a short sojourn in Sacramento returned to San Francisco and opened rooms for the practice of his art. To all who have seen his excellent picture of Captain Sutter (and what Californian has not?) his works will need no recommendation. His long practice and experience in the production of portraits places him among the very best living American portrait painters and we therefore feel certain that our citizens will learn with pleasure that Mr. Osgood will be happy to see them at his rooms in Dr. Rabe's building on Clay Street."[79]

In addition to painting portraits Osgood is believed to have been the artist of several views of San Francisco as it was in the early 1850's before the leveling and grading of streets had swept away all traces of the original settlement.[80]

Stephen William Shaw

In the first year of the Gold Rush Stephen William Shaw, who had no more artistic ability than a natural talent for drawing, launched an instantly successful career as a portraitist in San Francisco. Before coming to San Francisco Shaw had acquired a certain dexterity in drawing faces as an itinerant painter in the principal cities of the South. He happened to be in New Orleans when the news that gold had been discovered sped him on to California.[81] After an unprofitable and disagreeable winter in the mines, followed by a hazardous voyage of discovery with the expedition that first explored and named Humboldt Bay,[82] Shaw settled in San Francisco as a 'fashionable' portraitist. His first commission, a portrait of John White Geary, San Francisco's first mayor,[83] seemingly unloosed a flood of portrait requests from city officials and civic leaders, and possibly led to Shaw's appointment as official artist for the newly established San Francisco chapter of the masonic order.[84]

In the early 1850's, when photography commenced intruding upon the portraitists' exclusive domain Shaw began using portrait-type photographs to which he added color and

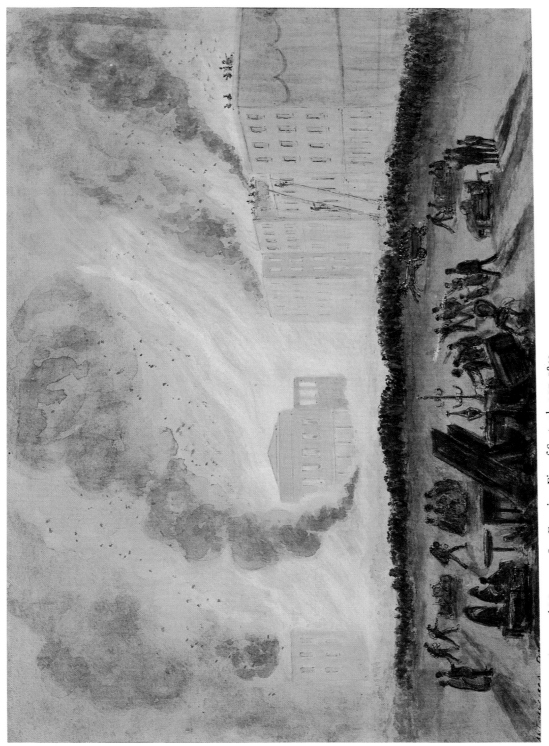

PLATE 19 Francis Samuel Marryat San Francisco Fire of September 17, 1850

a background of natural scenery. Although the demand for *bona fide* oil portraits held fairly steady for Shaw he found it profitable to turn out photographic portraits to the extent that in 1858 nine of the ten portraits he exhibited at the Mechanics' Institute Fair were based on photographs. His most notable composition in this class was a portrait-photograph of a little girl seated on a flowery bank beside a large Newfoundland dog. The scenic background was the work of Thomas Almond Ayres. When displayed in a Clay Street window the picture drew much admiring attention; the *Alta California* hailed it as "a beautiful work of art . . . The idea of combining natural scenery and a portrait is new . . . delightful."[85]

Stephen William Shaw seldom ventured beyond portraiture. Only three California scenes painted by him in the 1850's are on record: a view of Lachryma Montis, General Vallejo's residence in Sonoma County;[86] a view of Mount Shasta; and a view of the upper end of Yosemite Valley near Indian Lake.[87] The Yosemite scene was probably based on one of Thomas Almond Ayres's drawings as Shaw is not known to have visited the valley.

William Smith Jewett

Shaw's chief competitor in the portrait field during the fifties and sixties was William Smith Jewett, a New York artist who came around the Horn to California in 1849 as a member of a mining company. Jewett was in truth headed for the mines but judging from his letters he was also on the alert for any opportunity to improve his fortune in business or by brush and palette.

Soon after arriving at San Francisco on December 19 the gold-mining company "went to smash"[88] and Jewett found himself momentarily without definite plans. Friends he had known in New York and certain wealthy men to whom he had letters of introduction strongly advised Jewett to open a studio in San Francisco; the community, it seemed, was teeming with prosperous individuals who were eager to have their portraits painted to send back home. Since traveling to the mines in December was almost impossible because of the heavy winter rains, Jewett was easily persuaded to set up his easel "amongst all this crazy stuff."[89] With the patronage of old friends and new acquaintances, all men of importance in San Francisco, Jewett was instantly embarked upon a busy painting schedule. Within a month he gleefully wrote home: "I made $50 today in painting one little head at one sitting. There are other artists here and doing comparatively nothing, some do not endeavor to paint at all. I somehow appear to be popular. I don't how how long it may last . . . There are some gents here who are determined I shall paint a mamoth panorama of the rivers and diggings, they offer all the money and every possible convenience, it would be a most uncongenial task to my mind . . . besides there has been some artists here on the same business and the ground is preoccupied . . ."[90] Two weeks later Jewett boastfully informed his eastern relatives: "No one who is anybody thinks of being painted by anyone but W. Jewett. I have

the famous of all[91] . . . Colonel Stevenson[92] called on me twice and wants I should paint him. Judge Colton[93] is now waiting and I *may* get the governor of the state[94] . . . Colonel Jack Hayes (Hays)[95] is here and I am to paint him, this is a great place for heroes of the Mexican War."[96]

In Jewett's day a window vignette was a common device to indicate a portrait subject's social position. Typically, the elegantly dressed sitter was posed beside a window through which opening could be seen broad acres, an imposing residence, or other symbol indicative of wealth and social standing. Instead of the customary social status vignette Jewett favored a factual landscape background related to the activities and interests of the portrait subject. The end result was a portrait-in-landscape. In his portrait of Colonel James Collier,[97] collector of customs at San Francisco, the artist depicted the colonel standing on the north slope of Telegraph Hill. Appropriately, the harbor and shipping of which Collier was then legal guardian is shown in fine perspective from North Beach to Golden Gate, the water studded with craft of all descriptions, under way or anchored. According to the *Alta California*, the portrait and the landscape, though two in subject were yet "one in harmony and beauty."[98] In his portrait of Colonel Jack Hays,[99] Jewett again provided an appropriate setting. The former Texas Ranger, mounted on a powerful charger, holds his long rifle at the ready as he rides alone through a mountainous wilderness. Much admired at the time, the picture was later credited with making Jewett's name a household word among San Franciscans. His portrait-in-landscape of Theodore Dehone Judah[100] depicted a five-car train and locomotive in the background, symbolizing Judah's service as construction engineer for California's first passenger railroad, the Sacramento Valley Railroad.

Jewett's most celebrated blend of portraiture and place is his "Promised Land,"[101] painted in 1850 at the request of the noted ornithologist Colonel Andrew Jackson Grayson. On-the-spot sketches for the painting were made by Jewett when the artist and Grayson journeyed together to the exact crest in the Sierra Nevada from which summit the Grayson family, at the end of their two thousand mile overland journey in 1846, had their first breathtaking view of the Sacramento Valley.[102] The skillfully composed painting includes three full-length portraits, Grayson in a buckskin suit, Mrs. Grayson in bodice and full skirt,[103] and their young son sitting on his mother's knee. An old grey horse nibbling the deep cool grass in the forested shade, a woodsman's gun, a slain deer, a saddle, and scattered cooking kettles—evocative mementos of the long overland journey—complete the scene. The composition is a perfect blend of art and western history.

Early in his California career Jewett, impressed with the color and historic impact of the Gold Rush on the nation's history, conceived the ambitious project of painting portraits of all the distinguished leaders of California. The portraits were to be offered to the state (for a price),[104] but the first canvases were destroyed by one of the great San Francisco fires in

May, 1851. Jewett had also been burned out the year before, and after the second disaster lost interest in executing the portrait series. He continued to paint individual portraits, seemingly never lacking clients. He painted several likenesses of General Sutter,[105] and in 1855 sold a full-length portrait of Sutter dressed in military uniform to the state for $2500, half the amount he believed the painting to be worth.[106] Also destined for the state capitol was Jewett's portrait of Colonel John Charles Frémont, painted in 1852. No record has been found that it was ever placed there.[107] While the Frémont portrait was still on Jewett's easel the *Alta California* reported: "We may also speak of a work which Mr. Frémont will leave behind that will be as well prized by the state, and interest his admirers. This is a painting—a most successful portrait of Colonel Frémont which is now in course of preparation. It is the work of Mr. Jewett, an artist who has already acquired flattering distinction in California and it is (or will be when finished) one of the most splendid pictures in the country."[108]

In addition to his portraits of distinguished Californians Jewett is identified with the Gold Rush decade by three historically important and aesthetically pleasing California landscapes. The best known is a view of Coloma,[109] the flourishing settlement that sprang up around the site of the gold discovery. Jewett painted it on-the-spot in May, 1850, for John T. Little, proprietor of the largest store in the northern mines[110] and part owner of the mill. Little paid Jewett six hundred dollars for the painting, a sum he undoubtedly recovered the next year by the publication and sale of lithographic copies in color.[111] Local sales were stimulated by an enthusiastic review in the *Alta California*: "Lithograph.—Sutter's Mill and Coloma Valley.—We have received from the publisher John T. Little . . . a large lithographic engraving of the above named valley. It is from a painting, sketched on the spot and painted by the artist, W. S. Jewett, now residing in this city. The painting has been pronounced exceedingly truthful and beautiful. The lithograph is decidedly the best as well as the largest California view we have yet seen. It is wonderfully minute and accurate, tastefully colored, and seems a faithful copy of the picture so creditable to the true artist from whose pencil and brush it came, a fresh counterpart of nature. As a picture it will ever be an appropriate ornament of every California drawing room for its innate excellencies of composition, the fidelity with which our alpine scenery is delineated, as well as being the point where gold was first discovered already of historic interest. The meandering river, the innumerable hills, woods, houses, tents, miners, gulches, and ravines are depicted with the utmost attention and artistic grace. It was lithographed by Sarony & Major of New York and is for sale at Cook & LeCount's."[112]

The other two known California landscapes by Jewett are views of Hock Farm, Sutter's home on the Feather River.[113] They are actually two versions of the same subject, differing only in minor details. Both depict the placid river gently flowing past fertile fields where cattle graze; beyond the pasture rise the sharp Sierra Buttes. In the right foreground three

men (there are only two in one of the paintings) are putting off from shore in a small sail-rigged rowboat; one of the men is pushing the boat out into the stream by means of a long pole.[114] These three fine landscapes were painted rapidly and competently by an artist who possessed a facility with the brush uncommon in the California-based artists of Jewett's day.

Thomas Story Officer

William S. Jewett's instant success in California was far from typical for the time and place. This writer knows of no other artist who came to California in the Gold Rush with cash and credit and letters of introduction that immediately resulted in a full calendar of portrait commissions. Artists usually arrived nearly penniless, lived and painted for years in impoverished obscurity, and frequently saw their works carried out the door by creditors. Even artists as talented as Jewett might, and often did, end up in a pauper's grave. We cite one such case from the tragedy-filled files of the *Alta California* that reveals the abysmal indifference to art and artists that still prevailed in San Francisco at the close of the 1850's: "Mr. Thomas S. Officer, the talented portrait painter, lies near to death's door and is in pecuniary distress. Out of the many to whose pleasure he has contributed by his gay, social manners, as well as by his pleasing artistic productions, may there not be found someone who will extend a helping hand?"[115]

If anyone extended a helping hand it failed to save Officer. On December 8, 1859, he died penniless at St. Mary's Hospital and was buried in the public plot at Lone Mountain Cemetery. The day after he died the *Alta California* paid him this tribute: "Mr. Officer was, in all probability, the best portrait painter ever in California; his coloring was without equal, his finish in miniatures beautiful in the extreme. The warm gray tints of which he was so fond, and with which he was most successful gave to the other portrait painters in this city valuable hints, by which some were wise enough to profit. As soon as Mr. Officer began his labors in California a visible improvement was noticed among the other artists of this city . . ."[116]

It was not for lack of talent that Thomas Story Officer died in poverty. He had studied art under Thomas Sully; in 1847 and 1849 he had exhibited miniatures and portraits at the National Academy of Design in New York, of which he was a member, and had successfully painted miniatures and portraits in New York City, Philadelphia, New Orleans, Mexico City, and Australia. After settling in San Francisco in 1855 he won a bronze medal at the 1858 Mechanics' Institute Fair; his prize winners were described as having "delicacy of handling, force of character, and exquisiteness of finish."[117]

Not lack of talent but lack of appreciation of that talent sent this gifted artist to a pauper's grave. Officer's unassuaged death poignantly reveals the lowly status of art and artists in the San Francisco of his day.

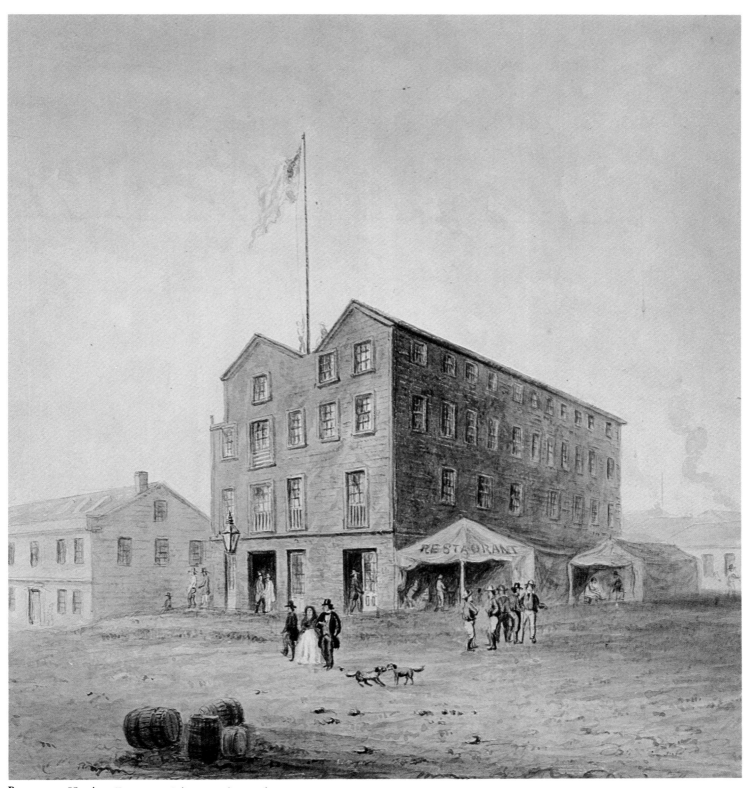

PLATE 20 Harrison Eastman Saint Francis Hotel, San Francisco

PLATE 21 Charles Christian Nahl and Hugo Wilhelm Arthur Nahl Saturday Night in the Mines

Leonardo Barbieri

Painting in the scattered cattle towns of Southern California lagged far behind the practice of that profession in the booming cities of Northern California. Indeed, during the fifties and sixties painting as a profession was almost unrepresented south of the Tehachapi. Now and then an artist wandered into Santa Barbara, Los Angeles, or San Diego on a sketching tour but seldom remained in the area for any length of time.

One short-time visitor to Southern California was Leonardo Barbieri, an obscure Italian artist known to have been painting portraits in San Francisco in 1849,[118] possibly earlier. In the spring of 1850 Barbieri started south along El Camino Real on a leisurely sketching and painting jaunt. Stopping at Monterey for a time he painted portraits of Dr. and Mrs. William McKee (Concepción Munras), members of the Hartnell, Munras, De la Guerra y Noriega families,[119] and other prominent *Californios* of the old capital. At Santa Barbara while a guest in the historic Carrillo adobe[120] he was commissioned by the people of Santa Barbara to paint a portrait of Father José María de Jesús Gonzales Rubio.[121] Barbieri's portrait-blazed trail can be traced definitely only as far as Santa Barbara, but it seems highly probable that he also visited Los Angeles and San Diego and was the artist of a number of unsigned portraits of prominent Southern Californians[122] that appear to be his work, one of which is a portrait of Rosario Estudillo Aguirre.[123]

Solomon Nunes Carvalho

For a short time Los Angeles could claim as a resident artist Solomon Nunes Carvalho who had come to California in 1853 as artist and daguerreotypist with John Charles Frémont's Fifth Exploring Expedition.[124] Following his service with Frémont, Carvalho painted at Los Angeles in 1854 a portrait of Pio Pico,[125] a former governor of California, portraits of the socially and politically influential Dominguez family,[126] and at least two landscapes, "Sunset on the Los Angeles River," and "Entrance to the Valley of Santa Clara between Utah and California."[127] For a few months Carvalho operated a daguerreotype studio in rooms above the *Nueva Tienda de China*, but business was slow and he decided to take his daguerreotype equipment to San Francisco.

Henry Miller

From the meager reports available it seems Southern Californians showed even less interest in art and artists than Northern Californians. One Henry Miller,[128] artist of a remarkable set of California views,[129] noted that in the hour or so that he stood in the street sketching Amaza Lyman's residence at San Bernardino in 1856 not one person paused to comment or ask a question. At San Diego Miller was paid "the beggarly sum" of ten dollars for a view of the town; at the end of his stay he had earned less than his hotel bill.[130]

Emil Dresel

Emil Dresel, artist-partner of the San Francisco lithography firm Kuchel & Dresel, toured the state in 1856 making sketches of towns which were to be lithographed and published as a set by his firm. The bound volume appeared in 1857 with Los Angeles the only Southern California town included in the otherwise comprehensive collection.[131]

Henri Penelon

The only artist known to have become a resident of Southern California as early as the 1850's was a French portraitist, Henri Penelon.[132] After settling at Los Angeles about 1853 Penelon painted a number of portraits, his sitters for the most part being members of local Mexican families.[133] In 1861 Penelon had a hand—not very gifted—in the redecoration of the old plaza church. Later on he practiced daguerreotype photography.

Reconnaissance Art

From 1849 to 1869, the year the Pacific Coast was linked to the East by rail, twenty or more major United States expeditions engaged in the exploration of the Far West. The objectives of the explorations were staggering in scope: to locate feasible routes for wagon and rail roads to the Pacific, to survey and mark the southwestern and northwestern national boundaries and the boundaries of the United States territory bordering the Pacific Ocean, to document in written and pictorial records the geographical features and natural resources of the entire trans-Mississippi region, and to chart and mark for the safety of marine commerce the imperfectly known West Coast from the Mexican to the Canadian border.

Governmental exploration of the Far West and the West Coast during the 1850's brought into existence a wealth of paintings, drawings, and sketches. Those graphic documents, produced in an age of national exploration and wonder, aroused the first intense public interest in the beauty and grandeur of the Far West and in a measure created the image of California as a land of unspoiled splendors that more or less persists to this day.

Reconnaissance art was produced not only by official artists engaged to delineate the features of the American frontier, but also by artistically gifted surveyors, engineers, cartographers, scientists, draughtsmen, hydrographers, doctors, or other experts attached to the various expeditions. In that large company were some eight to ten artistic individuals who sketched and painted while on duty in California.

Coast Survey

The discovery of gold in California brought hundreds of ships from all over the world to the port of San Francisco. Sea captains navigating the incompletely known approaches to Cali-

fornia harbors relied on sketchy maps and charts made by early explorers. The number of shipwrecks off the unmarked California coast and in San Francisco Bay multiplied proportionately as commerce increased. Spurred into action by these disasters the United States government authorized the Coast Survey[134] to chart and mark not only the thousand-mile-long shoreline, but also the state's rivers, bays, and inlets.

William Birch McMurtrie

The Coast Survey got under way with the arrival at San Francisco in September, 1849, of the schooner *Ewing*, commanded by Navy Lieutenant William P. McArthur. Aboard the *Ewing* was the Philadelphia artist William Birch McMurtrie, official draughtsman of the hydrographic party. Between 1849 and 1851 McMurtrie painted several views of the entrance to the bay and of San Francisco.[135] Two of the latter, depicting the city from Telegraph Hill looking south[136] and from California Street looking north,[137] are of almost photographic accuracy. Buildings in all stages of construction are drawn with meticulous attention to detail; many are identifiable. In the view from Telegraph Hill looking south the artist added water color to the pencil lines in muted tones of brown, buff, and gray. The California Street view, done in livelier colors and equally detailed, may have been one of the contemporary paintings used by the artist George Henry Burgess for his retrospective (1890's) "San Francisco in 1849."[138] McMurtrie's finished paintings are realized in heavy pencil lines and strong colors, in fine perspective. One drawing, "Looking South from Telegraph Hill" (April, 1850)[139] was put on stone in 1851 by F. Palmer and published by N. Currier. The *Alta California* judged it to be "certainly the most graphic and accurate view of this city we have yet had the pleasure of seeing. The limnings of the surrounding country are faultless."[140]

McMurtrie's service on the Pacific Coast is not fully documented for the years 1854 to 1858, but dated drawings and watercolors in an early sketchbook[141] establish his presence intermittently on the West Coast during those years. His carefully delineated views add immeasurably to our visual knowledge of specific California localities as they appeared in the 1850's.

Henry S. Stellwagon

Also serving with the Coast Survey was the artistically gifted Henry S. Stellwagon, U.S.N., who added unofficially to the pictorial documentation of California. While stationed in the San Francisco theatre from 1849 to 1851 Stellwagon filled a portfolio with watercolors including views of the Sacramento River in flood, Saucelito (December 1, 1849), entrance to the bay (December, 1849), San Francisco (November-December, 1849, with key), and Benicia taken from the frigate *Savannah* (February, 1849). Carefully drawn in faultless perspective, the views are obviously from the brush of a talented and trained artist, but since the

paintings were not part of the official records and have remained in private ownership they cannot be said to have had a part in the shaping of the California image.

James Madison Alden

In May, 1850, the United States government sent out another Pacific Coast survey unit to re-examine and complete the charting of the coastline from the Mexican border to Puget Sound. At San Francisco draughtsman James Madison Alden joined the hydrographic party commanded by his uncle Lieutenant James Alden, a veteran of Wilkes's South Seas expedition.

For part of the cruise James Madison Alden and the official artist William Birch McMurtrie were shipmates and co-workers. Young Alden possessed considerable artistic talent and as the survey progressed he executed a number of watercolors of important headlands, river mouths, estuaries, bays, islands, and towns from San Diego to the Strait of Juan de Fuca. In addition to the heavily colored paintings positively identified as the work of McMurtrie and/or James Madison Alden, the pictorial record includes several delicate sketchy watercolors from what appears to have been a different hand, perhaps that of Lieutenant Alden.[142] The set includes a view of Cox's Bar, Downieville Buttes, and Monte Carlo, remote mining localities in northern California, and one of Crescent City on the coast.[143]

James Madison Alden served with the Coast Survey along the California coast from 1854 to 1857. The numerous watercolors he painted make up in freshness and accuracy of detail what they lack in aesthetic appeal. Illustrative examples are his "From Point Bonita Entrance to San Francisco Bay," "Saucelito Cove, Bay of San Francisco," "San Pedro,"[144] "Mare Island February 1855,"[145] and "The Old Presidio Church (Santa Barbara)."[146]

The Coast Survey continued to depend upon the services of on-the-spot artists for visual representations of the West Coast until the late 1860's when cameras came into general use for field work.

Boundary Survey

Following the War with Mexico and the signing of the peace treaty in 1848 came the monumental task of surveying and marking a new southwestern boundary between the two countries from a point above El Paso, Texas, on the Rio Grande, to the Pacific Coast a few miles south of San Diego. The first boundary commissioner, John B. Weller, was succeeded in 1850 by John Russell Bartlett, a bibliophile and ethnologist of Providence, Rhode Island.

John Russell Bartlett

The new commissioner accepted the appointment largely because it would give him a first-hand opportunity to study the languages and customs of the southwestern Indian tribes. Bartlett was an above average amateur artist, but in order to be assured of a professional

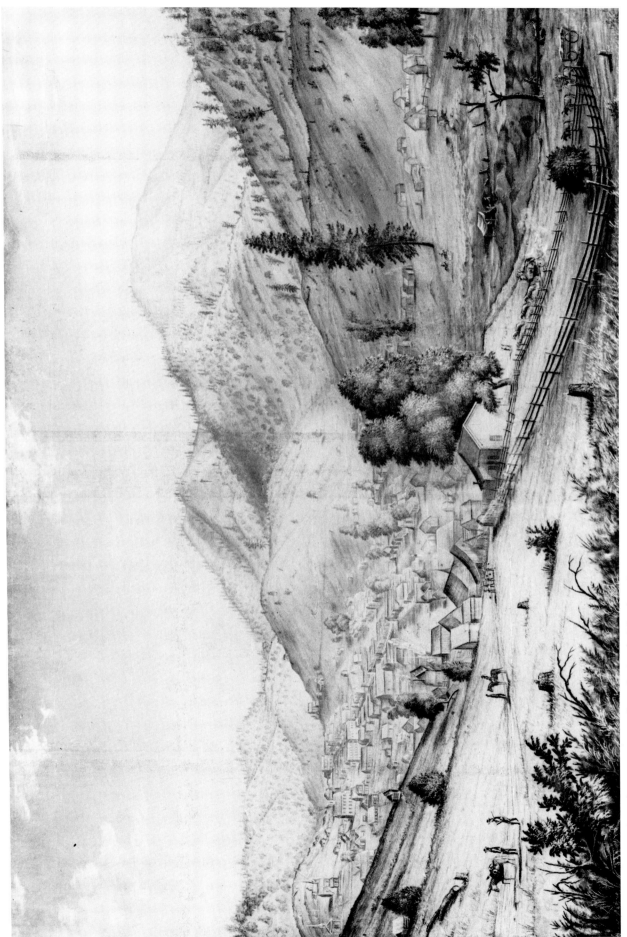

PLATE 22 Thomas Almond Ayres Sonoro from the South: Morning 1853

pictorial record of the natives he invited Henry Cheever Pratt, a Boston landscapist and portraitist, to accompany the expedition as official artist.

The survey across the great southwest expanse began in December, 1850, at Doña Ana, a small settlement on the Rio Grande north of El Paso. It was anticipated that the work would be completed in six months to a year but a thousand unforeseen complications developed and it was not until January, 1852 that the main body of the commission reached San Diego. A month later Bartlett, who had separated from the working force to detour deep into Mexico in search of provisions, arrived by ship from Acapulco, empty-handed. Still lacking the provisions and animals necessary for the long return to El Paso, and unable to secure any locally, the commissioner set out with a small party for San Francisco, the nearest likely supply depot. The other members of the commission remained encamped at San Diego.

On the westward trek from El Paso and on the detour into Mexico Bartlett had spent much of his time sketching and painting camp scenes, wayside events, views of settlements and missions, and painting portraits of Indians and Mexicans. In California his brush and pen were no less active. As he rode north along El Camino Real in a specially designed "ambulance" he stopped frequently to take sketches. Some of them he completed then and there; others were worked up into finished pieces after arriving at San Francisco. While in the northern part of the country he interspersed commission business with sightseeing jaunts to Carmel Mission, New Almaden, the Napa and Russian River valleys, and the Calistoga geysers.[147] Delineations of these historic, scenic, and geographical points of interest were executed in pen and ink, sepia, or water colors. He was at his artistic best in lively cross-country scenes; characterized by a certain spontaneity and a sense of movement they have a chiaroscuro quality not commonly found in documentary art. Conversely, Bartlett's bland watercolors of California subjects are no more than prosaic representations of actual prospects.

Henry Cheever Pratt

While awaiting Commissioner Bartlett's return to San Diego, the artist Henry Cheever Pratt finished a number of paintings based on sketches he had taken on the journey west and painted portraits. In February, 1852, he exhibited his canvases in his 'studio.' Undoubtedly this was the first art show ever held in San Diego. The San Diego *Herald* reported:

"H. C. Pratt, the artist of the Boundary Commission, we understand has succeeded in taking the likenesses of several Indians to be placed in the Indian gallery in Washington City. We have seen a beautiful portrait, executed by him, of Inez Gonzales, a handsome Mexican captive girl, bought from the Apache Indians by some New Mexican traders, and rescued from them by the American Commissioner. It is designed, we believe, to grace the same national collection . . .

"Mr. Pratt has just completed some very fine portraits of gentlemen of this place. He has also in his studio several lifelike pictures of some distinguished personages in their line, such as Don José Aguilar, Governor of Sonora, General Lonis Tonery of the Opata Indians, Shuguilmakai, head of the Pimos, and others. These portraits are all done with a fidelity and artistic skill which reflect the highest credit on Mr. Pratt. Some very superior landscapes, views in California, also adorn his studio."[148]

Bartlett returned to San Diego with the needed supplies late that spring but delayed the return across the desert to El Paso until he and Henry Cheever Pratt together visited the principal settlements in Southern California. On this final California sightseeing excursion views of Los Angeles, Mission San Gabriel, and Mission San Luis Rey were added to the artists' portfolios.

On the eve of departure from San Diego a box of paintings prepared for shipment mysteriously disappeared. It is believed to have contained many of Pratt's canvases. The half dozen or so since recovered show Pratt to have been a capable draughtsman with a flair for dramatic composition.

Considered as a whole, the western paintings of John Russell Bartlett and Henry Cheever Pratt were documentary art of a high quality.

Railroad Surveys

The national dream of a transcontinental railroad gained substance in 1853 with the passage of the Pacific Railroad Survey Bill. The bill authorized the United States Army Corps of Topographical Engineers to determine by surveys of the Far West the most practical of several proposed railroad routes from the Mississippi River to the Pacific Coast. Four major and a number of minor surveys were initiated in the 1850's. By the time California was finally linked to the East by rail in 1869 the vast trans-Mississippi region had been surveyed and mapped and the principal natural and man-made features that lay in the path of proposed railroad routes had been extensively delineated by artists or other experts attached to the various surveys. Of the eleven railroad survey artists and delineators who pictorially documented the Far West seven are on record as having painted or sketched California views.

One survey party, under the direction of Lieutenant Robert S. Williamson, set out from Benicia in June, 1853, to find a pass through the coast range feasible for a southern railroad route. The company traveled south over the old wagon road that wound through the San Joaquin and Tulare Valleys, crossed Warner's Pass, and led into Los Angeles.

Charles Koppel

The official artist of the Williamson survey, Charles Koppel, a German painter and civil engineer, documented the journey in a series of views. His delineation of Los Angeles as seen

from the Broadway Hill is of special interest because of the scarcity of early views of that settlement; it is also the first published view of Los Angeles.[149]

William Phipps Blake

William Phipps Blake, a geologist and artist with Williamson's party, used his artistic ability not only for geological cross sections, but also to depict specific prospects including "Sierra Nevada, from the Four Creeks" (Plate 4 of the *Pacific Railroad Reports*), "Mission San Gabriel," and "San Diego from the Bay."[150]

Heinrich Baldvin Möllhausen

In the spring of 1854 a survey party working along the 35th parallel from Arkansas to the Pacific coast under the direction of Lieutenant Amiel W. Whipple entered Southern California by way of the Mojave Desert and Cajon Pass. On the cross-country journey Whipple's chief illustrator was Heinrich Baldvin Möllhausen, a German naturalist, author, and portraitist. Möllhausen painted numerous Indian portraits and at San Diego executed a view of the mission.[151]

Frederick W. Egloffstein

A railroad exploration along the 41st parallel from Salt Lake City to the Feather River region directed in 1854 by Lieutenant Edward G. Beckwith brought into California Baron Friedrich W. Egloffstein, a German artist and cartographer. Egloffstein was the artist of a precisely drawn panorama, "Northern Slopes of the Sierra Nevada at 9 A.M., View Towards the West," that included Mount Shasta, fifty miles distant.[152]

As might be expected, railroad reconnaissance art consisted principally of naturalistic landscapes intended to represent the country as it was in truth. Dull, accurate portrayals for the most part, but here and there, particularly in the California views, one comes across a scene with a touch of the picturesque as though the artist had been carried beyond mere documentary reporting by the beauty of the land.

Strictly speaking it cannot be claimed that the railroad survey delineators had much if any effect on the progress of painting in California, but certainly their representations of the spectacular scenery of the Far West and the Pacific Coast were of consequence in attracting Atlantic-side artists to the region, particularly to California.

III. *Painting in Eldorado 1849–1859*

1. Ryan, William Redmond. *Personal Adventures in Upper and Lower California, 1848–1849.* London: William Shoberl, 1850, 2 vols., vol. 1, pref.

2. *Chamber's Journal*, July 6, 1850, p. 14.

3. Shinn, Charles Howard. *Mining camps. A Study in American Frontier Government.* New York: C. Scribner's Sons, 1895, p. 113: A "family rule" type of mining company.

4. In *Personal Adventures* ... Ryan states he was the first house painter in San Francisco. However, nearly a year earlier (November 10, 1847) a certain T. W. Perry advertised in the *Californian*: "House and Sign Painter ... All jobs done in a workmanlike manner and on reasonable terms ..."

5. The original art work and manuscript journal have not been located.

6. *The Examiner* (London), May 18, 1850, p. 309.

7. Louisiana State Museum Library, Index of records copied from cemetery offices. Entry for William Ryan: "Died October 6, 1855, native of Ireland (?), age 28 years."

In an unpublished manuscript in the Henry E. Huntington Library and Art Gallery, "Trial and Attempted Execution of a Horse Thief at Monterey, February, 1849," William Rich Hutton refers to William Redmond Ryan as an English artist living in Monterey.

8. McIlvaine, William. *Sketches of Scenery and Notes of Personal Adventure in California and Mexico.* Philadelphia: n.p., 1850.

9. National Academy of Design exhibit records, 1825–1860.

10. "Prairie, California," and "Panning Gold" are in the M. & M. Karolik Collection, Museum of Fine Arts, Boston; "Sacramento River, California," has not been located.

11. These four paintings came to light in 1949, one hundred years after McIlvaine's visit to California, when a hitherto unknown roll of the artist's paintings was acquired by the Cadmus Book Store, New York City. Information accompanying the paintings indicated they had been stored in the United States Mint by an employee, James C. Booth, who went with McIlvaine to California.

12. Upham, Samuel C. *Notes of a Voyage to California via Cape Horn, together with Scenes in El Dorado, in the Years 1849–50.* Philadelphia: The Author, 1878, pp. 409, 454.

13. The 8th plate, "San Francisco in 1848" was based on a drawing by J. C. Ward. Excerpts from Ward's diary were published with illustrations in issues of the *Argonaut* beginning August 10, 1878.

14. In the California Historical Society.

Bayard Taylor came to California again in 1859 on a lecture tour but is not known to have painted or sketched during that visit.

15. In the collection of George A. Pope in the 1940's; present location unknown.

16. In the Society of California Pioneers.

17. "Great Fire in San Francisco" and "San Francisco Fire 1850" (oval) are in the Society of California Pioneers; "San Francisco Fire of September 17, 1850," is in the Oakland Museum.

18. Marryat drawings and paintings published in the *Illustrated London News* include "Street View in San Francisco" (December 28, 1850), "View of the Country near Russian River," and "Lynch Law in California, Scene of the First Execution in San Francisco on June 10, 1851," depicting the

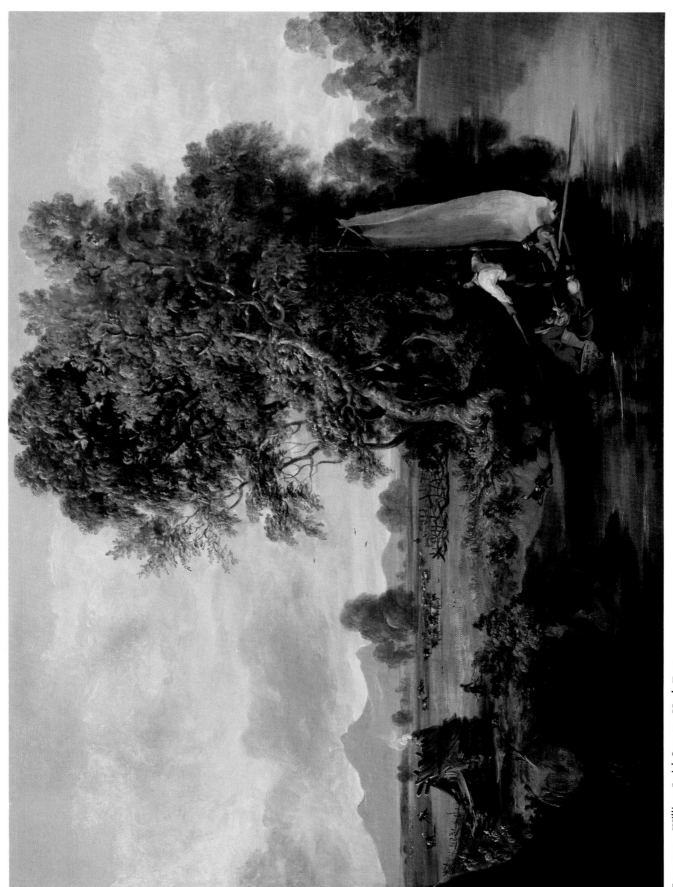

PLATE 23 William Smith Jewett Hock Farm

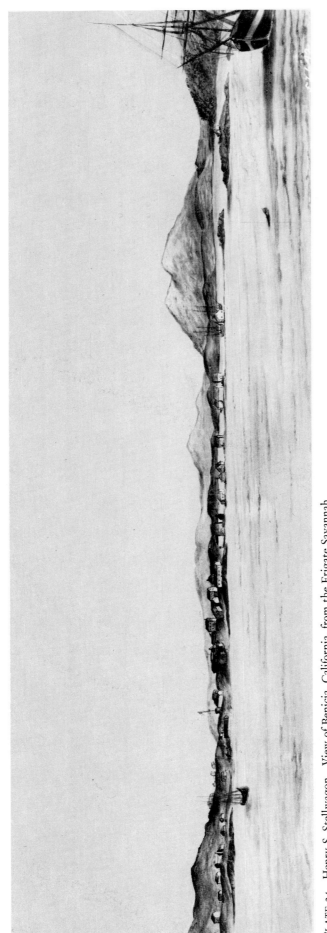

PLATE 24 Henry S. Stellwagon View of Benicia, California, from the Frigate Savannah

hanging of the thief Jenkins from a corner of the custom house. It was probably painted from eye-witness accounts as Marryat was in Sacramento at the time.

19. Marryat, Samuel Francis. *Mountains and Molehills, Or, Recollections of a Burnt Journal.* London: Longman, 1855. Contains 26 engravings and 8 lithographic plates. Especially revealing of life in Gold Rush California are: "Vacarro (Vaquero)," "The Winter of 1849," "A Prospector," "The Sonora Stage," "A French Miner," "John Chinaman," and "Feast of Lanterns."

20. Marryat gave the watercolor to Charles Hopps, a San Francisco artist. Hopps made an enlarged copy of it in 1851.

21. Borthwick, John David. *Three Years in California.* Edinburgh & London: William Blackwood & Sons, 1857, p. 3.

22. *ibid.,* p. 54.

23. *ibid.,* p. 161.

24. *Illustrated London News,* January 24, 1852.

25. James Mason Hutchings, a '49'er, distinguished himself in California as an author, publisher, and lecturer.

26. Borthwick, John David. *Three Years in California.* Edinburgh & London: Wm. Blackwood & Sons, 1857, p. 203.

27. "Our Camp on Weaver Creek," "Monte in the Mines," "Faro," "A Flume on the Yuba," "Chinese Camp in the Mines," "Bull & Bear Fight," "A Ball in the Mines," and "Shaw's Flat."

28. *Alta California,* September 27, 1857; *National Magazine,* July–December, 1857, p. 242.

29. Edgar Preston Richardson, in *Painting in America* (New York: Thomas Y. Crowell Co., 1956), states that Thomas McAlpin, an English amateur artist, was one who "with little talent did very well decorating river boats."

30. George B. Underwood (unknown) painted the scenery for Mahoney Hall at Volcano (Volcano *Weekly Ledger,* January 26, 1856); John Fairchild, a San Francisco amateur artist, painted the scenery for the Metropolitan and the American theatre in San Francisco and a panorama depicting the activities of the Vigilantes (*Alta California,* November 11, 1856)—to name but two of California's numerous scenic painters.

31. The firm of Bierke and Johnson painted the ceiling of the Bank Exchange, San Francisco, in January, 1854 (*Golden Era,* vol. 2, number 2.)

32. Baker, Eastman, and Nahl have been arbitrarily selected as representative of hundreds of fellow artists who laid the foundations of successful art careers in California during the Gold Rush years.

33. George Holbrook Baker's "Diary." In the Society of California Pioneers.

34. Pencil sketches by George Holbrook Baker depicting San Francisco Harbor in May 1849, and a view of the city in 1854 are in the Society of California Pioneers.

35. Publishers of books, magazines, and newspapers in America and abroad kept the gold fever at white hot heat with graphic reports of this sort, and on-the-scene artists were only too happy to feed the fire with their California sketches, drawings, and paintings.

36. Baker made the sketch of Sacramento on July 7, 1849 for Benjamin T. Martin, supercargo and part owner of the *Elvira.* Martin took Baker's view to Massachusetts and thirty-six years later com-

missioned George A. Frost of Cambridge to make a 2′ x 3′ oil painting from it. (Letter written by B. T. Martin to William F. Chamberlin January 20, 1886, in the Society of California Pioneers.) The Frost copy is in the California State Library, California Section.

37. George Holbrook Baker's "Diary." In the Society of California Pioneers.

38. Baker's diary entry for August 10, 1849, reads: "Pueblo San Jose. At Mission Santa Clara arrived just before sunset and there was something so peculiarly Mexican about it I determined on making a sketch, which I did in the Plaza over the saddle of my horse." A few days later Baker "took a sketch" of Stockton and of a "beautiful ranch on the Stanislaus."

39. In 1855 the firm published *Sacramento Illustrated,* a 36-page history of Sacramento lavishly illustrated with reproductions of Baker's drawings.

40. Baker published *The Spirit of the Age* from its inception December 6, 1855 until June, 1856. Although published and illustrated by the artist the news sheet contains no references to artists or art activities.

41. Baker displayed the view with the following announcement:
"To the Public: The subscriber respectfully solicits the patronage of the public to a work of art which must appeal somewhat to the patriotism and public spirit of every citizen who rejoices in the good name of Sacramento. The beautiful "City of the Plain" has often been represented but on account of the level nature of its site no one comprehensive view has ever been taken from actual observation. The work which now claims your attention is the result of some months labor and is calculated to fill this void. It exhibits at a glance the situation and appearance of Sacramento as seen from the height of the ordinary flight of a bird, and is thus intended to be published as a bird's eye view of Sacramento . . ."
"Sacramento 1857," a large original drawing by Baker was in the collection of the M. H. DeYoung Memorial Museum, San Francisco, in the late 1940's.

42. Harrison Eastman's sketchbook contains a pen & wash drawing of the San Francisco post office. In The Bancroft Library.

43. The St. Francis Hotel, a four-story frame building at Clay and Dupont (present-day Grant Avenue), was opened for business in 1849; the structure burned in 1853. Eastman's painting of the hotel is in the California Historical Society.

44. In the California Historical Society.

45. In the Golden Era Building, 151 Clay St. It was in Eastman's studio in 1862 that the artist William Keith gave Eastman art instruction. At that time Keith was employed by Eastman as an engraver.

46. Soulé, Frank, Gihon, John H. and Nesbitt, James. *The Annals of San Francisco* . . . New York: D. Appleton & Company, 1855.
The illustrations from the Sacramento *Union* were reproduced from drawings Eastman had made of remote locations while on an extended tour of the mining region in the summer of 1854.

47. Eastman's business associates of the early 1850's in San Francisco included William F. Herrick, engraver, artist, and newspaper publisher; Andrew V. S. Anthony, draughtsman, engraver, and watercolorist; Thomas Armstrong, engraver, lithographer, and watercolorist.

48. The lithograph was based on a drawing by Charles Bradford Gifford, designer and lithographer active in California from the 1850's into the 1870's.

49. Present location of the original unknown.

50. Charles Nahl's pictorial diary of his journey across the Isthmus provided him with themes for a number of topics, one of which, "Boaters Rowing to Shore at Chagres" (1855), has only recently come to light. (In 1975 at Kennedy Galleries, Inc., New York City.)

51. Charles Nahl and August Wenderoth collaborated on "Miners in the Sierras" (ca. 1851), the earliest known representation of a mining scene by either artist. Privately owned.

Also dating from Charles Nahl's Sacramento period is a drawing of Sutter's mill in 1851 which was published in *Gleason's Pictorial Drawing-room Companion* in 1852. In 1867 an oil painting based on the 1851 sketch was exhibited at Jones & Wooll's art shop in San Francisco. (*Evening Bulletin*, September 23, 1867.) In 1900 the painting was exhibited at the Mark Hopkins Institute of Art. It is believed to have been destroyed in the 1906 fire.

52. In the Stanford University Art Museum, Stanford, California.

53. Nahl exhibited this painting at the State Agricultural Society's Fair in 1859. It was once owned by J. O. Coleman of Sacramento; now in the Stanford University Art Museum.

54. Paul Morrill manuscript in The Bancroft Library.

55. The original drawing is in Colton Hall, Monterey, the building in which delegates met in September, 1849 to establish statehood and form a constitution.

56. San Francisco City Directory, 1856.

57. Signed "Nahl & brother 1856 San Francisco." In the Fireman's Fund American Insurance Companies, San Francisco, California.

58. In the Stanford University Art Museum.

59. In the Stanford University Art Museum. This painting won second premium at the State Agricultural Society's Fair in 1859. (Sacramento *Daily Union*, September 20, 1859.)

60. Original drawings in the George A. Pope collection in 1947.

61. The most celebrated of Charles Nahl's retrospective paintings is "Sunday Morning in the Mines." It was painted in 1872 for Edwin Bryant Crocker, Nahl's patron, from the artist's sketches made in the early 1850's. Other well known large scale paintings by Nahl of the late 1860's and 1870's include "The Fandango," "California Rancho," "Sunday Morning in Monterey" (alternate title: "La Plaza de Toros"), "Joaquin Murietta." For a complete list of Nahl's paintings see *Charles Christian Nahl* . . . by Moreland L. Stevens with the assistance of Marjorie Arkelian. Sacramento: E. B. Crocker Art Gallery, 1976.

62. Martin is believed to have traveled steerage in the *Panama*.

63. Namely those of Joseph A. Baird, Marjorie Arkelian, and this writer.

64. *Alta California*, January 16, 1850.

65. One of Martin's fancy business cards is in the Harrison Eastman folder, Oakland Museum. The original engraving is in the California Historical Society.

66. References to Martin's paintings appear in the *Alta California*, January 7, 12, 16, 1850.

67. *Illustrated California News*, September 1, 1850. A search of this short-lived publication (September 1–December 1, 1850) failed to turn up a reproduction of Martin's "A Miner Prospecting."

This may have been the painting now known as "The Prospector," which was sent East by clipper ship, consigned to C. A. Reynolds. Privately owned.

68. Bruff, J(oseph) Goldsborough. *Gold Rush! The Journals, Drawings, and Other Papers of J. Goldsborough Bruff . . . April 2, 1849–July 20, 1851*, edited by Georgia Willis Read and Ruth Gaines. New York: Columbia University Press, 1949, p. 464.

69. Sacramento *Union*, December 23, 1851.

70. "Mountain Jack & a Wandering Miner" (in the Oakland Museum) is one of three paintings known as the Mountain Jack series. Of the series "The Prospector," is privately owned and a Mountain Jack hunting scene is as yet unlocated.

71. Arkelian, Marjorie, "An Exciting Art Find," *Art*, vol. 2, January/February, 1974.

72. The composition of "Mountain Jack and a Wandering Miner," is remarkably similar to Ashur B. Durand's "Kindred Spirits," which also has the two principal figures posed on the protruding lip of an overhanging ledge above a deep narrow canyon. (Original in the New York City Public Library.) Martin may have seen "Kindred Spirits" before going to California.

73. *California Courier*, November 1, 1850.

74. *Literary World*, vol. 8, February 15, 1851, p. 137.

75. *Weekly Placer Herald*, September 3, 1853.

76. *Alta California*, August 7, 1854.

77. Bayard Taylor saw the finished portrait in Osgood's studio in September, 1849; it was favorably mentioned in the *Alta California*, September 6, 1849. The portrait, now in the New York Historical Society, New York City, is identical with the 1850 Sartain engraving and may therefore be the 1849 original.

78. After Edward Gilbert was killed in a duel in April, 1852, Osgood's portrait of the popular journalist was ceremoniously hung in the San Francisco council chambers.

79. *Alta California*, March 2, 1852.

80. In the July 31, 1870 *Alta California* the editor states that "paintings of San Francisco, painted twenty years earlier by Osgood and other very fine paintings (by Osgood) are still in California." (Location unknown.)

81. Shaw arrived at San Francisco on August 30, 1849.

82. While in the Humboldt Bay area Shaw sketched the scenery and painted portraits of Indians, including one of the old chief KiWellatah. A photographic copy of the chief's portrait is in the Society of California Pioneers.

83. John White Geary was San Francisco's first postmaster, last alcalde, and first mayor.

84. As official artist of the Masonic Order in San Francisco Shaw painted some two hundred portraits of the organization's officers. (American Art Annual, 1900–1, vol. 3, Boston, 1900, p. 60.)

85. *Alta California*, March 11, 1858.

86. A Britton & Rey lithograph of Shaw's Lachryma Montis painting is in the New York Historical Society. The location of the original painting is not known.

87. Shaw exhibited two oil paintings at the first Mechanics' Institute Fair (1857): "View of Mount Shasta," and "The Upper End of Yo-Hamite Near Indian Lake."

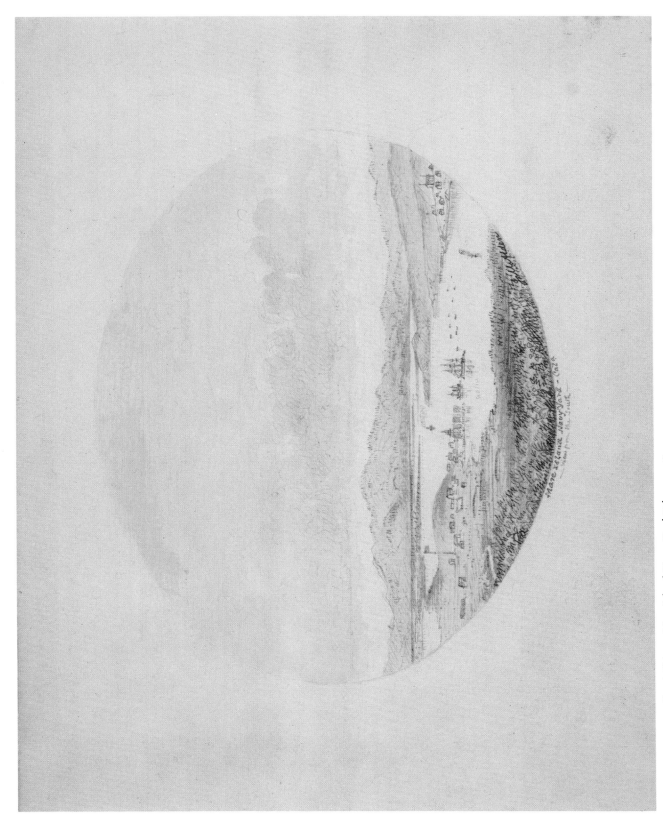

PLATE 25 James Madison Alden Mare Island Navy Yard February 1855

88. Evans, Elliot A. P., "Some Letters of William S. Jewett, California Artist." California Historical Society *Quarterly*, vol. 23, June 1944, p. 162.

89. *ibid.*, pp. 162–163.

90. *ibid.*, pp. 162–163.

91. *ibid.*, pp. 163–164.

92. Colonel Jonathan Drake Stevenson came to California in 1847 in command of the First New York Volunteers.

93. George Quincy Colton, first Justice of the Peace, San Francisco.

94. Peter Hardeman Burnett, inaugurated December 20, 1849.

95. Formerly a Texas Ranger; was elected sheriff of San Francisco in April, 1850.

96. Evans, Elliot A. P. *op. cit.*, p. 163.

97. Location unknown.

98. *Alta California*, February 11, 1851.

99. Privately owned in 1973. Reproduced from the original in Greer, James K. *Colonel Jack Hays . . .* rev. ed. Waco, Texas: W. M. Morrison, 1974.

100. The identity of the man in this formerly unlabelled portrait was a matter of conjecture until Marjorie Arkelian, art historian at the Oakland Museum, noticed that the ring on the sitter's little finger matched exactly the description of a ring made for Judah from a gold nugget he picked up at Negro Bar while constructing the railroad in 1855. The portrait is in the Oakland Museum.

101. Privately owned. In 1976 on loan to the Smithsonian Institution, Washington, D.C.

102. Dr. Elliot A. P. Evans's research on the route of the Graysons pin-points the exact location as Hotchkiss Hill above Georgetown, from which point the Sacramento Valley can be seen. Evans, Elliot A. P., "The Promised Land." Society of California Pioneers Quarterly *Newsletter*, November 1957, pp. 4–5. Suggestions of time and distance are given in Jewett's letter dated May 27, 1850. Evans, Elliot A. P., "Some Letters of William S. Jewett, California Artist." California Historical Society *Quarterly*, vol. 23, June 1944, p. 170.

Colonel Grayson expressed his emotion upon viewing the Sacramento Valley for the first time in these words: "The broad valley of the Sacramento and the far-off mountains of the coast range, mellowed by distance, and the delicate haze of Indian summer lay before me—whilst the timber growing upon the border of the Rivers Las Plumas and Sacramento, but dimly seen at that distance, pointed out our course. I looked upon the magnificent landscape with bright hopes for the future." *The Hesperian*, vol. 2, April 1859, p. 101.

103. The artist was gently chided in *The Pioneer*, vol. 2, August 1854, p. 112, for departing from historical accuracy in depicting Mrs. Grayson and the boy in drawing-room clothes.

104. Sacramento *Union*, September 10, 1851.

105. The location of four portraits of Sutter by Jewett are known: the one purchased by the state is at the California State Capitol in Sacramento; an oval bust 5-1/2″ x 12-1/2″, signed and dated 1856 is in the Oakland Museum; two are in the Society of California Pioneers.

106. Letter written by Jewett April 14, 1855. Evans, Elliott A.P., editor. "Some Letters of William S. Jewett, California Artist," California Historical Society *Quarterly*, vol. 23, September 1944, p. 227. Portrait reproduced opp. p. 227.

107. The Jewett portrait of Frémont was exhibited at the Midwinter Fair, 1894. Present location unknown.

108. *Alta California*, February 1, 1852.

109. Artist's title: "View of Culloma." The original painting is believed lost.

110. John T. Little's Emporium located on the north side of the American River was one of the first business houses in Coloma. Sioli, Paolo, comp. *Historical Souvenir of El Dorado County, California.* Oakland: P. Sioli, 1883, p. 177.

111. Less than a dozen copies are presently known.

112. *Alta California*, April 5, 1851.

113. Hock Farm, eight miles from Sutter's Fort, was Sutter's home and refuge after goldseekers and settlers began overrunning his lands.

114. The painting with three men in the boat (1852), signed W. Jewett across the stern, is in the California State Capitol. The painting depicting two men in the boat has been offered for sale by dealers at various times in the past twenty years. Title variant: "A View of the Buttes from Hick (sic.) Farm Ranch, California." Present location unknown.

115. *Alta California*, October 30, 1859.

116. *Alta California*, December 9, 1859.

117. *The Hesperian*, vol. 1, October 1858, pp. 166–167.

118. Mentioned in the *Alta California*, December 31, 1849, as the artist of a portrait of Edward W. Harrison, ex-collector of the port of San Francisco, painted in San Francisco while the artist was living with John Prendergast, an English artist.

119. In 1960 two portraits of the Hartnells by Barbieri were in the old custom house in Monterey; two Munras portraits by Barbieri were in the Carmel home of María Antonio Field, a Munras descendant. (*Monterey Peninsula Herald*, October 29, 1960.) Barbieri's portraits of Pablo and José De la Guerra y Noriega are in the Santa Barbara Historical Society, Santa Barbara, California.

120. Built in 1826 by Daniel Hill who came to California in 1823 in the *Rover*.

121. In Mission Santa Barbara.

122. In the Los Angeles County Museum of Natural History, Los Angeles, California.

123. Privately owned.

124. Carvalho, S[olomon] N[unes]. *Incidents of Travel and Adventure in the Far West . . .* New York: Derby & Jackson, 1857.

125. In the Los Angeles County Museum of Art.

126. Bohme, Frederick G. "The Portuguese in California." California Historical Society *Quarterly*, vol. 35, September 1956, p. 236.

127. Both paintings were exhibited in 1856 at the 5th annual exhibit of the Maryland Historical Society, Baltimore, Maryland.

128. Unidentified artist.

129. A collection of original pencil drawings attributed to Henry Miller is in The Bancroft Library. The thirteen town views were published by the Book Club of California with the title: *13 California Towns from the Original Drawings*. San Francisco: The Book Club of California, 1947.

130. Hayes, Benjamin Ignatius. *Pioneer Notes from the Diaries of Judge Benjamin Hayes 1849–1875.* Los Angeles: Privately printed, 1929, p. 132.

131. Thirty-six lithographic views of California cities and towns by Kuchel and Dresel were exhibited in 1857 at the Mechanics' Institute Fair; a collection of thirty views was published under the title, *California Views.*

132. DeWar, John. *Adios Mr. Penelon.* Los Angeles: Los Angeles County Museum of Natural History, 1968.

133. Henri Penelon is represented at the Los Angeles County Museum of Natural History by some ten portraits (attributed) of local citizens.

134. Known after 1878 as The United States Coast and Geodetic Survey.

135. It was an official drawing by McMurtrie of Anacapa Island off the coast of Santa Barbara to which James McNeill Whistler, then a lowly employee in the drafting rooms of the U.S. Coast Survey, Washington, D.C., added a few more seagulls, an alteration that cost the youthful Whistler his job.

136. In the California Historical Society.

137. In The Bancroft Library.

138. In the Oakland Museum.

139. Formerly in the M. H. De Young Memorial Museum, San Francisco (ca. 1912). Present location unknown.

140. *Alta California,* April 21, 1851. Now scarce, the lithograph is the most famous of Currier's San Francisco views.

141. In The Bancroft Library.

142. There is no doubt that Lieutenant James Alden, in common with naval officers of his day, received instruction in painting and drawing as part of his naval training. That he had more than a passing interest in pictorial Californiana is evidenced by his interest in the artistic development of his nephew, James Madison Alden, and by the purchase of five Yosemite drawings by Thomas Almond Ayres (now in the Yosemite Museum). Corroborating correspondence of the writer with Eliza Dukes of Orlando, Florida, a descendant of Lieutenant James Alden, further supports the theory that Lieutenant Alden was an amateur 'Sunday' painter, and possibly the artist of the pastels.

143. In the California Historical Society.

144. The views of Point Bonita, Saucelito, and San Pedro are privately owned.

145. In the California Historical Society.

146. In Mission Santa Barbara.

147. A portfolio of Bartlett's original art works is in the John Carter Brown Library, Providence, Rhode Island. A watercolor of the Calistoga geysers is in the Rhode Island Historical Society, Providence, Rhode Island.

148. San Diego *Herald,* February 14, 1852.

149. Approximately twelve of Koppel's California views, including that of Los Angeles, were published in the *Pacific Railroad Reports.* (Published in 13 volumes by the United States government between 1855 and 1860 under the title *Reports of Explorations and Surveys to Ascertain the Most Practicable and Economical Route for a Railroad from the Mississippi River to the Pacific Ocean.*)

150. William Phipps Blake drew the sketches for the wood engravings that illustrate his report in the *Pacific Railroad Reports*. Blake's report was also published in a separate edition with additional illustrations from his brush.

151. Möllhausen's view of Mission San Diego is reproduced in the *Pacific Railroad Reports*. The original drawing is in the California Historical Society. Nine of Blake's paintings and drawings executed on the trail and in California are in the Oklahoma Historical Society, Oklahoma City, Oklahoma.

152. Reproduced in the *Pacific Railroad Reports*.

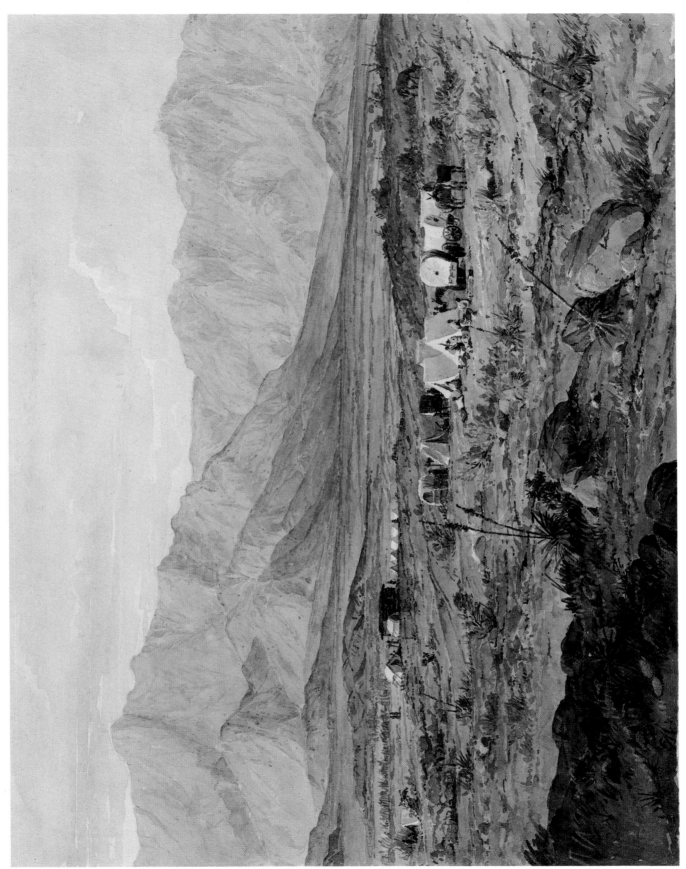

PLATE 26 John Russell Bartlett Vallecito June 3, 1852

Chapter Four

California's Own Art World, 1860—1875

The Beginnings 1849-1859

The beginnings of California's own art world reach back to the summer of 1849 when certain artists who had come to California to dig for gold decided they could do better with brush and palette in San Francisco or Sacramento than with pick and pan in the foothills. Probably few who made that decision were aware at the time that there was no market for paintings and not much thought of art among the people of those gold-mad communities. It is safe to say that in the very early days of the Gold Rush even a Rembrandt seated at an easel in the public square would scarcely have drawn a curious glance from the hurrying passers-by. Yet the undaunted ex-goldseeker artists remained in numbers to practice their precarious calling, and over the next quarter century scores of artistically gifted individuals followed the example of those first hardy souls until easel painting came to be practiced in California in all the varied lines common to contemporaneous America and Europe: portraiture, genre, still-life, topographical, and scenic landscape, as well as allegorical, mythological, historical, and literary representations. By 1875 painting in California—that is to say in San Francisco which until the mid-seventies *was* California, aesthetically speaking—had become a respectable, supported profession. And San Francisco had evolved into the undisputed art center of the West, a near-miraculous cultural evolution realized in a mere twenty-five years.

No progress toward that astonishing climax was possible until the public had acquired a taste for good art. Since there were no art galleries or functioning art-oriented societies in Gold Rush California that objective had to be reached through less conventional channels. Foremost among the forces directed toward awakening an art-consciousness in California was the fervent sponsoring of local art in newspapers and magazines. The heroic attempt of journalists to instill cultural values in pioneer Californians began early in 1849 with the inclusion of art notes in the newspapers. Notices of the arrival or departure of an artist, reviews (generally favorable) of freshly completed paintings or works in progress, sketching tours being planned and other tidbits of information were intended to alert readers to the art activities taking place in their city. How effective the art notes were in diminishing the general indifference to art cannot be known, but by June, 1851, the *Alta California* reported with satisfaction that a taste for art was manifesting itself in the decoration of saloons. Paintings of nude females in obscene poses were going out of style and the newer "public rooms" were being furnished with canvases depicting more respectable subjects. "Public

taste was becoming more refined."[1] The editor might also have mentioned that saloon keepers and gambling hall proprietors were beginning to make room for paintings by local artists, thus distinguishing their establishments as the first art galleries in California.[2] Similarly, though on a somewhat loftier plane, the reading rooms of the Athenaeum, an exclusive club for subscribers, served as a quasi-gallery for California paintings.[3] The windows of book and stationery stores, music houses, and dealers in artist's materials were frequently used to display paintings, the proprietors acting as intermediaries between the artists and the public.[4] In 1854 Marvin and Hitchcock, San Francisco dealers in music, books, and stationery, felt there was sufficient interest in art to justify converting the entire second floor of their building into a picture gallery. This innovation was enthusiastically endorsed by the editor of the *Pioneer* who reminded his readers that "a drawing room or parlor is never furnished until its walls are decorated with elegant pictures. Adorn and relieve the great white blank walls of your drawing rooms."[5]

The newspaper crusade to arouse public appreciation of art made substantial headway in 1857 when the California State Agricultural Society and the Mechanics' Institute commenced including galleries of local paintings in their great annual fairs. The fairs gave the artists their first opportunity to display their works on a juried, competitive basis. But for some inexplicable reason many of them failed to take full advantage of the opportunity presented by the Agricultural Society. The committee on works of art "trusted that another year the exhibit in this department will be much increased. There are now a number of artists on the Pacific Coast . . . but few among them have made any contribution to this Fair . . . In portrait painting, particularly, some fine specimens might have been procured but not one is exhibited."[6] In fact, the art committee that year had so little to do the members doubled as judges of dental specimens. However, at least one visitor was impressed. Bayard Taylor, in California on a lecture tour, wrote: "The display of productions—agricultural, mineral, and artistic, astonished even the Californians themselves . . . Few of them had been aware of the progress which their State had made in the arts."[7]

The 1857 art exhibit of the first Mechanics' Institute Fair received somewhat stronger support from resident and visiting artists and proved an exceedingly popular attraction; the rooms were crowded daily with enthusiastic spectators. Included in the display of paintings were works by two of the state's 'first ladies of painting,' Mary Park Seavy Benton and Mrs. A. T. Oakes. In commenting on Mrs. Oakes's work the judges reported there were "but few of this class of picture [landscape in oil] on exhibit," and went on to explain why:

"The luxuries of painting can only follow the introduction of wealth-creating improvements, and it cannot be expected that at this epoch of the development of arts in California the talents of artists in this class will be duly encouraged . . . [The judges] express their surprise and gratification at the strides which the fine arts have made in our infant city, and

their pleasure at the appreciative spirit of its citizens, without whose encouragement no elegant art would flourish . . . Since Jewett's work in 1850 only seven years have elapsed, and already so many worthy productions cover the walls of the Exhibit that we have been compelled to pass over in silence many an aspirant's deserving efforts. There can no longer be a doubt that the State possesses an abundance of artistic talent, yearning to evolve itself, and fertile as our soil, which only awaits the cultivating hand of taste and wealth to foster and promote its growth."[8]

The "abundance of artistic talent" was in evidence at the next Mechanics' Institute Fair held in 1859 when nearly half of the serious artists at work in California competed for awards. Frderick A. Butman's oil paintings "Yosemite Valley" and "Yosemite Falls"[9] were judged "superior works of art." George Henry Goddard won first premium with a water color landscape, "The Stream,"[10] and Charles Christian Nahl received the second premium for his realistic painting, "Emigrants Attacked by Indians."[11]

The astonishing popularity of the art exhibit at the fair gave promise of a day not far distant when a qualified artist could expect to earn a respectable living in California in his own profession.

The Golden Era 1860-1875

California's attraction for artists was not one whit diminished by the tapering off of the gold excitement in the mid-fifties or by the well-known fact that it was virtually impossible for an artist to earn a living in California solely in the fine arts. Undaunted by reality, fresh contingents of artists continued to converge upon San Francisco in search of new inspiration in a virgin land. Their presence lent distinction and encouragement to the local art circle revolving around the Nahl brothers, William S. Jewett, Stephen William Shaw, Frederick A. Butman, and other 'old timers,' nearly all of whom had weathered through the artistically barren Gold Rush years in California.

Portraiture had been the mainstay of that pioneer group, but the trend of the times carried west by the talented newcomers was toward landscape painting. The resident colony[12] embraced the trend and a period of scenic landscape painting commenced that was to dominate artistic expression in California for the next fifteen to twenty years. Coincidentally, the new art direction came at a time when roads and stagecoach services were being extended into remote parts of the country. It had become comparatively easy to travel away from the centers of population and artists began wandering far afield for months at a time on sketching trips. The soft blues and purples of the open distances enthralled them; the richly varied landscape and the stupendous grandeur of the high country filled them with awe and delight. They reacted to the scenery as though it were the eighth wonder of the world, as perhaps it then was. Their canvases of panoramic dimensions depicting

Yosemite Valley, Mount Shasta, the canyon of the Tuolumne, the peaks of the Sierra Nevada, the giant redwood trees, the jagged northern coastline, and a thousand other 'scenes of wonder and curiosity' won acclaim at home and abroad as truly great works of art. Today those epic canvases, painted when the interior regions were untouched by man, vividly preserve for posterity much of the wild and virgin scenery that has since been lost, lost utterly.

Among the first grandiloquent landscapists to depict California as an unspoiled paradise were Thomas Hill, William Keith, and Albert Bierstadt, a talented foreign-born trio whom art historians frequently credit with pioneering scenic painting in California.

Thomas Hill

The first member of the celebrated trio to arrive in California was English-born, French-trained Thomas Hill, a successful portrait and still life painter from Philadelphia. While in San Francisco from 1861 to 1866 Hill turned his talent chiefly to painting small landscapes, finding his subjects in the Russian River Valley, Napa Valley, and Lake Tahoe.[13] Following this initial visit to California, Hill studied art in Paris for several months, then opened a studio at Cambridge, Massachusetts, where he painted a number of California landscapes from his on-the-spot sketches. Hill returned to California in 1871 and for the rest of his long life divided his time between San Francisco and Yosemite Valley. His monumental paintings of the valley, of which "Grand Canyon of the Sierras, Yosemite,"[14] is a typical example, made him famous. Hill was a prolific painter with a quick sure touch and his paintings were much admired in his day.

William Keith

William Keith, the second arrival in the Hill-Keith-Bierstadt triumvirate, is the most celebrated of California's nineteenth-century artists. Born in Scotland in 1839, Keith was brought to New York as a child where he was apprenticed to a wood engraver. In 1859 the young engraver visited California briefly while on an assignment for Harper's. In 1862 Keith returned to San Francisco where during his first years as a resident he eked out a bare living with odd jobs of engraving, part of the time working for Harrison Eastman. About 1864 Keith began painting landscapes in his free time and soon devoted himself exclusively to that field. His earliest scenic paintings were of San Francisco and the Bay Area;[15] to these in 1868 he added views of Oregon, Washington, the California foothills, and the Sierra Nevada. Except for intervals of travel, Keith painted in California from 1862 until his death in 1911.

In his first years of landscape painting William Keith produced grandiose canvases in the manner of Hill and Bierstadt. To this period belong "The Big Canyon of the Tuolumne,"[16] "The Crown of the Sierras,"[17] and "California Alps,"[18] the latter a six by ten foot canvas.

Later in his career Keith turned from painting faithful transcriptions of actual prospects to a more poetic interpretation of nature.

Albert Bierstadt

The third member of the famous trio was German-born Albert Bierstadt, widely known a century ago for his dramatic landscapes of western scenery. Albert Bierstadt first saw San Francisco and Yosemite while on a brief visit to California in 1863. The artist returned to California in 1871 and for two and a half years made sketching trips out of San Francisco into Yosemite Valley, the high country, the interior valleys, and to Oregon. Near the end of his California visit Bierstadt exhibited thirty of his paintings in San Francisco.

The stunning Bierstadt exhibit and equally impressive exhibits by Hill and Keith in the same period did much to open the eyes of San Franciscans to the astonishing quantity and quality of art being produced right in their own city.

Although there still were no art galleries in the strict sense of the word in California in the sixties the works of San Francisco's artists became fairly well known locally, as has been pointed out, through displays of paintings in hotel lobbies, clubs, reading rooms, store windows and art dealers' shops. For example, the Mercantile Library early in its existence, placed on display a notable collection of California views and engravings by the California-based Swiss artist Charles H. B. Fenderich;[19] at the same time the What Cheer House, a temperance hotel owned by Robert B. Woodward, had a number of locally produced paintings of California towns and mining districts on the lobby walls.[20] Woodward's Gardens, a popular pleasure resort, had an art gallery of seventy-two paintings. Over half the collection was from the brush of Virgil Williams whom Woodward had brought to California expressly to lay out an art pavilion at the Gardens. During the Ladies Christian Commission Fair held in 1864 the public enjoyed an exhibit of California paintings assembled by the popular portraitist William Smith Jewett. An auction sale of the collection afterwards raised a substantial sum of money for the benefit of wounded Civil War soldiers. Among the most highly praised works auctioned off were Frederick A. Butman's vividly colored landscape, "Chaparral in the Coast Range," Gideon Jacques Denny's "Scene on Walker's River," and a Thomas Hill view of Lake Tahoe.

Of utmost importance to the advancement of California art and art appreciation during the sixties were the ten or more knowledgeable San Francisco dealers who handled not only good imported art but also the best California work of resident and visiting artists. California paintings placed with dealers ranged in size from monumental landscapes of wildly beautiful mountain scenes, frequently with genre details, to cabinet views of such popular subjects as the Cliff House, Golden Gate (invariably with a steamer headed in or out), Land's End, Seal Rocks, the city from Telegraph Hill, and other scenic vistas around the

great bay. Of special appeal to dwellers in rawboned San Francisco were views of 'country-seats,' the serene and gracious homes built by men who had become wealthy in California. In this class were the views of Oak Knoll, James Warren Osborn's[21] estate in the Napa Valley, painted by Edward Vischer and offered for sale in August, 1863, at Roos & Wunderlich's for the benefit of Osborn's widow.

The one single event that advanced the cause of California art to a greater degree than any other in the sixties was the art exhibit at the Mechanics' Institute Fair of 1864, to which the artists submitted literally hundreds of landscapes, marines, portraits, genre, and still-life studies. The California exhibit covered the walls of four galleries. Typical subjects were the grand view, the pastoral valley, the dramatic cliff, the awesome canyon—romantic themes set off with genre details. Of the exhibitors Frederick A. Butman, Gideon Jacques Denny, and Thomas Hill were most fully represented.[22] So outstanding was the quality of the California paintings and so enthusiastic the audiences that at subsequent fairs it became the policy to jury only California paintings by California-based artists.

The public's demonstrated interest in California art stimulated San Francisco's leading resident artists and a dedicated group of art enthusiasts to promote the organization of an art union modeled on similar organizations in the East. Samuel Marsden Brookes who had been painting still lifes in San Francisco since 1862 drew up the prospectus. The aim of the organization was "the cultivation of the fine arts and the elevation of popular taste." At specified intervals paintings would be distributed by lottery to holders of a five-dollar membership card. Eighty-seven prominent San Franciscans and eighteen artists signed the articles of incorporation. The California Art Union, the first in the West on a cultural rather than a sales-promotion basis, opened on January 12, 1865 with an exhibit on the second floor of Jones, Wooll & Sutherland, picture dealers.[23] Fifty of the one hundred and thirty oil paintings assembled were by local artists. The popular Frederick A. Butman was represented by five colorful landscapes: "View of Yuba River Valley," "Sunset on Emerald Bay, Lake Tahoe," "Mount Shasta from the North," "Yosemite," and "Coast near Monterey." Gideon Jacques Denny, best known for his marines, exhibited two of his infrequent landscapes, "Moore's Beach," and "Scene in Sonoma Valley." Norton Bush, who since 1857 had been recognized as an amateur artist of exceptional talent, made his professional debut with a view of Sacramento Valley. Virgil Williams exhibited "Yosemite Ford." Of special interest was Hill's "Merchant of Venice," purchased in advance by the art union for seven hundred dollars in California gold. Each member was promised an engraved copy of the painting.

During the spring of 1865 pictures were added to the display as old ones were withdrawn, and for a few months the exhibit rooms drew large audiences. But the optimistic promises to award paintings as lottery prizes as well as engraved copies of Hill's "Merchant

of Venice," could not be fully kept. New pictures were not forthcoming frequently enough to retain the public's interest, and lenders began recalling their paintings for their private enjoyment. Before the year ended the California Art Union dissolved and the gallery closed. The initial success of the venture, however, indicated to artists and art enthusiasts that in the not-too-distant future a similar organization under a more sophisticated management would undoubtedly succeed. Benjamin Parke Avery of the *Bulletin* was among those who looked forward confidently to the day when "there will exist [in San Francisco] a distinct Art School, supported by a cultivated public taste, and where already there are more evidences of aesthetic culture than exist in any other community so isolated, so exposed to frontier influences, and so youthful."[24]

The "cultivated public taste" so confidently predicted by Avery did in fact become evident along in the sixties when San Francisco's first millionaires began getting rid of inferior European paintings purchased in the first flush of wealth as cultural symbols and began buying not only good art of European origin but the best art being produced in California, much of which it was claimed would do credit to the art centres of Europe. With the shift in taste came the pre-dawn of a new day for California art and artists.[25] Business perked up at the art shops; artists more frequently found prospective clients at their studio doors, and the auction houses—always a vital part of life in San Francisco—became the happy hunting ground of the rich.

Rich, but not necessarily generous. While San Francisco's men of wealth might pay fair prices for paintings purchased directly from the artists or from dealers, they were niggardly in their bidding at auctions. Consequently, paintings were knocked down for a fraction of their true worth. But the artists, steeped as they were in the theory that study in the art centres of Europe was the *sine qua non* of a successful art career at home, kept scurrying to the auction houses as the only way to raise ready cash for study in Europe. Even the well-established Frederick A. Butman who had acquired two wealthy patrons sacrificed collections of his paintings at auctions: fifty oils in 1866 to finance a round trip to Europe (the proceeds fell far short of that mark), and sixty canvases in 1871, "the best collection of landscapes ever brought together in this city," reported the *Alta California*. "They comprise views in California, Oregon, Washington Territory, Maine, New Hampshire, France, Spain and Switzerland . . . all very carefully finished;" and after the auction: "Considering the weather the sale was well attended and the bidding correspondingly spirited."[26]

Spirited but shockingly low. Butman's view of Mount Shasta from Shasta Valley went for $110; two of his Lake Tahoe views at $180 and $260. Even in that day the seven thousand dollar total was not much for sixty paintings, some of them in California gold frames, but it carried the artist off on a painting visit to his old home in Gardiner, Maine.

It cannot be denied that there were generous men among the auction bidders—San

71

Francisco's leading philanthropists and patrons of art[27]—but art auctions seemingly brought out their most penurious traits. Unashamedly, perhaps gleefully, they acquired for pennies California paintings that are the priceless cornerstones of present-day collections.

The endless stream of artistic talent flowing into California rose to flood level with the commencement in 1869 of transcontinental train service. Among the distinguished artists who sped westward in the cindery comfort of shiny-new railroad coaches were some who in earlier years had tramped and sketched the country as goldseeker, surveyor, mapmaker, journalist, illustrator, professional artist, or whatever. Notable among these were Albert Bierstadt who, since his first visit in 1863, had become internationally known; Harry Cheever Pratt, artist with the 1850-1852 boundary commission whose portfolio of southwestern and California paintings is still missing; and Thomas Hill, returning as fate willed it to spend the rest of his life perpetuating Yosemite's beauty on canvas.

First-time visitors in the early railroad years included a dozen or more professional artists who became lastingly identified with California painting. Foremost among these were William Hahn, justly celebrated for his California genre paintings of familiar everyday scenes; Thomas Moran, noted for his colorful Yosemite views; William Alexander Coulter, delineator of waterfront views and dramatic marines; and Italian-born Domenico Tojetti, decorator of San Francisco mansions and churches, and masterly painter of religious, allegorical, and literary themes.

The incoming artists flocked to San Francisco, known to all as the art center of the West. From that base they fanned out into the countryside in search of unhackneyed subjects. Improved roads, good stagecoach service, and the completion of valley and coast railways made travel comparatively easy in the early seventies, and the construction in 1872 of a stagecoach road into Yosemite with Hutchings' hotel at the terminus, brought remote Yosemite Valley within a two- to three-days' journey of San Francisco. Nearly every newly-arrived painter thought it necessary to do one or two views of Yosemite Valley; in those early exhilarating years thousands of landscapes were executed in that unspoiled wonderland.

Other than the counter-pull of Yosemite (and the Tahoe area to a lesser degree), the chronological path of painting in California was from north to south. The scenic Monterey Peninsula was freshly discovered in 1874 by the gifted French artist Jules Tavernier while on a chance sketching trip out of San Francisco. Tavernier promptly built a studio at Monterey in which to paint, exhibit, and teach classes in art. He was joined by artist-friends including his countryman Leon Trousset who had been painting in California since the early 1850's. Tavernier and Trousset were pioneer painters of an area that has ever since been a loadstone for artists.

A few painters traveled as far afield as Southern California in the early seventies, but

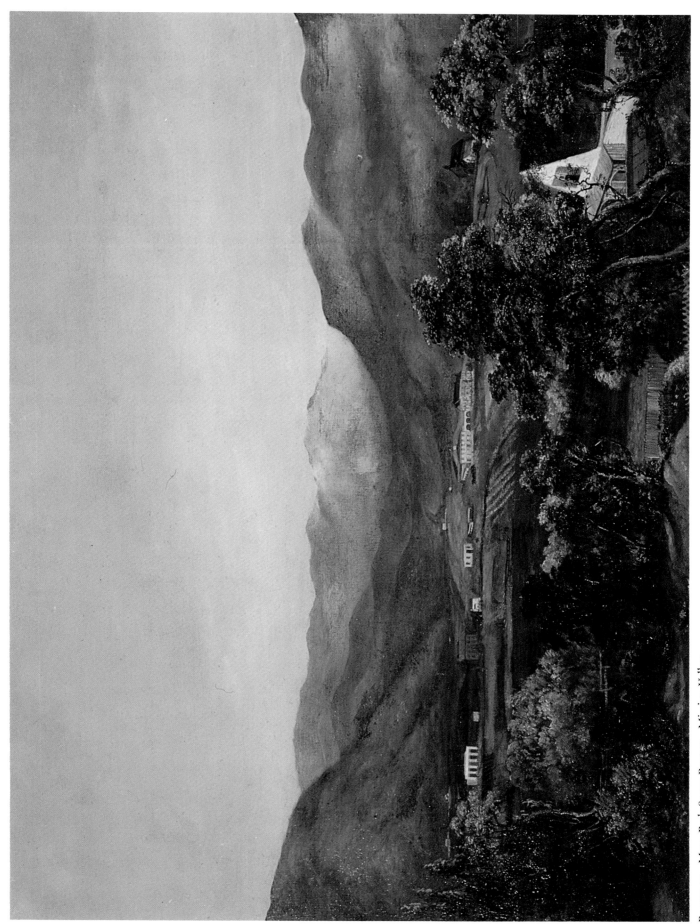

PLATE 27 Mary Park Seavy Benton Mission Valley

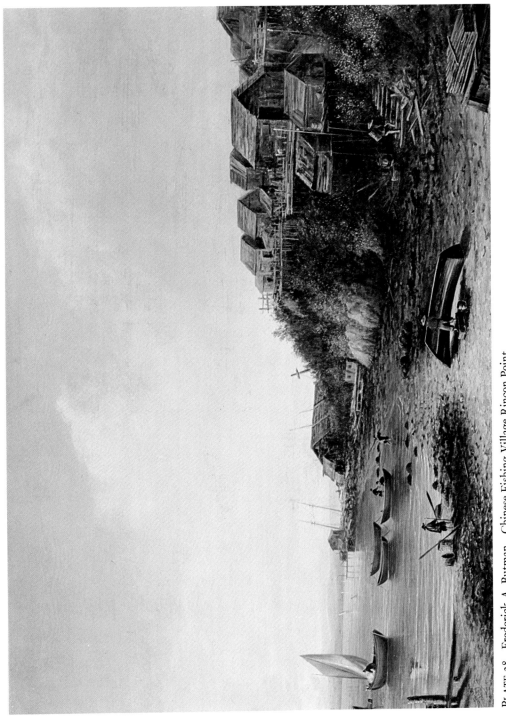

PLATE 28 Frederick A. Butman Chinese Fishing Village Rincon Point

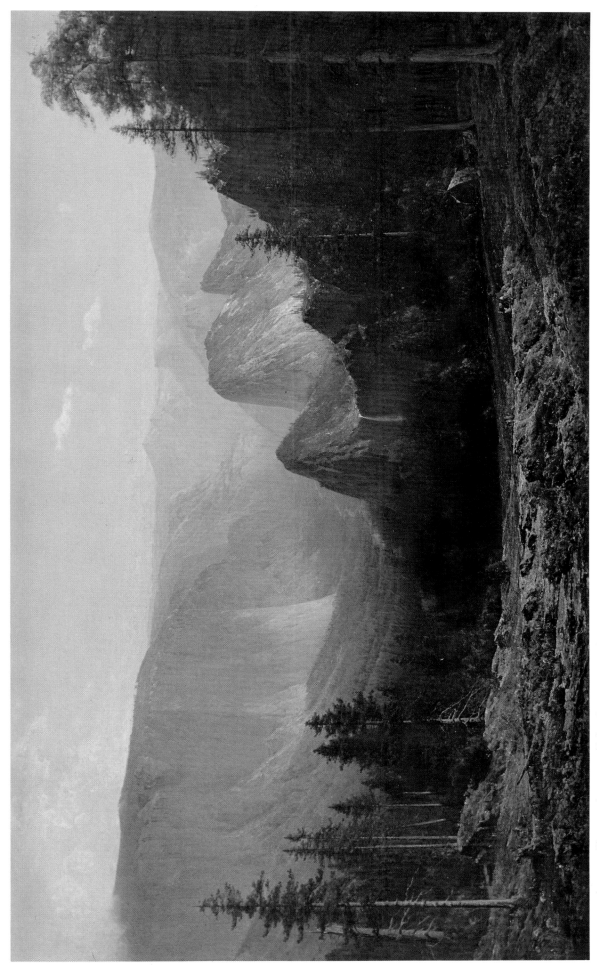

PLATE 29 Thomas Hill Grand Canyon of the Sierras—Yosemite

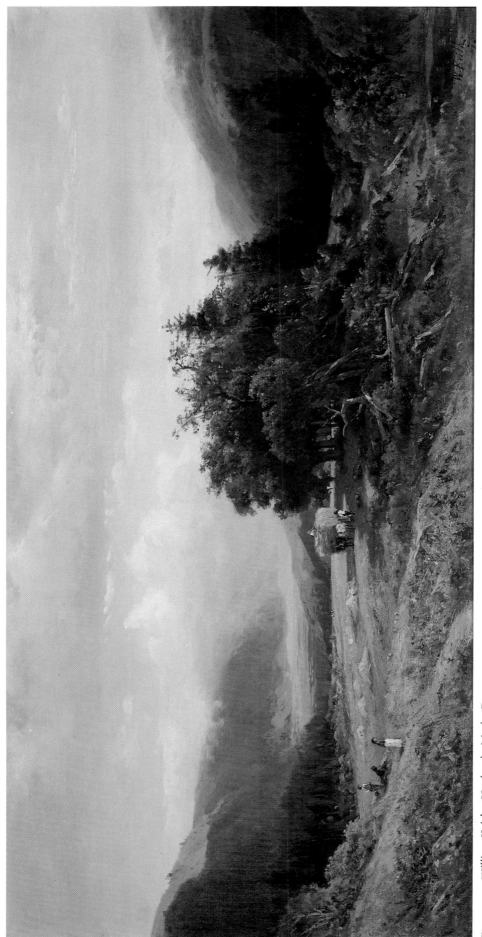

PLATE 30 William Keith Haying in Marin County

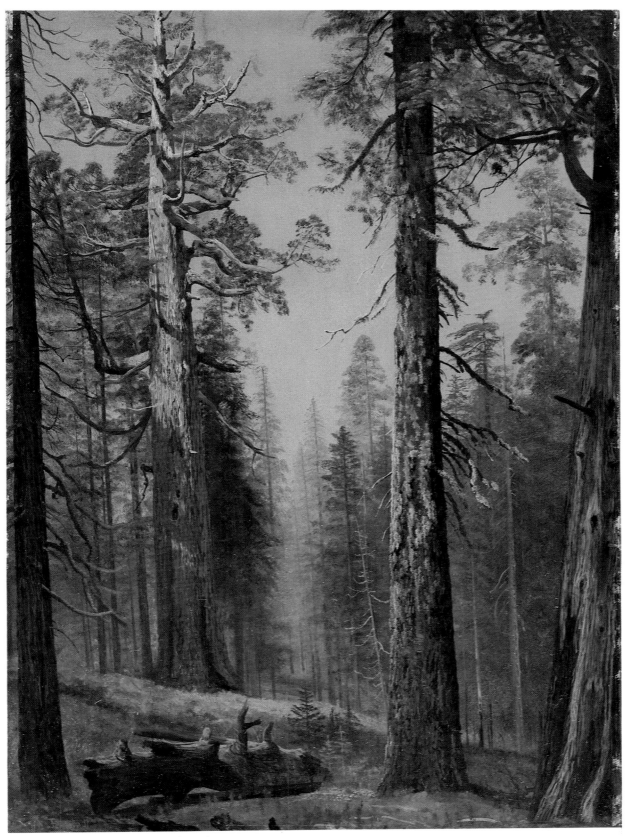

PLATE 31 Albert Bierstadt Redwood Trees

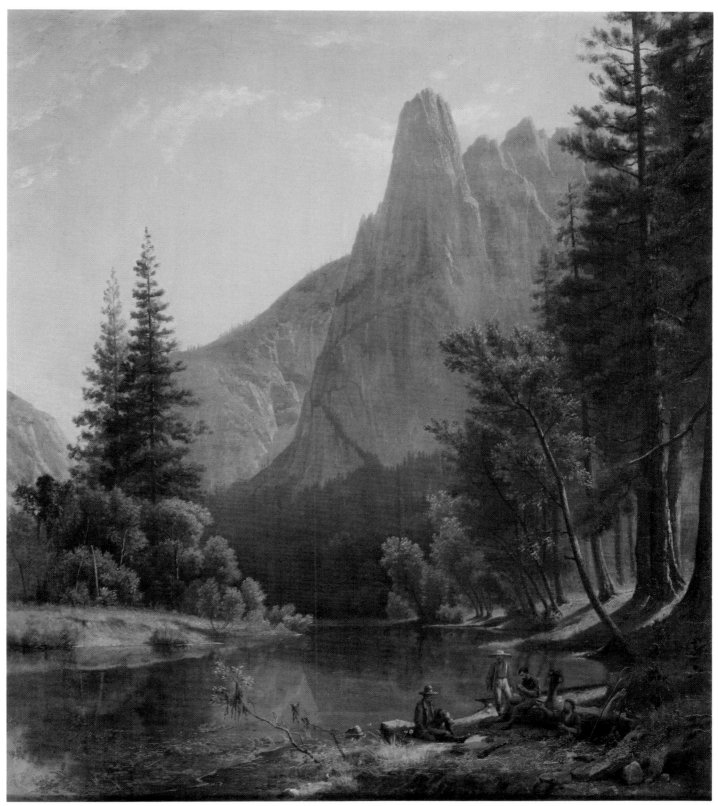

PLATE 32 Virgil Williams Along the Mariposa Trail

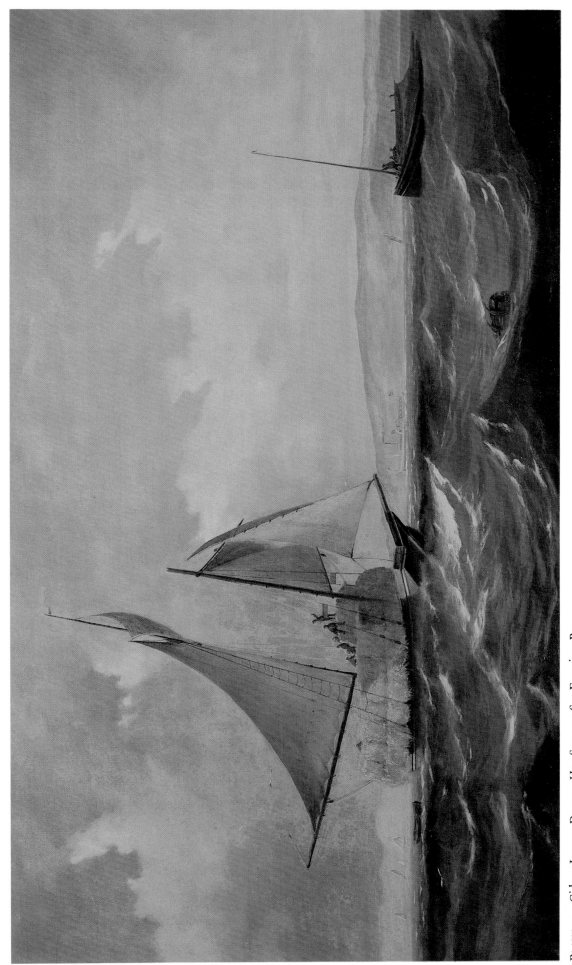

PLATE 33 Gideon Jacques Denny Hay Scow on San Francisco Bay

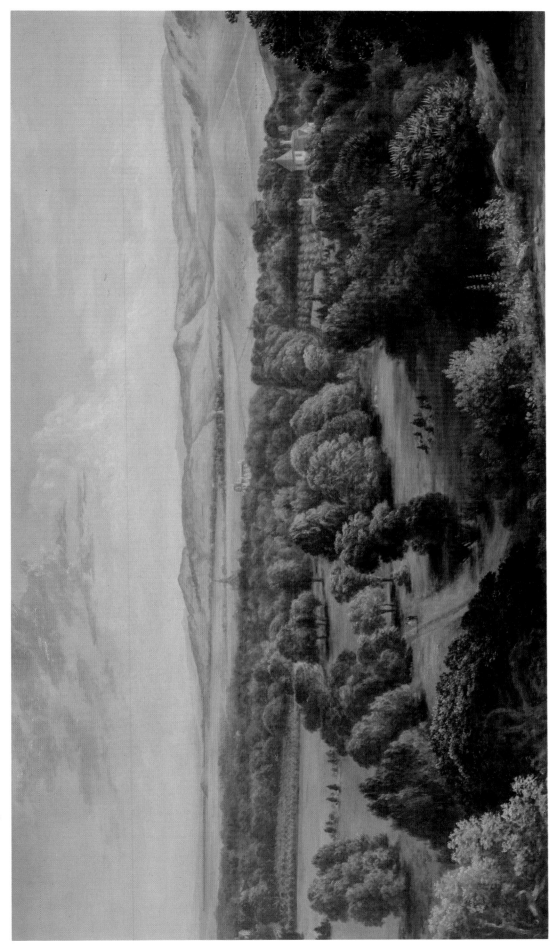

PLATE 34 Henry Cheever Pratt Valley of San Mateo Taken from Howard's Hill

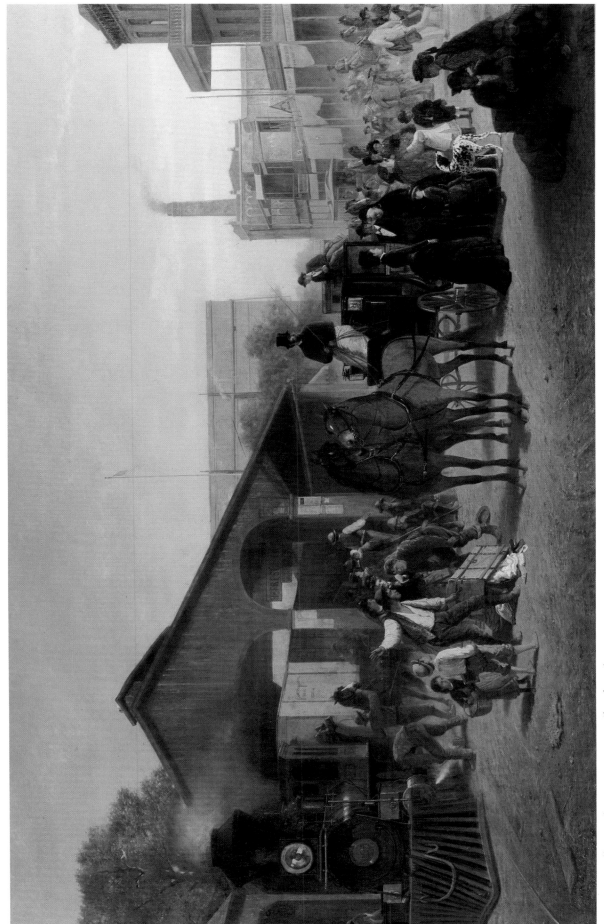

PLATE 35 William Hahn Sacramento Railroad Station

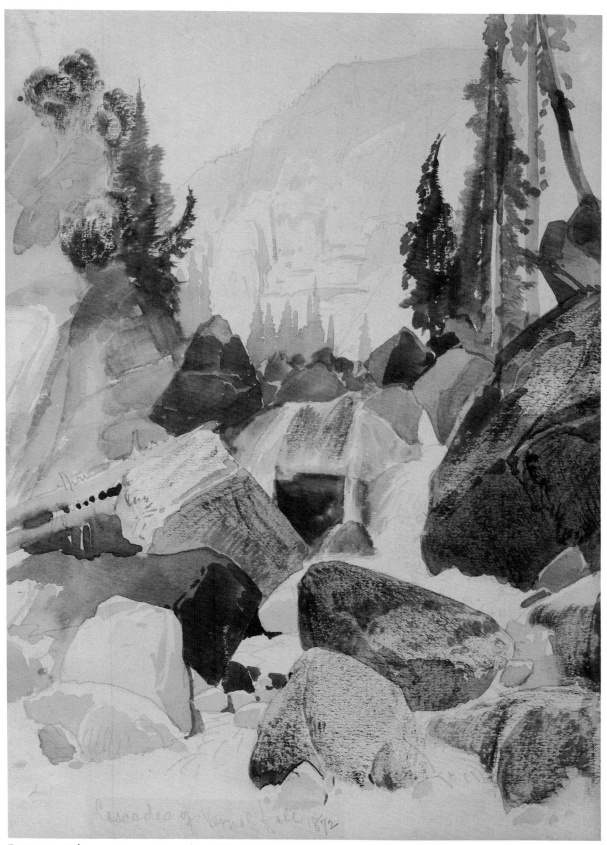

PLATE 36 Thomas Moran Cascades of Vernal Falls

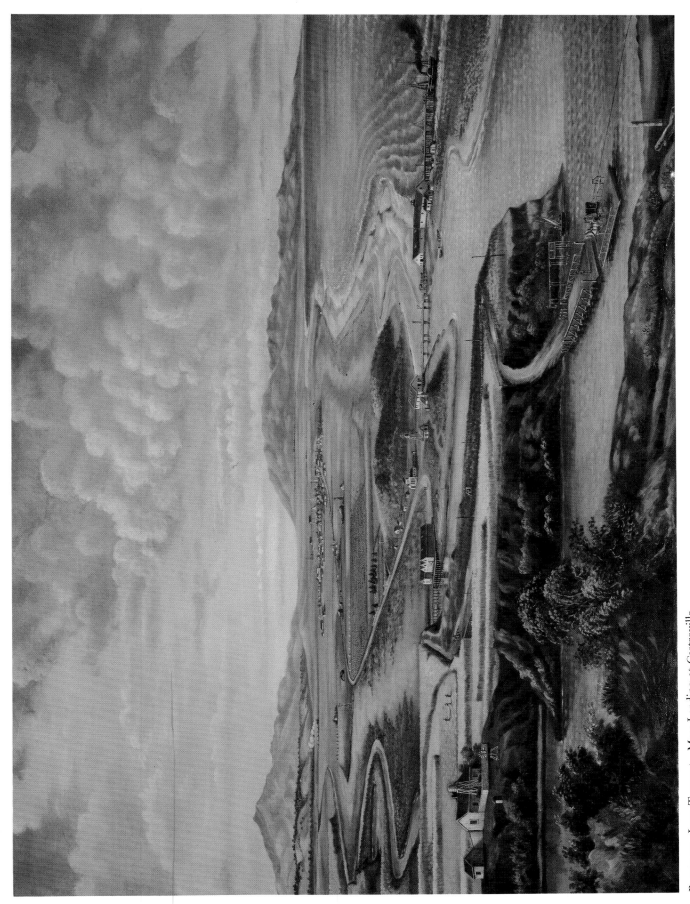

PLATE 37 Leon Trousset Moss Landing at Castroville

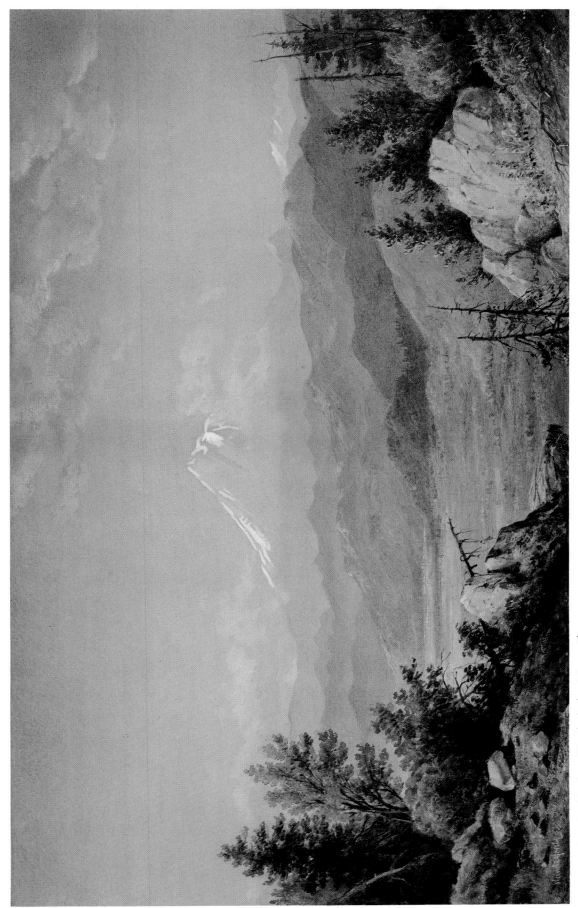

PLATE 38 Juan Buckingham Wandesforde Mount Shasta

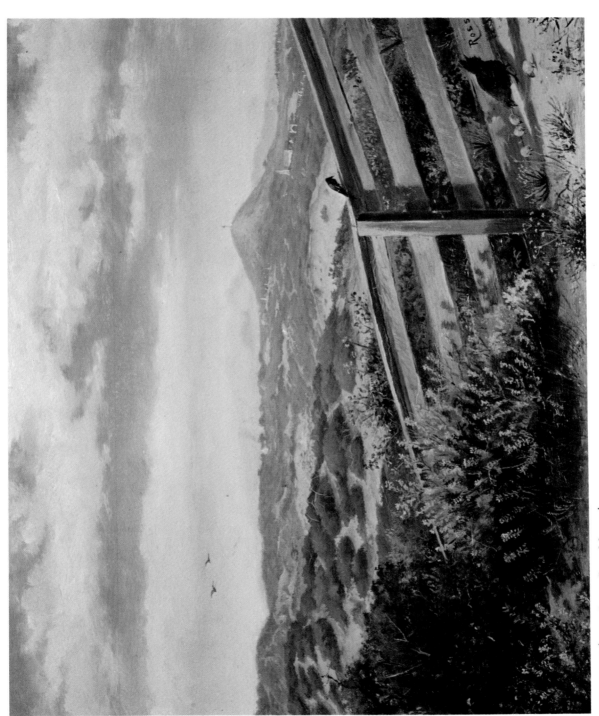

PLATE 39 Thomas Ross Lone Mountain

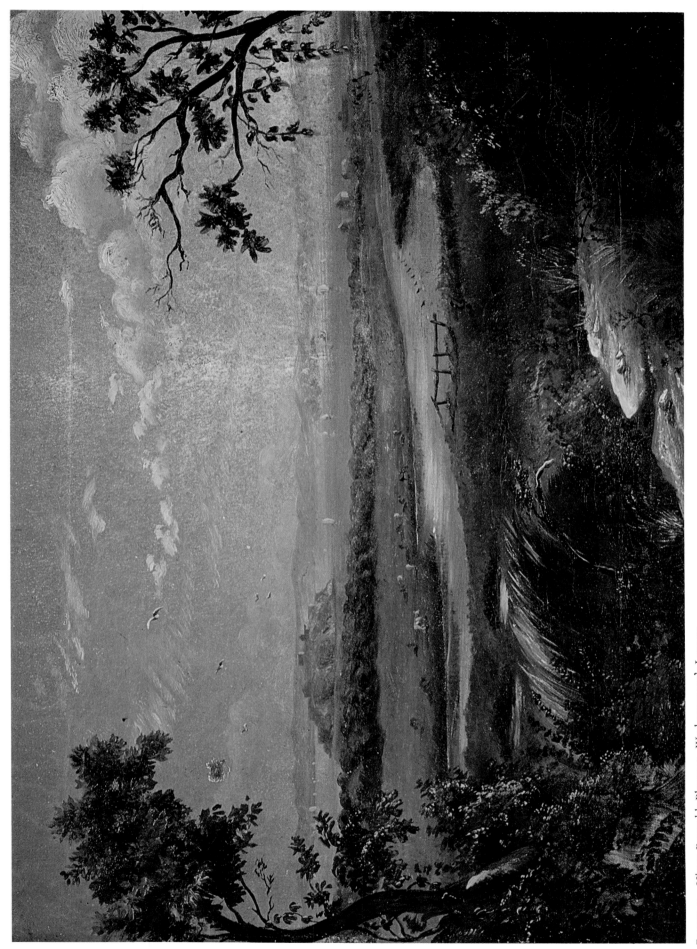

PLATE 40 Hiram Reynolds Bloomer Washerwoman's Lagoon

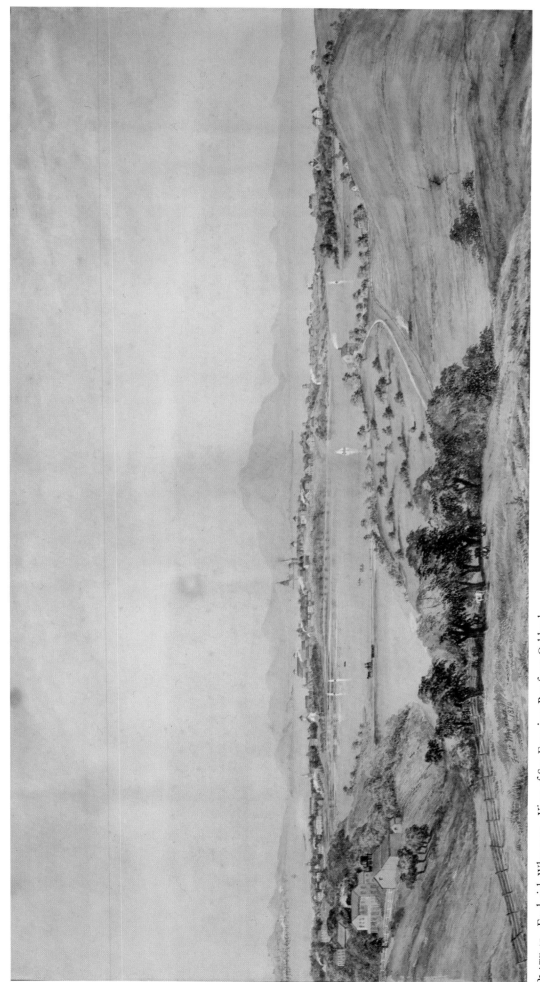

PLATE 41 Frederick Whymper View of San Francisco Bay from Oakland

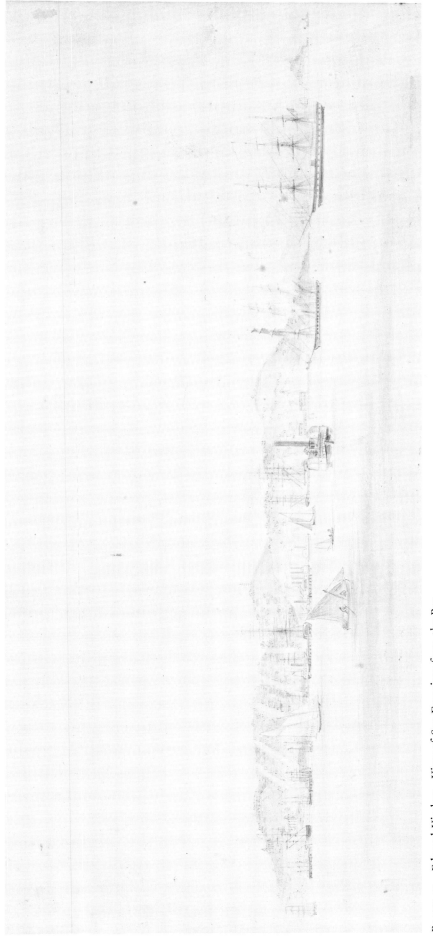

PLATE 42 Edward Vischer View of San Francisco from the Bay

found the inhabitants not much interested in having portraits of their families or views of their homes or towns; furthermore, the landscape lacked the drama and color of Northern California and consequently there was little inducement to linger in that part of the country. Among the finest artists who made brief visits south of the Tehachapis in those early years were Edwin Deakin, William Hahn, Edward Vischer, and James Walker. Of the limited legacy of Southern California paintings emanating from these distinguished visitors possibly the works of James Walker are of the greatest appeal today.

James Walker, a New York artist, had learned to speak Spanish in Mexico and in California had many friends among the Spanish-speaking Vallejos, Picos, Peraltas, and other old *Californio* families. It was during his frequent visits to Rancho Santa Margarita y Las Flores near Oceanside and at General Beale's Rancho Tejon that Walker witnessed the action and drama portrayed in his huge canvases of life on a California rancho. Best known of his California paintings are "Cattle Drive,"[28] "Vaqueros at the Roundup,"[29] and "Judge of the Plains,"[30] in which the artist effectively catches the flavor of ranch life as it was in Hispanic California.

It was true, as local editors frequently remarked, that San Francisco was not a cauldron bubbling with culture, but within that busy stir were all the elements needed to insure its development as the lasting art center of the West. Fundamental to that future was an art association to serve as a coordinating agency for local artists, an art school to provide the artistically gifted with competent art instruction, and men of wealth and taste to nourish both.

The first step toward those goals was taken in March, 1871, when a group of artists and connoisseurs formed the San Francisco Art Association for the purpose of having sketch nights, receptions and exhibitions, and ultimately an art school. Nearly two hundred professional and amateur artists, art connoisseurs, and persons of musical and literary tastes signed the prospectus. The association's first officers included Juan Buckingham Wandesforde, an English artist who had traveled and painted in many parts of the world before coming in 1862 to San Francisco, Frederick Whymper who had traveled in Alaska as artist with the Russian-American Telegraph Exploring Expedition prior to coming to San Francisco on a Pacific Coast assignment for the *Illustrated London News*, and Samuel Marsden Brookes, one of the founders of the defunct California Art Union, still eager to promote local art and artists.

The San Francisco Art Association held its first reception May 9, 1871 in the Mercantile Library's museum room. The impressive display of paintings in oil and water color, in pencil, crayon, and India ink numbered nearly two hundred; the number could have been doubled or trebled had space permitted. The opening exhibit purposely featured California landscapes to publicize the work of resident artists.

73

The second annual exhibit surpassed the first with a galaxy of 287 paintings by local, eastern, and foreign artists. Among the outstanding California landscapes were Thomas Hill's "Mount St. Helena," Hiram Reynolds Bloomer's "Castle Lake," Edwin Deakin's "Lower Yosemite Falls," and Thomas Ross's view of the sand hills of western San Francisco. Following this dazzling art assembly attended by the crème de la crème of San Francisco society, the San Francisco Art Association—the first art association of any consequence west of the Mississippi—became the basic coordinating agency for the advancement of painting in California. It was of more help than anything else in the cultivation of a taste for art. The exhibitions were considered the "most refined social events of the city."[31]

The Bohemian Club, founded in 1872 by a group of journalists, was also destined to be instrumental in advancing local art. Membership was open to anyone who "appreciated polite literature, fine arts, and music." Although in the early years there were no formal art exhibits, the club lounge served as a gallery for paintings by artist-members.

Soon after the Bohemian Club was established an informal art group styling themselves the Graphic Club began meeting weekly in the smoky coziness of Stephen William Shaw's studio to sketch on impromptu themes, discuss art ideas, and—just possibly—to exchange opinions about the work of nonmembers. Shaw and Whymper officiated; their friends of comparable artistic ability comprised the select membership. For a time the members published *The Album*, a magazine of art news. The *Overland Monthly*, November, 1873, noted the club's activities: "The Graphic Club has done much to stimulate a wholesome competition among our painters, and to cultivate among them that esprit de corps which is so conducive to the elevation of their profession. The Club and the Art Association together, are doing a fine work in this community, and promise to be permanent institutions."

The San Francisco Art Association[32] did indeed become a permanent institution and its School of Design,[33] the first art academy in the West, is still functioning. Art instruction was not new in California,[34] but for the first time a full curriculum of standard art courses was available. Virgil Williams, well-known in San Francisco as a painter of romantic landscapes, became the school's first director and was one of its most gifted teachers. Under his lifelong directorship the School of Design flourished as the center of local art activity. It was the *alma mater* of many of California's first-generation talented sons and daughters, a number of whom won scholarships for further study in Europe and went on to become California's leading artists.

The surge of interest in art generated by the opening of the School of Design sent an unprecedented volume of business into the art shops. Several of the older dealers responded by refurbishing and enlarging their rooms or found more spacious quarters. Snow & Roos opened a new art store with an adjoining art gallery, the ceiling of which was frescoed with designs by Charles Christian Nahl[35] and other local artists; Morris Schwab and M. D. Niles

substantially enlarged their displays of local paintings; a pretentious new concern, the Beaux Arts Gallery, opened with an outstanding display of paintings by local artists. Simultaneous with the proliferation of art dealers' shops a change took place in the auction houses. Prices zoomed. At H.W. Newhall's auction rooms on November 25, 1875, landscapes, marines, still life, and genre studies brought prices ranging upwards into three and four figures.[36] The quality of the paintings was clear evidence of California's prodigious growth from an artistic point of view; the eagerness of the bidders and the high prices were proof indisputable that California's fine artists had at last come into their own in a popular, flourishing, and secure craft.

A century earlier—on February 5, 1775—Junípero Serra had unwittingly commenced the recorded history of painting in California by listing the so-called 'Diaz' painting in an inventory of mission furnishings. Between February 5, 1775 and November 25, 1875, the date of the Newhall auction, countless artists had given to the world an image of California which has not even yet been entirely effaced: a land of soaring peaks, lush valleys, winding rivers, tranquil lakes, awesome canyons, redwood forests, rugged coast. They had endlessly perpetuated on canvas "all the flashing and golden pageant of California, the sudden and gorgeous drama, the sunny and ample lands."[37]

In their day those scenic canvases of California's natural wonders were immensely popular, but toward the close of the century a change in public taste threw them into disfavor. Factual representations of specific localities, no matter how romantically presented or skillfully executed, ceased to interest connoisseurs; the rising demand was for pictures of informal subjects presented in the impressionistic technique. The market for the once all-enthralling grandiose representations of Yosemite, Lake Tahoe, Tuolumne Canyon, Mount Shasta and other spectacular sights simply disappeared.

Today, after an interval of nearly one hundred years, a fresh interest has arisen in California art of the nineteenth century. Almost any painting of the period commands a high price and is eagerly purchased by private collectors and public institutions. There can be little doubt that this return to images of the past, to a time when man and nature seemingly co-existed in peace and beauty, is prompted in large part by a nostalgic longing to recapture the vanished beauty and serenity of an earlier day.

NOTES

IV. *California's Own Art World, 1860–1875*

The Beginnings, 1849–1859

1. *Literary World*, vol. 8, January–June, 1851, pp. 31–32, article on California art quoting the *Alta California*.

2. Charles C. Nahl's celebrated "Emigrants Crossing the Plains" first came to public notice in a Sacramento saloon.

3. *Alta California*, October 5, 1851.

4. Among the merchants who generously displayed local paintings in their store front windows were A. Goupil, a French firm from New York selling prints in 1850; Atwill & Company, music & picture dealers (*Evening Picayune*, September 14 & 16, 1850); Jones & Wooll, proprietors of a picture and framing store on Montgomery Street from early 1850; Markwell Caspari & Company, vendors of "fine pictures and engravings" (*Alta California*, December 18, 1851); and Marvin & Hitchcock, stationers and booksellers at the Pioneer Bookstore from early 1850. In 1854 D. L. Gunn's shop windows were attracting boardwalk crowds with a display of Ayres's and Smith's paintings for the panorama "California on Canvas," and a year or so later people gathered in front of Henry Morse's store to admire portraits by Stephen William Shaw.

5. *The Pioneer*, vol. 1, April 1854, p. 255.

6. California. State Fair and Exposition. *Report of the California State Agricultural Society. Transactions. 1859.* Sacramento: State Printer, 1860.

7. Taylor, Bayard. *New Pictures from California.* New York: Putnam, 1894.

8. Mechanics' Institute Report. 1859.

9. Frederick A. Butman's "Yosemite Valley" and "Yosemite Falls," were on display in October, 1859, at Jones, Wooll, & Sutherland, dealers in picture frames, engravings, lithographs, artists' materials and looking glasses. Present location unknown.

10. Present location unknown.

11. In the Stanford Art Museum. Newspaper editors were usually enthusiastic about Nahl's work, but this painting drew scalding criticism in the *Alta California*, September 10, 1859: "The Indians resemble mulattoes more than the Indians of the Plains. The conception is bad. There is too much attention on the horror of the scene. Everybody is killing everybody—a sort of round robin of bloody and desperate purposes."

The Golden Era 1860–1875

12. San Francisco City Directories could not keep abreast of the population growth. Of the twenty-five or more artists known to be residing in San Francisco in 1859 only ten are listed as "painters" in the directory for that year: Fortunato Arriola, F. A. Butman, A. Claveau, A. Edouart, W. S. Jewett, Charles and Arthur Nahl, T. S. Officer, C. H. Revere, S. W. Shaw, and J. H. Wise.

13. "Our Camp" and "Paper Mill Creek, Marin County" (in the Oakland Museum) are typical of Hill's early work in California.

14. In the E. B. Crocker Art Gallery, Sacramento, California.

15. "Land's End" and "Seal Rocks" (in the Oakland Museum), "A View Along the Golden Gate Showing the Water Flume" (in the George A. Pope Collection), "Mission Dolores" and "Cliff House" (in the Society of California Pioneers) are among Keith's early California works.

16. Exhibited at the San Francisco Art Association in 1872.

17. Exhibited at the San Francisco Art Association in 1873.

18. Location unknown.

19. San Francisco Mercantile Library Association. *Fourth Annual Report, 1857–1858,* pp. 5, 11.

20. Opened in 1856, the What Cheer House became something of a cultural center with its informal picture gallery and well-stocked reading room.

21. Also spelled Osborne.

22. Butman exhibited 6 landscapes, Denny 7 portraits and marines, and Hill 6 portraits and 7 landscapes.

23. *Alta California*, January 12, 1865.

24. Avery, Benjamin P. "Art Beginnings on the Pacific Coast." *Overland Monthly*, vol. 1, July and August, 1868, pp. 28–29.

25. "A taste for art . . . is spreading among the people of this Coast. Artists now command good prices for their creations, and the wealthier classes evince a credible desire to adorn their residences." (*Illustrated San Francisco News*, August 14, 1869.)

26. *Alta California*, February 19, 1871.

Auction bidding reached its nadir in January, 1868, at Duncan's Sales Rooms when 5 handsome oil paintings by Fortunato Arriola, a talented Mexican artist working in San Francisco, sold for prices ranging from $27.50 for "Castle Peak on the Pacific Railroad," to a high of $130 for "Donner Lake, Pacific Railroad."

27. To name but a few: Leland Stanford, Milton S. Latham, Edwin Davis, E. B. Crocker (Charles C. Nahl's unflagging patron), J. L. Bardwell, Tiburcio Parrott (Jules Tavernier's generous sponsor), William Alvord, J. B. Haggin, William Morris, D. O. Mills, William C. Ralston, F. L. A. Pioche.

28. In the California Historical Society.

29. Privately owned.

30. Privately owned.

31. Avery, Benjamin P. "Art in California." (Ms.) Papers on Art, III, The Bancroft Library.

32. Presently known as the San Francisco Art Institute.

33. Founded February 8, 1874.

34. As early as 1847 one Henri Cambuston of Monterey taught drawing to the sons of the *Californios*, and soon after California attained statehood courses in drawing were offered in the public schools. Private instruction by California's early artists had been available in San Francisco since Gold Rush days. Mary Park Seavy Benton, possibly the state's first woman artist, began in 1855 a lifelong career as a teacher of art at her husband's parish in Mission Valley. George Holbrook Baker frequently supplemented his meager art fees by giving drawing lessons. Other San Francisco artists who gave studio lessons to promising art aspirants were Fortunato Arriola (Toby Rosenthal and Ransom Gillett Holdredge studied under him), Juan Buckingham Wandesforde, Frederick A. Butman, William Keith and Domenico Tojetti.

35. *Evening Bulletin*, April 10, 1869.

36. The highest bids were for works by Edwin Deakin, William Hahn, Norton Bush, Thomas Hill, William Marple, Gideon J. Denny, and Benoni Irwin.

37. Whitman, Walt. *Song of the Redwood Tree*. Mills College, Oakland: The Eucalyptus Press, 1934.

PART II

Biographical Information and References
Relating to the Artists

ALFRED THOMAS AGATE (1812-1846), was born at Sparta, New York. He received instruction in art from his artist-brother Frederick S. Agate and from Thomas Seer Cummings, artist and founding member of the National Academy of Design. While still quite young Alfred distinguished himself in New York City as a miniaturist and portraitist and in 1831 became an associate (later an honorary) member of the National Academy of Design. In 1838 he joined the art corps of the United States South Seas Surveying and Exploring Expedition commanded by Lieutenant Charles Wilkes. The expedition arrived on the West Coast in 1841 and Agate was a member of the party that journeyed overland from Oregon to San Francisco. After the expedition disbanded at New York Harbor in 1842, Agate remained on the rolls to assist in preparing the pictorial records for publication. He was engaged in that task when he died of tuberculosis on January 5, 1846.

REFERENCES:

Archives of American Art. Detroit, Michigan. Microfilm roll # NY59-5.
Bishop Museum, Honolulu, Hawaii. Card catalog.
Groce, George C. and Wallace, David H. *The New-York Historical Society's Dictionary of Artists in America, 1564–1860*. New Haven: Yale University Press, 1957.
Hamilton, Sinclair. *Early American Book Illustrators & Book Engravers, 1670–1870*. Princeton: Princeton University Press, 1958.
M. & M. Karolik Collection of American Watercolors and Drawings 1800–1875. Boston: Museum of Fine Arts, 1962.
National Academy of Design. *Exhibition Record, 1826–1860*. New York: New York Historical Society, 1943.
Poesch, Jessie. *Titian Ramsay Peale and His Journals of the Wilkes Expedition*. Philadelphia: The American Philosophical Society, 1961.

JAMES MADISON ALDEN (1834-1922), was born September 26, 1834, at Roxbury, Massachusetts. He enlisted in the navy in 1853 and from 1854 to 1857 served on the West Coast with the Coast Survey. From 1857 to 1861 he was the official artist of the United States-Canada Boundary Survey. He was honorably discharged from the navy in 1865 with the rank of acting ensign. The following year he became secretary to Admiral David D. Porter, superintendent of the United States Naval Academy, and lived at Annapolis until 1870. He was with Admiral Porter from 1866 to 1892.

Alden died at Orlando, Florida, in 1922. He is represented in the National Archives by sixty original watercolors.

REFERENCES:

American West. Painters from Catlin to Russell. Text by Larry Curry, and foreword by Archibald Hanna. Los Angeles: The Viking Press Inc. in association with the Los Angeles County Museum of Art, 1972, pp. 24, 37.

Callahan, Edward W., editor. *List of Officers of the Navy of the United States and of the Marine Corps from 1775 to 1900* . . . New York: L. R. Hamersly & Company, 1901, p. 19.

Deutsch, Herman J. "Surveying the 49th Parallel, 1858–61." *Pacific Northwest Quarterly*, vol. 53, January 1962, p. 18.

Monterey Public Library, Monterey, California. Letter written by Sarah Alden Dorsey regarding her gift to the library of a watercolor view of Monterey painted by her father, James Madison Alden.

Stenzel, Franz. *James Madison Alden, Yankee Artist of the Pacific Coast, 1854–1860.* Fort Worth: Amon Carter Museum of Western Art, 1975.

THOMAS ALMOND AYRES (ca. 1818-1858), was one of ten children born to John and Mary Ayres, either at New York City or at Woodbridge, New Jersey. Their relatives began moving 'out west' to Wisconsin in the 1830's, where in 1840 John and Mary took their large family. Young Thomas worked as a draughtsman with an engineering firm in St. Paul, but in his spare time painted in oils and water colors, chiefly landscapes. Caught up in the gold fever he left for California on February 4, 1849, and arrived at San Francisco on August 8. Evidently he spent the first months in California in the mines, but from 1850 to 1854 he was on the move over the north-central part of the state sketching and completing pictures. In June, 1855, he went with James Mason Hutchings to Yosemite to make drawings for Hutchings' proposed *California Illustrated Magazine.* Ayres drew some thirteen views; they were the first pictures ever made of Yosemite Valley. Ayres visited Yosemite again the next year and upon returning to New York in 1857 exhibited his drawings of the valley at the Art Union. Impressed by Ayres's artistic ability, Harper Brothers sent the artist back to California to make illustrations for a series of articles on California. Ayres began the assignment in Southern California with visits to Los Angeles, San Diego, and a number of outlying settlements. With that part of his sketching tour completed in April, 1858, Ayres boarded the *Laura Bevan,* bound for San Francisco. The ship was caught in a sudden storm off Point Dume and sank. All aboard perished.

REFERENCES:

Catalogue of Original Paintings, Drawings and Watercolors in the Robert B. Honeyman, Jr., Collection. Compiled by Joseph Armstrong Baird, Jr. Berkeley: The Friends of The Bancroft Library, University of California, Berkeley, 1968, pp. 2–3.

Farquhar, Francis P. *Place Names of the High Sierra*. San Francisco: Sierra Club, 1926, p. 111.

Groce, George C. and Wallace, David H. *New-York Historical Society's Dictionary of Artists in America 1564–1860*. New Haven: Yale University Press, 1957.

Letters from Irma Hilgedick, New York City, to Jeanne Van Nostrand, March 4, 1961, and March 16, 1971. In the Jeanne Van Nostrand Archives of California Artists. Berkeley.

Sacramento *Union*, June 1, 1858.

Van Nostrand, Jeanne. "Thomas A. Ayres, Artist-Argonaut of California." California Historical Society *Quarterly*, vol. 20, September 1941, pp. 275–279.

GEORGE HOLBROOK BAKER (1827-1906), was born on March 9, 1827, at East Medway, Massachusetts, and was educated in Boston private schools. After graduation and following a three-year apprenticeship to a commercial artist in New York, he enrolled at the National Academy of Design where his student work won prizes. In February, 1849, he joined the general exodus to the California gold mines. After a brief stay in the mines he opened a store at Sacramento. Early in 1850 business took him to Portland, Oregon, and that same year to Boston to purchase supplies for the Sacramento store. He recorded the return trip across the plains to Sacramento in sketches which James Mason Hutchings published as lettersheets in 1853. After 1854 Baker devoted all his time to artistic pursuits, principally lithography. On February 11, 1856, he married an English girl, Mary A. Belden. In 1862 Baker moved his business and home to San Francisco.

In San Francisco Baker vigorously promoted the city's developing art world and by teaching and example fostered painting as a profession in his adopted state. He remained active in his profession into the 1890's. His death occurred on January 21, 1906.

REFERENCES:

Baker, George Holbrook. Diary, account books, sketches, etc. In the Society of California Pioneers, San Francisco.

The Oakland Museum. Art Department. Archives of California Art.

Peters, Harry Twyford. *California on Stone*. Garden City, New York: Doubleday, Doran, 1935, pp. 47–50.

San Francisco *Chronicle*, January 21, 1906.

San Francisco City Directories, 1862–1906.

Society of California Pioneers. Inventory, 1927.

LEONARDO BARBIERI, an Italian portrait painter, is believed to have come to California in 1847. He painted in San Francisco, Monterey, Santa Barbara, and may also have painted portraits at Los Angeles and San Diego. He is said to have been associated in San Francisco with the French filibuster Count Raousset de Boulbon. A portrait of the Count painted by

Barbieri was discovered in Paris in the 1930's and is now in the collection of the California Historical Society.

Barbieri may have gone to Mexico in 1854.

REFERENCES:

Baer, Kurt. *Painting & Sculpture at Mission Santa Barbara*. Washington, D.C.: Academy of American Franciscan History, 1955.

California Daily Courier. Extra. July 1, 1850.

"Personalia and Marginalia." California Historical Society *Quarterly*, vol. 18, March 1939, p. 96.

Society of California Pioneers, San Francisco. Turrill catalogue, items 1252 & 1254.

JOHN RUSSELL BARTLETT (1805-1886), ethnologist, bibliophile, and amateur artist, was born in 1805 at Providence, Rhode Island. He was educated at academies in Canada and upstate New York and early in life showed considerable artistic talent. At school he mastered accountancy, but his interests centered on literature, history, and geography. After completing his formal education at age eighteen he worked as a clerk in a dry goods store and then as a bookkeeper in a bank, but gratified his taste for history and literature and the company of learned men by being active in the Franklin Society, the Rhode Island Historical Society, and the Providence Athenaeum. His scholarly interests, including extensive study of the language and customs of North American Indians, were continued after 1836 in New York City where with a partner he operated a bookstore catering to the city's literati. In 1850, through influential friends, he was appointed United States Boundary Commissioner and for three years traveled in the Southwest, Mexico, and California, engaged in the United States-Mexican Boundary Survey. In 1854 Bartlett returned to private life and published a two-volume account of his travels and adventures. In his later years he served as librarian of the John Carter Brown Library in Providence, Rhode Island.

REFERENCES:

Bartlett, John Russell. Letterbooks, journal, paintings & drawings. John Carter Brown Library, Providence, Rhode Island.

Bartlett, John Russell. *Personal Narrative of Explorations and Incidents in Texas, New Mexico, California, Sonora, and Chihuahua. Connected with the United States and Mexican Boundary Commission*. New York: D. Appleton, 1854.

Faulk, Odie B. *Destiny Road. The Gila Trail and the Opening of the Southwest*. New York: Oxford University Press, 1973.

Hine, Robert V. *Bartlett's West. Drawing the Mexican Boundary*. New Haven: Yale University Press, 1968.

RICHARD BRYDGES BEECHEY (1808-1895), the third son of the portrait painter Sir William Beechey, was born in England on May 17, 1808. He entered the Royal Navy in 1824

and the next year sailed as midshipman and artist on the *Blossom*, commanded by one of his brothers Captain Frederick William Beechey, on a voyage to Bering Strait. He executed water color paintings of the San Francisco and Monterey areas during the winter layover of 1826-1827. From 1835 to 1857 he was engaged in naval surveys of the River Shannon, Cork Harbour, and the west coast of Ireland. During his active naval career and after retirement he exhibited paintings at the Royal Academy, the British Institution, and the Society of British Artists. He retired from the navy in 1870 with the rank of captain, later being promoted to admiral. His residence was at Plymouth, England, where he died on March 8, 1895.

REFERENCES:

Bénézit, E. *Dictionnaire Critique et Documentaire des Peintres, Sculpteurs, Dessinateurs et Graveurs*. Paris: Librarie Gründ, 1961.

Geographical Society *Proceedings*, vol. 22, 1878.

Grant, Maurice Harold. *A Dictionary of British Landscape Painters, from the 16th century to the early 20th century*. London: F. Lewis, 1952.

Hydrographic Department, Office of the Admiralty, London. Letter written by the Hydrographer to Miss Edith M. Coulter, May 24, 1938. In the Jeanne Van Nostrand Archives of California Artists.

Illustrated London News, April 20, 1895.

London *Times*, March 12, 1895.

The Mitchell Library of New South Wales, Melbourne, Australia. Card catalog & clipping file.

O'Byrnne, William R. *A Naval Biographical Dictionary*. London: John Murray, 1849.

MARY PARK SEAVY BENTON (1815-1910), one of the first (if not *the* first) woman artists of California, was born in Boston on August 10, 1815. At the age of eight she registered in a drawing school and from then until her death at age ninety-five painted and taught art. In 1855 she left New York where she had been painting and teaching to join her husband, the Reverend John Elliot Benton, who had gone to San Francisco three years earlier. The Bentons made their home in Mission Valley near Reverend Benton's church, the completion of which Mrs. Benton helped finance by giving drawing lessons. She was put in charge of drawing in the San Francisco public schools; her students exhibited their work along with that of their teacher at the annual fairs held by the California State Agricultural Society and the Mechanics' Institute. The Bentons moved in 1861 to Reverend Benton's new pastorate at Folsom and from there in 1867 to Oakland, where Mrs. Benton became a teacher of drawing at the City Female Seminary. In 1889 she and her daughter May, also an artist, went to Europe to study the famous drawings in the Royal Library at Dresden. Upon returning to California Mrs. Benton continued to maintain a home and studio in Oakland and to teach art. She died in Oakland on December 6, 1910. She is represented at the California Historical Society by a large oil, "Mission Valley."

REFERENCES:

California State Agricultural Society. *Transactions*. Sacramento: State Printer, 1859, 1860, 1866.
Hesperian, vol. 1, September 15, 1858, p. 152; October 1, 1858, pp. 166–167.
Mechanics' Institute and Library of San Francisco. *Industrial Exhibition Reports,* 1858, 1859, 1871.
Oakland *Tribune,* December 8, 1910, obit.
Sacramento *Union,* September 20, 1859.
San Francisco *Alta California,* September 24, 1857; October 4, 1858.
San Francisco *Chronicle,* October 15, 1928.
San Francisco City Directories, 1856, 1858.

ALBERT BIERSTADT (1830-1902), born at Solingen, Germany, was brought to America by his parents when a small child and reared in New Bedford, Massachusetts. As a very young man he gave drawing lessons and in 1853 returned to Germany to study art. After four years of study and travel Bierstadt returned to New Bedford to continue his career as a landscape artist. His travels to the American West began in 1859 when he joined Colonel Frederick W. Lander's expedition across the Rocky Mountains. The landscapes which Bierstadt produced from sketches taken on that trip brought him instant recognition; a year later he was elected a member of the National Academy of Design in New York. On a second western journey made by overland stage in 1863, Bierstadt arrived at San Francisco in April and remained on the Pacific Coast until November, visiting Yosemite, Tahoe, Mount Shasta, and Oregon. Upon returning East he worked up his sketches into the finished paintings that established his reputation as the foremost artist of California's spectacular scenery. Bierstadt came to California again in 1871 and for two and a half years kept a studio in San Francisco. From that base he made trips to the high country, the big trees, the Mount Whitney area, and Yosemite. The artist's final visit to California in 1880 was a stopover on the way to the Northwest and Alaska.

REFERENCES:

The Crayon, vol. 6, September 1859, p. 287.
Ewers, John C. *Artists of the Old West.* Garden City, New York: Doubleday & Co., 1965, p. 174.
Hendricks, Gordon. *A. Bierstadt.* Fort Worth: Amon Carter Museum of Western Art, 1972.
———"The First Three Western Journeys of Albert Bierstadt." *The Art Bulletin,* vol. 46, September 1964, pp. 333–365.
Neuhaus, Eugen. *History and Ideals of American Art.* Stanford: Stanford University Press, 1931, p. 83.
San Francisco *Alta California,* September 16, 1863; January 19, 1864; August 1, 3, 1871.
Santa Barbara Museum of Art. *A Retrospective Exhibition, Albert Bierstadt, 1830–1902, introduction by Thomas W. Leavitt.* Santa Barbara: The Museum, 1964.

WILLIAM PHIPPS BLAKE (1825-1910), was born in New York City on June 21, 1825. He attended private schools and in 1852 graduated from Yale University's Sheffield Scientific School with a major in chemistry. From 1854 to 1856 he served as geologist with Lieutenant Robert S. Williamson's Pacific railway survey in California. For the next thirty-five years he held various important national and international positions as mineralogist, geologist, chemist, and teacher, and in 1895 became director of the School of Mines at the University of Arizona, an office he retained until 1905. He died at Berkeley, California, on May 31, 1910, a few days after having received an honorary degree from the University of California.

REFERENCES:

Arizona University. *The Published Writings of William Phipps Blake, with an Introduction by Kendrick Charles Babcock*. Tucson: University of Arizona Press, 1910.
Dictionary of American Biography. New York: C. Scribner's Sons, 1928–1936.
National Cyclopedia of American Biography. New York: J. T. White & Company, 1892–1933.
Peters, Harry Twyford. *California on Stone*. Garden City, New York: Doubleday, Doran, 1935, p. 59.
Taft, Robert. *The Pictorial Record of the Old West. XIV. Illustrators of the Pacific Railroad Reports*. Reprinted from the Kansas Historical *Quarterly*, November 1951, pp. 362–363.

HIRAM REYNOLDS BLOOMER (1850-1911), was brought from New York to San Francisco by his parents in 1852. While still very young he studied landscape and portrait painting in San Francisco under Thomas Hill, Stephen W. Shaw, and Virgil Williams, and from 1874 to 1892 he studied and painted in New York City and Europe. He returned to San Francisco as a recognized artist and until 1911 was active in his profession. He was a member of the San Francisco Art Association and of the Bohemian Club. After 1901 he made his home in Marin County, the locale of many of his later landscapes. His death occurred on June 3, 1911, as the result of a streetcar accident.

Various birth dates and given names have been assigned to this artist. The California State Board of Health record omits any first name and gives his birth year as 1850. The "H." is seen variously as Henry, Harry, and Hiram.

REFERENCES:

California Art Gallery, vol. 1, January 1873, p. 5.
California State Library. *News Notes of California Libraries*, vol. 3, January–October, 1908.
Champlin, John D. *Cyclopedia of Painters and Paintings*. New York: Scribner, 1886.
The Oakland Museum Art Department. Archives of California Art.
Overland Monthly, vol. 11, November 1873, p. 478.
San Francisco *Alta California*, September 10, 1874.
San Francisco *Call*, September 17, 1905.

JOHN DAVID BORTHWICK (1825-1900[?]), one of Dr. George Borthwick's two sons, was born at Edinburgh, Scotland. John David and his brother George attended the Edinburgh Academy where they were outstanding scholars and winners of scholarship prizes. Their home was next door to that of the artist George Inness and not far from the residence of a portrait painter named John Borthwick, probably a kinsman. Young John David may have received art instruction from one or both of those Edinburgh artists. John David's later success as a portraitist, genre, and landscape painter, and his membership in the Royal Academy, clearly indicates not only native talent but expert instruction.

John David Borthwick went to America in the mid-1840's and in 1851 left from New York for the California gold fields. From 1851 to 1854 he visited many of the California mining camps and outlying towns. From California he went to Nicaragua and thence to Australia. After 1860 his residence was in London where he pursued an active art career. He is believed to have died in England in 1900. He is represented by pencil sketches at the California Historical Society, and by an oil painting, "Interior of a Miner's Cabin," at the Society of California Pioneers.

REFERENCES:

Edinburgh Academy. *Register. A Record Since its Foundation in 1824.* Edinburgh: The Academy, 1914.
Edinburgh Post Office Directory 1826–1827; 1839–1840. Edinburgh: Ballantyne, 1839.
Graves, Algernon. *The British Institution, 1806–1867.* London: George Bell & Company, 1908.
———*Dictionary of Artists who have Exhibited in the Principal London Exhibitions from 1760 to 1893.* London: Henry Graves & Company, 1901.
———*The Royal Academy of Arts. A Complete Dictionary of Contributors and their Works from its Foundation in 1769 to 1904.* London: Henry Graves, 1905–1906.
Hutchings California Magazine, vol. 2, July 1857, p. 76.
Penny Magazine (London), December 5, 1840, pp. 477–478.

SAMUEL MARSDEN BROOKES (1816-1892), 'rose from the ranks,' as it were, to become one of the leading exponents of still-life painting in nineteenth century America.

Born in England on March 8, 1816, Samuel received his education in an English boarding school. In 1833 he came with his parents to America, to Fort Dearborn. He showed a fondness for drawing and after moving to Milwaukee in the early 1840's took some lessons in painting from two itinerant portrait painters, his only formal instruction of record. He spent the year 1845 in England studying at the National Gallery and at Hampton Court. Upon returning to Milwaukee, where he remained for the next fifteen years, he engaged in painting portraits, a number of which were commissioned by the Wisconsin Historical Society. In 1862 Brookes settled in San Francisco to continue his art career. He became the principal promoter of an art union and a regular exhibitor of portraits and still-life paintings

at the Mechanics' Institute Fairs. In 1871 he helped organize the San Francisco Art Association. He remained active in his profession into the 1880's, although his output diminished after 1881. His death occurred on January 31, 1892.

In their day, Brookes's still-life paintings were much admired and sold for high prices. His most famous one was "The Peacock," for which Mrs. Mark Hopkins gave him one thousand dollars with an additional thousand to show her appreciation of the work.

REFERENCES:

Arkelian, Marjorie. *The Kahn Collection* . . . Oakland: The Oakland Museum, 1974, pp. 13–14.
Gerdts, William H. and Burke, Russell. *American Still Life Painting*. New York: Praeger, 1971, pp. 128–129.
Marshall, Lucy Agar. "Samuel Marsden Brookes." California Historical Society *Quarterly*, vol. 36, September 1957, pp. 193–203.
"Samuel Marsden Brookes." *California Art Gallery*, vol. 1, May 1873, pp. 67–68.

NORTON BUSH (1834-1894), became California's most successful painter of tropical scenery during the 1860's and 1870's when views of exotic regions of the world were at the zenith of their popularity.

Born in Rochester, New York, on February 22, 1834, Norton Bush received art instruction while in his early teens, first from a local artist, James Harris, and then from Jasper F. Cropsey in New York City. In 1851 a painting by the young student was exhibited at the National Academy of Design, but in 1853, despite this auspicious start on a successful career at home, Bush departed for California. He crossed Central America by the Nicaragua route, sketching along the way the tropical scenery that would later be the subject of his most popular paintings. At San Francisco he worked at various jobs to support himself while he strove to improve his artistic ability. In 1857 he exhibited an oil painting of Mount Diablo that not only won a premium at the Mechanics' Institute Fair but also established Bush as an amateur of great promise. From then on he regularly exhibited his works at the various fairs and soon rose to professional stature. In 1875 he made a trip to South America and returned to San Francisco with additional sketches for tropical views. He served as a director of the San Francisco Art Association 1878-80, and in 1893 had charge of the California art gallery at the Columbian Exposition in Chicago. He died of a heart attack on April 14, 1894.

REFERENCES:

California State Library. *News Notes of California Libraries*, vol. 3, January–October, 1908.
Catalogue of Paintings in E. B. Crocker Art Gallery. Sacramento, California: E. B. Crocker Art Gallery, 1905.
Catalogue of the Mark Hopkins Institute of Art. San Francisco: San Francisco Art Association, 1902, p. 34.

Fletcher, Robert H. "Memorandum of Artists, 1906." (Typescript.) In the California State Library, California Section.
Hesperian, vol. 1, October 1, 1858, pp. 166–167.
Sacramento *Record-Union*, April 25, 1894.
The Wave, vol. 7, October 31, 1891, p. 6.

FREDERICK A. BUTMAN (1820-1871), was born at Bangor but grew up in Gardiner, Maine, where in 1843 he married and started raising a family. Sometime between 1849 and 1856, while keeping an apothecary shop in Gardiner, he began to paint, possibly without formal instruction. His earliest works were figure pieces but he soon turned to landscape painting. In 1857 he went to California where he became the first resident artist of San Francisco to paint landscapes exclusively. In 1860 he made an extensive sketching trip to remote parts of California and into Oregon. From 1866 to 1869 he was in Europe, sketching. Upon returning to the United States he paid a short visit to Gardiner before continuing to California. In 1871, while on a visit to Gardiner, he suddenly became ill and died there on July 26, 1871.

During his California years Butman produced some eighty oil paintings. He is represented at the California Historical Society by two historically important landscapes, "Chinese Fishing Village Rincon Point 1859," and "Hunter's Point" (ca. 1859).

REFERENCES:

California State Library. *News Notes of California Libraries*, vol. 3, January–October, 1908.
Catalogue of Special & Peremptory Sale of Fifty Elegant Oil Paintings to be sold without reserve Friday morning, February 16, 1866. San Francisco: H. M. Newhall & Company, Auctioneers, 1866.
Hittell, John S. "Art in San Francisco." *The Pacific Monthly*, vol. 10, July 1863, p. 105.
Kennebec *Reporter*, July 26, 1871.
San Francisco *Alta California*, October 30, 31, December 11, 1859; September 2, 1860; September 26, 1862; December 29, 1865; October 28, December 28, 1867; November 24, 1869; February 16, April 3, 24, July 10, October 10, 1870; January 15, February 19, 22, August 16, 1871.

JOSÉ CARDERO (1768-?), a self-taught artist-sailor, was born in Andalusia, Spain. He joined the Spanish navy and in 1788 sailed from Cadiz as a member of the crew of the Alejandro Malaspina expedition. On the voyage from Cadiz to Acapulco, Mexico, Cardero executed a series of sketches of South American ports, and at Acapulco became an unofficial artist of the Malaspina expedition. His success as an expeditionary artist led to his appointment as artist-cartographer of the Alcalá Galiano and Valdés voyages of exploration. After a temporary residence in Mexico Cardero returned to Cadiz, where he became a bookkeeper in the Spanish Navy Department.

REFERENCES:

"The Art of the Malaspina Expedition of 1791–1792." Oakland Art Museum *Monthly Bulletin,* June 1960.

Cutter, Donald C. "Early Spanish Artists on the Northwest Coast." *Pacific Northwest Quarterly,* vol. 54, October 1963, pp. 11, 150–155.

————*Malaspina in California.* San Francisco: John Howell–Books, 1960, passim.

Fernandez, Justino. *Tomás de Suría y su viaje con Malaspina, 1791.* Mexico, D.F.: Libraria de Porrua Hermanos y cia, 1939, p. 16.

Museo Naval, Madrid, Spain. Archives.

Van Nostrand, Jeanne. *A Pictorial and Narrative History of Monterey, Adobe Capital of California 1770–1847.* San Francisco: California Historical Society, 1968.

Wagner, Henry R. "Four Early Sketches of Monterey Scenes." California Historical Society *Quarterly,* vol. 15, September 1936, pp. 213–215.

————"Journal of Tomás de Suría of His Voyage with Malaspina to the Northwest Coast of America in 1791." *Pacific Historical Review,* vol. 5, September 1936, pp. 234–276.

SOLOMON NUNES CARVALHO (1815-1897), of Sephardic Jewish descent, was born in 1815 at Charleston, South Carolina. While still quite young he began painting crayon portraits and by 1838 was established as an artist in Philadelphia, a painter of landscapes and portraits. He was of an inventive turn of mind and while working at Baltimore from 1850 to 1853 perfected the enamel daguerreotype.

In 1853 Frémont engaged Carvalho as artist-daguerreotypist to accompany his fifth expedition which was then preparing for a journey across the West to locate a feasible route for a railroad to the Pacific Coast. Carvalho filled the position as far as the Mormon settlement where he had to drop out because of illness. Three months later he took Frémont's 1843 route into Southern California. He was in California during 1854, first painting portraits and operating a daguerrean studio at Los Angeles and then at San Francisco. He returned East in 1855 and pursued a three-sided career as portraitist, daguerreotypist, and inventor. His last years were spent in New York City where he was listed in the directories as "President of the Carvalho Heating and Super-Heating Company."

REFERENCES:

Korn, Bertram Wallace. *Introduction to S. N. Carvalho's Incidents of Travel and Adventure in the Far West . . .* Philadelphia: The Jewish Publication Society of America, 1954, pp. 14–16.

Los Angeles *Star,* July 3, 8, 1854; August 24, 1854.

New York City Directories 1864–1893.

Pioneer, vol. 2, December 1854, p. 376.

Sturhahn, Joan. *Carvalho. Artist-Photographer-Adventurer . . .* Merrick, New York: Richwood Publishing Company, 1975.

Taft, Robert. *Artists and Illustrators of the Old West, 1850–1900*. New York: Charles Scribner's Sons, 1953, pp. 262, 274.

———*Photography and the American Scene*. New York: Macmillan, 1938, pp. 262–266.

LOUIS (Ludwig, Ludovik or Login) ANDREVITCH CHORIS (1795-1828), artist-naturalist, was born at Yekaterinoslaf, Ukraine, of German-Russian parentage. He studied art at Moscow and traveled in the Caucasus as artist-naturalist for the botanist Marshall von Biederstein. In 1815 he was appointed official artist of the South Seas expedition commanded by Otto von Kotzebue which visited San Francisco in 1816. At the conclusion of the voyage Choris went to Paris, studied lithography, and published *Voyage Pittoresque Autour du Monde* (1822), and *Vues et Paysages des Regions Equinoxiales* (1826), illustrated with lithographic reproductions by his hand, from his own paintings. Intending to continue his travels as an artist-naturalist, Choris left France on a projected trip through Central America. From New Orleans he went to Vera Cruz to begin the journey across Mexico, but when only a few miles on the road he was robbed and killed, on March 22, 1828.

REFERENCES:

Bishop Museum, Honolulu, Hawaii. Choris folder.

Catalogue of Paintings, Drawings and Watercolors in the Robert B. Honeyman, Jr., Collection. Compiled by Joseph Armstrong Baird, Jr. Berkeley: The Friends of the Bancroft Library, University of California, Berkeley, 1968, pp. 11–12.

Choris, Louis. *Voyage Pittoresque Autour du Monde*. Paris: Firmin Didot, 1822.

Choris, Louis. *San Francisco One Hundred Years Ago*. Translated by Porter Garnett. San Francisco: A. M. Robertson, 1913, pp. i-v.

Mahr, August C. *The Visit of the "Rurik" to San Francisco in 1816* . . . Palo Alto: Stanford University Press, 1932.

Nouvelle Biographie Génerale . . . Paris: Firmin Didot, 1868.

WILLIAM COGSWELL (1819-1903), was born at Fabius, New York, on July 19, 1819. In 1834 he became a helper in the studio of a portrait painter in Buffalo, and during that employment may have taught himself how to paint likenesses. For several years he was an itinerant portrait painter, moving from city to city on the East Coast and in the Middle West. In 1849 he went to California and remained a year engaged in painting portraits as well as the scenes for a gigantic panorama which he exhibited with great success in the East. He returned to San Francisco in 1871 and became active in the organization of the San Francisco Art Association. After 1873 Cogswell made his home in Southern California and was the founder of the Sierra Madre Villa. He died in Pasadena on December 24, 1903.

Cogswell painted many notable California and national personages, his best known work being a portrait of President Lincoln, which now hangs in the White House.

REFERENCES:

Art Digest, vol. 16, November 15, 1941, p. 29.

California Courier, November 1, 1850.

California State Library. California Section. Artist Information File.

Fairman, Charles E. *Art & Artists of the Capitol of the United States of America*. Washington, D.C.: Government Printing Office, 1927, p. 355.

Pasadena *Evening Star*, December 24, 1903.

San Francisco *Alta California*, August 12, 1871.

San Francisco *Chronicle*, December 25, 1903.

Society of California Pioneers *Quarterly*, vol. 8, 1931, p. 141; vol. 10, 1933, p. 111.

Worden, Perry. "A California Limner of Lincoln." Pasadena *Star News*, February 7, 1942.

GEORGE VICTOR COOPER (1810-1878), was born on January 12, 1810, at Hanover, New Jersey. When only fifteen years old he began studying painting in New York City under Samuel F. B. Morse. By 1844 he was well established as a painter, lithographer, sculptor, and cameo cutter. In January, 1849, he went to California with John M. Letts and spent that summer prospecting and sketching at various mining locations. Letts returned to New York in December, 1849, and in 1852 published an account of his first-hand experiences under the title, *California Illustrated* . . . Forty-eight of Cooper's drawings were reproduced in the book.

Cooper is believed to have remained in California until 1852, possibly until 1853, afterwards resuming his art career in New York. While stationed in Washington, D.C. during the Civil War he painted a portrait of President Lincoln, from life. The artist died in New York City on November 12, 1878. His paintings and drawings that were in his possession at the time of his death were inherited by his wife, Caroline E. Cooper. They have since dropped from sight.

REFERENCES:

Frick Art Reference Library, New York City. Biographical information furnished by Ella M. Cooper in 1932.

Letts, John M. *California Illustrated Including a Description of the Panama and Nicaragua Routes. By a Returned Californian*. New York: William Holdredge, 1852.

Literary World, vol. 9, June 5, 1852, p. 389.

Mallett, Daniel Trowbridge. *Mallet's Index of Artists* . . . New York: Peter Smith, 1948.

New York *Herald*, November 14, 1878.

Peters, Harry Twyford. *California on Stone*. Garden City, New York: Doubleday, Doran, 1935, pp. 10, 147.

Stevens, Harry M. *Old Guard of the City of New York Souvenir*. New York: Harry M. Stevens, 1906.

Wilson, Rufus Rockwell. *Lincoln in Portraiture*. New York: The Press of the Pioneers Inc., 1935, p. 275.

WILLIAM ALEXANDER COULTER (1849-1936), was born on March 7, 1849, at Glengarriff, County Cork, Ireland. In his early teens his love of the sea induced him to sign on an Irish brig as galley and cabin boy. While at sea during the next several years Coulter spent much of his spare time painting, using bits of sailcloth and colors from the ships' stores. When twenty years old he found himself in port at San Francisco. Having decided to quit the sea to become an artist he found employment as a sailmaker and lived in a sail loft where after hours he painted on scraps of old canvas. Some of his early paintings sold for $25 each; others brought as much as $100. Encouraged by this initial success, Coulter was soon on his way to Europe to study art. In 1874 (1875?) he returned to San Francisco and began painting marines. During the 1890's and early 1900's, while on the staff of the San Francisco *Call*, he turned out an almost daily pen and ink sketch for the marine section of the paper.

After a visit to Ireland in 1930 Coulter theoretically retired, but actually continued to paint until shortly before his death on March 13, 1936. One of Coulter's most spectacular canvases is a view of "San Francisco Burning, April 18, 1906," now hanging in the San Francisco Commercial Club.

REFERENCES:

California Historical Society. Card catalog.
Lloyd, Benjamin E. *Lights and Shades in San Francisco*. San Francisco: Bancroft & Company, 1876, p. 419.
The Oakland Museum. Art Department. Archives of California Art.
Perret, Ferdinand. (Card catalog.) *The California Section of the Ferdinand Perret Research Library of the Arts and Affiliated Sciences*. Compiled in Los Angeles, 1936–1942.
San Francisco *Call*, August 15, 1899.
San Francisco Mechanics' Institute and Library. *Industrial Exhibition Report*, 1894.

EDWIN DEAKIN (1838-1923), was fascinated by California's twenty-one missions as subjects for paintings. He first saw them in 1870, long after they had fallen into ruin. Deeply moved by these romantic relics of Spanish-California, Deakin spent the better part of the years from 1874 to 1890 painting in oils and water colors each mission as it had appeared originally.

Edwin Deakin was born on May 21, 1838, at Sheffield, England. Although frequently labelled self-taught, his early education may have included training in art. In 1856 the Deakin family settled in Chicago where Edwin began an art career. In 1870 he established a home and studio in San Francisco where he lived and worked until he moved to Berkeley in 1891. He was active in his profession almost to the time of his death on May 11, 1923. His well-known mission paintings overshadow his equally deserving landscapes of California, Nevada, and San Francisco.

REFERENCES:

Bird, Pauline R. "Painter of California Missions." *The Outlook*, vol. 76, January 1904.

Deakin, Edwin. *The Twenty-One Missions of California*. Berkeley: Edwin Deakin, 1899.

Gerdts, William H. & Burke, Russell. *American Still-Life Painting*. New York: Praeger Company, 1971.

Los Angeles County Museum of Natural History, History Division. *A Gallery of California Mission Paintings by Edwin Deakin*. History Division Bulletin Number 3. Produced by the staff of the History Division, Ruth I. Mahood, editor, with additional texts by Paul Mills and Donald C. Cutter. Los Angeles: The Ward Ritchie Press, 1966.

The Oakland Museum. Art Department. Archives of California Art.

San Francisco *Call*, July 12, 1908.

San Francisco *Chronicle*, May 27, 1923.

Swingle, John. *Edwin Deakin 1838–1923. An Exhibition. Paintings & Sketches, April 22–May 11, 1963*. Berkeley: Tamalpais Press, 1963.

GIDEON JACQUES DENNY (1830-1886), of Milwaukee, Wisconsin, joined the Gold Rush to California in 1849, but instead of going on to the mines from San Francisco he stayed in the city for two years working as a waterfront teamster. It was not until the mid-fifties, after studying art in Milwaukee under Samuel Marsden Brookes, that he returned to San Francisco as a painter of marines, landscapes, and portraits. In 1862 he was joined by Brookes, and the two artists shared a studio on Bush Street. In 1865 Denny cooperated with Brookes in promoting the first art union in San Francisco.

During the sixties and seventies Denny's marine paintings were extremely popular. One of his most notable successes was his painting for the drop curtain of the California Theatre. The scene represented the clipper ship *Western Continent* entering the Golden Gate, so true to life that the audience, many of whom had known the ship in Gold Rush days, burst into shouts and applause. The twenty-five panel paintings on the ferry boats *Newark* and *Bay City* were from his brush. His painting of the schooner yacht, the *Casco*, which hung for many years in the Ferry Building, was later added to the paintings in the salon of the *Bay City*.

Except for brief travels (Hawaii, Canada, South America), Denny lived in San Francisco from about 1855 until his death at Cambria, California, on October 7, 1886.

REFERENCES:

The Call Supplement, October 9, 13, 1886.

California State Library. California Section. Letter written by Carrie Denny, San Francisco, June 18, 1932.

Catalogue of the Mark Hopkins Institute of Art. San Francisco: San Francisco Art Association, 1901, 1902.

Comstock, Sophie P. "Painters of Northern California." Lecture read before the Kingsley Art Club,

E. B. Crocker Art Gallery, Sacramento, California, March 15, 1909.
San Francisco *Alta California*, February 16, 1860; April 11, 1864; December 9, 1868; April 11, August
 2, 1869; April 24, May 5, July 10, 1870; February 16, 18, 25, July 6, September 15, 1871; Novem-
 ber 11, 1874; December 7, 1877; May 28, 1883.
San Francisco *Bulletin*, October 9, 1886. obit.

FERDINAND DEPPE, a German horticulturist and amateur artist, made at least six trips to California between 1828 and 1836 in the employ of Heinrich Virmond, a German trader with headquarters in Mexico City and Acapulco. Deppe left California for the last time on the *Rasselas*, bound for Hawaii and the Orient. Eventually returning to his home near Charlottenburg, Germany, he devoted himself to horticulture. There is presently no further information about him except that in 1873 he wrote a letter to a California friend, David Spence. Deppe is mentioned in the writings of Alfred Robinson and Edward Vischer.

REFERENCES:

Bancroft, Hubert H. *California Pioneer Register and Index 1542–1848* . . . Baltimore: Regional Publishing
 Company, 1964, p. 119.
Lichtenstein, Hinrich. *Ferdinand Deppe's Travels in California in 1837* . . . Translated from the German
 by Gustave O. Arlt. Los Angeles: Dawson, 1953.
Ogden, Adele, ed. "Business Letters of Alfred Robinson." California Historical Society *Quarterly*,
 vol. 23, December 1944, p. 333.
Robinson, Alfred. Statement of recollections on early years in California made by Alfred Robinson,
 1878, for The Bancroft Library. In The Bancroft Library.
San Francisco *Bulletin*, October 15, 1860.
Thieme, Ulrich, and Becker, Felix. *Allegemeines Lexikon der Bildenden Künstler von der Antike bis zur
 Gegenwart*. Leipzig: Verlag von E. A. Seemann, 1913, p. 90.

JOSEPH DRAYTON (), whose engravings appeared in the *Analectic Magazine* in 1819 and 1820, was then established as an artist-engraver in Philadelphia. In 1838 he joined the Charles Wilkes expedition as one of the official artists. Jessie Poesche, in her biographical research on Titian Ramsay Peale, suggests that after the return of the expedition Drayton became an assistant, or agent, for Wilkes during the preparation of the various journals for publication.

REFERENCES:

Analectic Magazine (Philadelphia), vols. 14–15, 1819–1820.
Groce, George C. and Wallace, David H. *New-York Historical Society's Dictionary of Artists in America
 1564–1860*. New Haven: Yale University Press, 1957.
Hamilton, Sinclair. *Early American Book Illustrators and Wood Engravers 1670–1870*. Princeton: Prince-
 ton University Press, 1958, p. 120.

New York Public Library *Bulletin,* vol. 45, October 1941, pp. 824–825.

Philadelphia City Directories, 1820–1835.

Poesch, Jessie. *Titian Ramsay Peale, 1799–1885, and his Journals of the Wilkes Expedition.* Philadelphia: The American Philosophical Society, 1961, p. 98.

EMIL DRESEL (1819-1869), was born in Wiesbaden, Germany. He became an architect and was assistant city architect of Wiesbaden when he left Germany for the United States to join an older brother at Sisterdale, Texas. The gold excitement in California induced Emil and five or six other young adventurers to make a dash from Sisterdale for the mines, on horseback. After a short time spent mining Emil settled in San Francisco as an architect. In 1853 he joined C. C. Kuchel in the lithography business. Kuchel and Dresel, as the firm was known, turned out a great volume of work over the next several years, the crowning achievement being a remarkable set of thirty-six views based chiefly on sketches Dresel had made in 1856 during a tour of the state. About 1858 Dresel bought land in Sonoma County and became one of California's pioneer vineyardists, superintending his own vineyard and two others. He died very suddenly in July, 1869, at San Francisco.

REFERENCES:

Coville, Samuel. *Coville's San Francisco Directory.* San Francisco: Samuel Coville, 1856.

Groce, George C. and Wallace, David H. *New-York Historical Society's Dictionary of Artists in America 1574–1860.* New Haven: Yale University Press, 1957.

Moure, Nancy Dustin. *Dictionary of Art & Artists in Southern California before 1930.* Research assistance by Lyn Wall Smith; introduction by Carl Schaefer Dentzel. Los Angeles: Privately Printed, 1975.

Peters, Harry Twyford. *California on Stone.* Garden City, New York: Doubleday, Doran, 1935, pp. 141–151, 258.

San Francisco *Alta California,* September 6, December 28, 1857; January 10, February 3, 1858; August 7, 1859; August 3, 1863; July 29, 1869.

Watson, Douglas S. *California in the Fifties. Fifty Views . . . by Kuchel and Dresel.* San Francisco: J. Howell, 1936.

GASPARD DUCHÉ DE VANCY (-1788), was with the first foreign voyager to touch the California coast after the Spanish occupation and was the first professional artist known to have painted a California scene. Duché De Vancy, a French artist-engraver, whose paintings and engravings were known throughout Europe, was selected in 1785 by the French Controller General of France to be one of the artists of the Lapérouse expedition. His assignment was to depict places and ports on the route of the two expeditionary vessels, the *Boussole* and the *Astrolabe.* At Monterey Bay in 1786 De Vancy painted the scene of welcome to Lapérouse that took place at Mission San Carlos de Borromeo. Other views by Duché De Vancy, of the Northwest Coast, were dispatched by messenger to France from Kam-

chatka and appeared later in the published account of the voyage. In 1788, while in the South Seas, the entire expedition was lost.

No views of California are known to have been included in the Kamchatka package.

REFERENCES:

Bénézit, E. *Dictionnaire Critique et Documentaire des Peintres, Sculpteurs, Dessinateurs et Graveurs*. (Nouvelle edition). Paris: Librarie Gründ, 1961.

Buck, Peter H. "Explorers of the Pacific." Bishop Museum *Special Publication #43*. Honolulu: The Museum, pp. 54–55, 95–97.

Catalogue of Engraved British Portraits in the British Museum. London: The British Museum, 1912, vol. 3, p. 105.

Delingnieres, E. "Note sur Gaspard Duché de Vancy." *Rèun. de Societé des Beaux-Arts, 1900*.

Gazette des Beaux-Arts, vol. 1, 1905, p. 463.

Lapérouse, Jean François Galaup de. *Voyage Autour du Monde* . . . Paris: Imprimerie de la République, 1797.

Lebel, Gustave. "Bibliographie des revues et periodiques d'art parus en France 1746 a 1914." *Gazette des Beaux-Arts*, vol. 38, January–March, 1951.

Wagner, Henry R. "Four Early Sketches of Monterey." California Historical Society *Quarterly*, vol. 15, September 1936, pp. 213–215.

AUGUSTE BERNARD DUHAUT-CILLY (1790-1849), navigator and draughtsman, was born at St. Malo on March 26, 1790. His naval career began in 1807 with action against the British. He left the navy to become a captain in the merchant marine. After making several voyages to the French colonies in South America and in Central America he took command of *L'Heros*, and was dispatched in April, 1826 on a world trading voyage. His route brought him into California ports in 1827 and 1828. Upon returning to France Duhaut-Cilly settled at St. Sevran, where for a number of years he served as town mayor. He died of cholera at St. Sevran on October 26, 1849.

REFERENCES:

Auguste Bernard Duhaut-Cilly. (Pamphlet.) Paris: Bibliothèque Nationale, n.d.

Buck, Peter H. "Explorers of the Pacific." Bishop Museum *Special Publication #43*. Honolulu: The Museum, pp. 84–85.

Duhaut-Cilly, Auguste Bernard. *Voyage autour du monde, principalement à la Californie et aux Iles Sandwich, pendant les années 1826, 1827, 1828, et 1829*. Paris: Arthus Bertrand, 1834–1835.

Thompson, Robert A. *The Russian Settlement in California*. Santa Rosa: Sonoma Democrat Publishing Company, 1896, pp. 9, 15, 17.

HARRISON EASTMAN (1822-1890 or 1891), was born in 1822 at Concord, New Hampshire. Nothing is known of his youth, but it is believed that he received some local instruction in

art. The earliest information about him concerns his preparations in December, 1848, to join the Gold Rush to California. On Christmas Day he and fifteen young friends formed the Shawmut and California Company and with thirty-five hundred dollars of mutual funds purchased the brig *Rudolph*. On February 18, 1849, they sailed from Boston, arriving at San Francisco on September 16. The company promptly disbanded, each member going to the mines on his own. Eastman soon returned to San Francisco where he became a clerk in the post office. He worked after hours at engraving and lithography for various publishers. In 1852 he opened his own engraving and lithography business and for forty years flourished in those two art fields. He also painted in water colors and oils, specializing after 1860 in marines. Outstanding among the latter is "The Viscata Ashore in the Golden Gate," a watercolor painted in 1868 (in The Bancroft Library). Except for a visit to the Pacific Northwest in 1874, Eastman lived and worked continuously in San Francisco until his death in either 1890 or 1891.

REFERENCES:

Avery, Benjamin P. "Art Beginnings on the Pacific." *Overland Monthly*, vol. 1, August 1868, p. 115.
California State Census, vol. 7, 1852, p. 123.
California State Library. California Section. Artist Information File.
Catalogue of Original Paintings, Drawings and Watercolors in the Robert B. Honeyman, Jr., Collection. Compiled by Joseph Armstrong Baird, Jr. Berkeley: The Friends of The Bancroft Library, University of California, Berkeley, California, 1968, pp. 19–20.
Cornelius, Brother F. S. C. *Keith, Old Master of California.* New York: G. P. Putnam's Sons, 1942.
Eastman, Harrison. Sketchbook. In The Bancroft Library.
Great Register of Voters. San Francisco, 1866, 1872, 1876.
The Oakland Museum. Art Department. Archives of California Art.

FREDERICK W. EGLOFFSTEIN (ca. 1824-1898), a native of Prussia, served as artist-topographer for Frémont's last expedition to the Rockies (1853-1854), and afterwards served in the same capacity on the western exploration conducted by Lieutenant Edward G. Beckwith (1855) and on that of Joseph C. Ives (1857). During the Civil War Egloffstein joined the 103rd Regiment of New York Volunteers. From 1864 to 1873 he lived in New York City where he perfected the half-tone process of engraving. Egloffstein died in London in 1898. A collection of his original drawings is in the Newberry Library, Chicago.

REFERENCES:

The Artist in the American West 1800–1900. Santa Fé, New Mexico: Fine Arts Museum of New Mexico, 1961.
Goetzman, William H. *Army Exploration in the American West 1803–1863.* New Haven: Yale University Press, 1959, pp. ix, 333–335.

Groce, George C. and Wallace, David H. *New-York Historical Society's Dictionary of Artists in America 1564–1860*. New Haven: Yale University Press, 1957.

Newberry Library, Chicago. Collection of original drawings by Frederich W. Egloffstein.

Report of the Secretary of War on the Several Pacific Explorations. Washington D.C.: Government Printing Office, 1855.

Taft, Robert. *Artists and Illustrators of the Old West 1850–1900*. New York: Charles Scribner's Sons, 1953, pp. 8, 31–34, 262 *et seq.*

PAUL EMMERT (1826-1867), was born near Berne, Switzerland, the fourth son of Professor Frederick and Fredrika Dann Emmert. While quite young he developed a talent for drawing and painting and a strong interest in travel. By his nineteenth year he was established in New York City as a painter. He became interested in panoramas and in 1849 sailed for California to take sketches for one depicting the gold mines. The completed panorama was first shown in March, 1850, at Brooklyn, New York. That same year Emmert returned to California to sketch and paint the scenes for another panorama; for a short time, while engaged in working on his panorama, Emmert operated the Bear Hotel in Sacramento. When completed, Emmert showed the panorama at various theatres in the interior and in May, 1852, put it on display at San Francisco. In February, 1853, he went to Honolulu where he sketched views of the town and harbor that were lithographed in 1854 by Britton and Rey of San Francisco. Except for a visit to California in 1854 and another in 1858, when he accompanied the biologist Professor C. A. Shelton as his artist, Emmert lived in Hawaii. He died in Honolulu on March 13, 1867.

REFERENCES:

Bancroftiana. Berkeley: The Friends of The Bancroft Library, #60, February 1975, p. 11.

Bishop Museum, Honolulu, Hawaii. Card catalog.

Delavan, James. *Notes on California and the Placers . . .* New York: H. Long and Brothers, 1850.

Hutchings California Magazine, vol. 3, October 1858, p. 176.

Placer Times, May 2, 1850.

San Francisco *Alta California*, May 6, 12, 1852; September 2, 1854.

CHARLES H. B. FENDERICH (fl. 1837-1873), was a Swiss portrait artist resident in the East during the years 1837 to 1848. According to J. Goldsborough Bruff, Fenderich's portraits of political celebrities of the time were widely known and his skill as a lithographer had long been recognized. Fenderich went overland to California with Bruff's Washington City Company in 1849. After a year's residence in San José, during which he suffered a severe illness and was once reported dead, he moved to San Francisco and commenced painting portraits of prominent citizens. A number of the portraits were based on photographs. John S. Hittell, writing in 1863, classified Fenderich as a crayon portraitist.

No further information about this artist is presently at hand except that in 1873 he exhibited portraits of Starr King and Joseph Libby Folsom at the San Francisco Art Association.

REFERENCES:

Bruff, J[oseph] Goldsborough. *Gold Rush: The Journals, Drawings, and Other Papers of J. Goldsborough Bruff, Captain, Washington City and California Mining Association, April 2, 1849–July 20, 1851*. Edited by Georgia Willis Read and Ruth Gaines. With a foreword by F. W. Hodge. California Centennials Edition. New York: Columbia University Press, 1949, *passim*.
Catalogue of the San Francisco Art Association, 1873.
Hittell, John S. "Art in San Francisco." *Pacific Monthly*, vol. 10, July 1863, pp. 105–106.
San Francisco *Alta California*, September 5, 1856.
Society of California Pioneers, San Francisco. Turrill catalogue, item 1256.

GEORGE HENRY GODDARD (1817-1906), for whom the second highest peak in the Sierra Nevada is named, was born in 1817 at Bristol, England. He attended Oxford and became an architect. Desirous of acquiring a quick fortune he sailed in 1850 for California and the gold mines. He intended to commence mining immediately but found himself obliged first to survey Frémont's Mariposa estate. After finishing the survey he mined at several locations, unsuccessfully. During these early years, however, he made dozens of sketches of towns, camps, and scenery for various lithographic firms. The pay was unsatisfactory and in 1853 Goddard concluded he could do better as a surveyor for government sponsored surveys sent out to locate practical wagon-roads over the Sierra Nevada and to establish the state's boundaries. Goddard prepared a map of California that was published by Britton & Rey in 1857. It was the most accurate and complete map yet to appear.

Goddard amassed a large collection of minerals and documents related to his career as a surveyor, civil engineer, cartographer, and artist. The collection burned in the 1906 fire, and Goddard, then ninety years old and broken in spirit, died a few months later at his home in Berkeley, on December 27, 1906.

REFERENCES:

Berkeley *Daily Gazette*, December 28, 1906.
Catalogues of the San Francisco Art Association, 1872, 1878, 1887.
Farquhar, Francis P. *Place Names of the High Sierra*. San Francisco: Sierra Club, 1926, pp. 32–33.
Goddard, George H. Letters. California State Library. California Section.
Hubbard Scrapbook. California Historical Society.
Sacramento *Bee*, August 15, 1942.
Shumate, Albert. *The Life of George Henry Goddard, Artist, Architect, Surveyor, and Map Maker*. Berkeley: The Friends of The Bancroft Library, University of California, 1969.

Van Nostrand, Jeanne and Coulter, Edith. *California Pictorial*. Berkeley: University of California Press, 1948, p. 128.

WILLIAM (KARL WILHELM) HAHN (1829-1887), a German artist whose genre paintings are recognized as among the finest produced in America in the nineteenth century, came to San Francisco in 1867 where for the next fifteen years he maintained a studio, gave art lessons, and flourished as a landscape and genre painter.

Born on January 7, 1829, in the village of Ebersbach, Saxony, Hahn began the study of art at the age of fourteen in the Royal Academy at Dresden and continued his studies at Düsseldorf and in Paris. Emigrating to America in the early sixties he spent some years in New York before moving in 1867 to San Francisco. In California he visited Tahoe, the High Sierra, Yosemite, the Redwoods, and other scenic localities in the state. The landscapes that resulted from his on-the-spot sketches won high praise from fellow-artists and the press and sold well. But it was his scenes of everyday life with their wealth of closely observed details that placed him among the foremost genre painters of his time.

Hahn spent the year 1878 painting in New York, but returned to San Francisco to resume his activities in the city's art world. In 1882 Hahn and his wife traveled to England and on the continent. Their intention was to return to San Francisco, but at Dresden Hahn became ill and died on June 8, 1887.

REFERENCES:

Arkelian, Marjorie Dakin. *William Hahn Genre Painter 1829–1887*. Oakland: The Oakland Museum. Art Department, 1976.
———. *The Kahn Collection of Nineteenth-Century Paintings by Artists in California*. Oakland: The Oakland Museum. Art Department, 1975, pp. 25, 26, 54, 59.
The Oakland Museum. Art Department. Archives of California Art.
Smith, H. Armour. *William Hahn, Painter of the American Scene*. Yonkers, New York: Hudson River Museum at Yonkers, 1942.
Sommerdorf, Marilyn. "William Hahn, 1829–1887, American Genre Painter" (Research Report). Sacramento: Archives of the E. B. Crocker Art Gallery, 1976.

THOMAS HILL (1829-1908), California's foremost painter of Yosemite Valley scenes, was born in Birmingham, England, on September 11, 1829, and at the age of twelve years came to America with his parents. After serving an apprenticeship to a coach painter Thomas became a decorator-artist for a Boston furniture manufacturer. In 1853 he attended life classes at the Philadelphia Academy of Fine Arts and that year won the Maryland Institute first prize for portraiture. In 1861 he went to California where for the next five years he painted landscapes and historical scenes in his studio at San Francisco. In 1866, after studying

art in Paris for a few months he worked in Boston, but in 1871 returned to California. He made his winter home in San Francisco and spent his summers in Yosemite where he became known as the "Pioneer Artist of Yosemite." His paintings were exhibited throughout the country. At the Centennial Exposition at Philadelphia his "Yosemite Valley," and "Donner Lake," won the artist first medal for landscape painting. Hill's most famous California painting, "Grand Canyon of the Sierras—Yosemite," is in the E. B. Crocker Art Gallery, Sacramento, California.

Hill died at Raymond, a settlement near Yosemite, on June 30, 1908.

REFERENCES:

The American West. Painters from Catlin to Russell. Text by Larry Curry and foreword by Archibald Hanna. Los Angeles: The Viking Press, Inc., in association with the Los Angeles County Museum of Art. March 21–December 31, 1972. pp. 41, 147.

Arkelian, Marjorie. *The Kahn Collection of Nineteenth Century Paintings by Artists in California*. Oakland: The Oakland Museum. Art Department, 1975, pp. 28–29.

The Artist in the American West 1800–1900. Santa Fé, New Mexico: Fine Arts Museum of New Mexico, 1961.

Catalogue of Original Paintings, Drawings and Watercolors in the Robert B. Honeyman, Jr., Collection. Compiled by Joseph Armstrong Baird, Jr. Berkeley: The Friends of The Bancroft Library, University of California, Berkeley, 1968, pp. 33–34.

Catalogue of Paintings in the E. B. Crocker Art Gallery. Sacramento: E. B. Crocker Art Gallery, 1905.

HARRY HUMPHRIES (-1799), a lieutenant in the Royal Navy, sailed as master's mate of the *Discovery* with the Vancouver expedition to the Northwest Coast of America and to California during the years 1790-1795. Humphreys made the return trip to England as an officer of the *Chatham*, one of Captain Vancouver's expeditionary ships. While aboard the *Discovery*, on the way out, Humphreys kept a daily journal which is now in the Public Records Office, London. The journal is signed "H. Humphreys." (His name is also seen with the variant spelling: W. Humphries.) Humphreys died on October 21, 1799, in London.

REFERENCES:

Catalogue of Original Paintings, Drawings and Watercolors in the Robert B. Honeyman, Jr., Collection. Compiled by Joseph Armstrong Baird, Jr. Berkeley: The Friends of The Bancroft Library, University of California, Berkeley, 1968, pp. 138–152.

The Gentleman's Magazine, November 1799. (obit.)

Marshall, John. *Royal Naval Biography* . . . London: Longman, 1833, vol. 4, part 1.

WILLIAM RICH HUTTON (1826-1901), civil engineer, surveyor, draughtsman, and amateur artist, was born on March 21, 1826 in Washington, D.C. and was educated in local private

schools. In 1847 he went to California as clerk to his uncle, William Rich, a paymaster of the United States Volunteer troops. During a six-year residence on the West Coast, Hutton held various civil and military posts. He assisted Lieutenant Edward O. C. Ord in a survey of Los Angeles and later was appointed County Surveyor of San Luis Obispo County. In 1853 he returned to the East and engaged in civil engineering in Washington and New York City. He died in Montgomery County, Maryland, on December 11, 1901.

Hutton's portfolio of drawings and paintings which he took East with him in 1853 remained in his family's possession until 1939, when it was acquired by the Henry E. Huntington Library and Art Gallery. Fifty-six of his California pictures were reproduced from the originals in *California, 1847-1852 . . .* , published by the Henry E. Huntington Library and Art Gallery in 1942.

REFERENCES:

California 1847–1852. Drawings of William Rich Hutton. Reproduced from the Originals in the Henry E. Huntington Library. With an Introduction by Willard O. Waters. San Marino: The Henry E. Huntington Library, 1942.

The Club (Publication of the Engineers Club), vol. 6, July 1894.

"Journal of John Henry Hollingsworth." California Historical Society *Quarterly*, vol. 1, September 1922, pp. 255, 268.

Monterey *Peninsula Herald*, October 29, 1960.

WILLIAM SMITH JEWETT (1812-1873), was born at South Dover, Dutchess County, New York. He began painting portraits in New York City in 1833, and in 1845 was elected an Associate Member of the National Academy of Design. His portraits were exhibited at the Academy and at the American Art Union. Although firmly established in his profession at home, Jewett succumbed to the gold fever and in 1849 sailed for California. He arrived at San Francisco on December 17, and almost immediately opened a studio in which he painted one after the other portraits of California's prominent citizens. Occasionally he turned out a landscape, but the major part of his work was in portraiture. In 1864 he assembled a picture gallery for the Ladies Christian Commission Fair, to which he loaned two of his own large views of Yosemite waterfalls. For the fair's closing auction he donated "A Run for Life." Jewett returned to New York in 1869 and the following year was married. After a brief visit to San Francisco in 1871, Jewett and his wife went to Europe. They returned to the United States in 1873 because of the artist's failing health, and were in Springfield, Massachusetts, when Jewett died, on December 3, 1873.

REFERENCES:

California Art Union. *A Classified Catalogue of Paintings on Exhibit at the Room of the California Art Union.* San Francisco: California Art Union, 1865.

Evans, Elliot A. P. "The Promised Land." Society of California Pioneers *Quarterly Newsletter*, vol. 8, November 1957, pp. 2–12.

———. "Some Letters of William S. Jewett, California Artist." California Historical Society *Quarterly*, vol. 23, June 1944, pp. 147–77; September 1944, pp. 227–246.

Ewer, Ferdinand C. "The Fine Arts." *The Pioneer*, vol. 2, August 1854, pp. 112–115.

Illustrated San Francisco News, October 9, 1869, p. 106.

"National Academy of Design. Complete List of Members from its Foundation in 1826 to Date." *American Art Annual*, vol. 9, 1911, p. 45.

Sacramento *Union*, June 6, 1855.

San Francisco City Directories 1850–1869.

WILLIAM KEITH (1838-1911), one of California's most honored landscape painters, was born in Scotland on November 21, 1838 and, at the age of twelve years was brought to New York by his widowed mother. Young Keith learned wood engraving and early in life distinguished himself as an engraver for *Harper's Weekly*. In 1858 he spent two months in California on assignment for *Harper's*, and in 1859 moved permanently to California. In San Francisco he found employment as an engraver, but by 1864 began devoting his time to landscape painting. Rural California, the High Sierra, and Yosemite Valley provided Keith with a lifetime of subjects for colorful romantic canvases. After a period of study at Düsseldorf and visits to the great art galleries of Dresden and Paris in the years 1870 to 1872, Keith returned to San Francisco. Except for subsequent travels on the continent in the 1880's and to British Columbia and Alaska, Keith lived the rest of his life in California, with San Francisco as his headquarters. After 1885 his home was in Berkeley. He continued to be a leader in California art and to paint until his death on April 13, 1911.

Hundreds of Keith's paintings and sketches were lost in the San Francisco fire of April, 1906. Nevertheless, this popular prolific artist is well represented in California and national galleries and in homes throughout the country.

REFERENCES:

Catalogue of Original Paintings, Drawings and Watercolors in the Robert B. Honeyman, Jr., Collection. Compiled by Joseph Armstrong Baird, Jr. Berkeley: The Friends of The Bancroft Library, University of California, Berkeley, 1968, p. 56.

Cornelius, Brother F.S.C. *Keith, Old Master of California.* New York: G. P. Putnam's Sons, 1942.

Hay, Emily P. B. *William Keith as Prophet Painter.* San Francisco: Paul Elder, 1916.

Mills, Paul. *An Introduction to the Art of William Keith.* Oakland: Oakland Art Museum, 1957.

"William Keith 1839–1911." *Bulletin of the California Palace of the Legion of Honor*, vol. 3, no. 3, July 1945, pp. 34–39.

EDWARD MEYER KERN (1823-1863), a Philadelphia artist-naturalist and painter in water colors and oils, served as artist-naturalist for Frémont's expedition to California in 1846 and

on Frémont's expedition to the Colorado Rockies in 1848. In 1849 Kern acted as topographer for Lieutenant Simpson's expedition to the Navajo country, and from 1853 to 1856 was the official artist of the North Pacific Exploring Expedition commanded by Captain John Rodgers and Commander Cadwalader Ringgold. While at San Francisco with Ringgold and Rodgers in 1855, Kern was reported to be preparing for publication a series of sketches of San Francisco harbor and the adjacent country. Kern served briefly in the Civil War as a captain in the Topographical Engineers. He died in Philadelphia on October 18, 1863.

Kern's projected San Francisco views have not been located, and no finished California paintings by him are on record. His Fort Sutter Papers are in the Henry E. Huntington Library and Art Gallery, San Marino, California. He is represented by non-California graphic records at the Academy of Natural Sciences, the Gilcrease Institute, the Museum of Fine Arts, Boston, the Naval Academy, and the National Collection of Fine Arts in the Smithsonian Institution.

REFERENCES:

Golden Era, vol. 3, November 18, 1855.

Hefferman, William J. *Edward M. Kern, the Travels of an Artist-Explorer*. Bakersfield: Kern County Historical Society, 1953.

Hine, Robert V. "The Kern Brothers and the Image of the West." *Desert Magazine*, vol. 24, October 1961, pp. 20–24.

———. *Edward Kern and American Expansion*. New Haven: Yale University Press, 1962.

Philadelphia *Public Ledger*, November 28, 1863. obit.

Taft, Robert. *Artists and Illustrators of the Old West, 1850–1900*. New York: Charles Scribner's Sons, 1953, pp. 358–359.

CHARLES KOPPEL, a German civil engineer, came to California via Panama in 1853 to serve as assistant engineer and artist of Lieutenant Robert S. Williamson's railroad survey party. Koppel documented the route of the survey between Benicia and San Diego in numerous topographical sketches and was the artist of the earliest known lithographed view of Los Angeles. Aside from that distinction he is unknown in California art annals. He may have been the C. Koppel who did a nearly life-size bust of Jefferson Davis in 1865.

REFERENCES:

Anderson, Jean C. "The Pacific Railroad Survey in California, July–December, 1853." Historical Society of Southern California *Quarterly*, vol. 30, September 1948, p. 177.

California State Library. *News Notes of California Libraries*, vol. 5, July 1910, p. 397.

Groce, George C. and Wallace, David H. *New York Historical Society's Dictionary of Artists in America 1564–1860*. New Haven: Yale University Press, 1957.

Taft, Robert. *Artists & Illustrators of the Old West, 1850–1900*. New York: Charles Scribner's Sons, 1953, pp. 266, 267.

GEORG HEINRICH VON LANGSDORFF (1774[1773?]-1852), artist-naturalist, physician, and world traveler, was born at Wollstein in Rheinhessen, Germany. He graduated in medicine at Göttingen, but was more interested in the natural sciences than in medicine. In 1797 he accompanied Prince Christian of Waldeck, an officer in the Portuguese army, to Portugal, and later served as surgeon-major of the English auxiliaries in Spain. In 1803 he participated in the round-the-world expedition commanded by Captain A. J. von Krusenstern. Arriving at Sitka in 1806, he joined Count Nikolai Petrovitch Rezanov in a voyage to California, where he executed the earliest known view of the Spanish settlement at San Francisco. After returning to Sitka he journeyed to Russia and entered the Russian diplomatic service as representative to Brazil. In 1831 he retired to Freiburg in Breisgau, Germany, where he died on June 29, 1852.

REFERENCES:

Allegemeine Deutsche Biographie. Leipzig: Verlag von Dunder & Humblot, 1883, pp. 689–690.

Catalogue of Original Paintings, Drawings and Watercolors in the Robert B. Honeyman, Jr., Collection. Compiled by Joseph Armstrong Baird, Jr. Berkeley: The Friends of The Bancroft Library, University of California, Berkeley, 1968, p. 58.

Langsdorff, Georg Heinrich. *Langsdorff's Narrative of the Rezanov Voyage to Nueva California in 1806. An English Translation Revised and Corrected, with Noets, etc.*, by Thomas C. Russell. San Francisco: Private Press of Thomas C. Russell, 1926, pp. xi, 5.

WILLIAM MCILVAINE (1813-1867), was born on June 5, 1813, at Philadelphia, the eldest son of Joseph Bloomfield McIlvaine, a prosperous Philadelphia merchant. He graduated from the University of Pennsylvania in 1832 as a Bachelor of Arts and received the degree of Master of Arts in 1835. After completing his courses at the university he traveled extensively in Europe, studying art, and painting. Upon returning to Philadelphia he became associated with his father in business but continued to paint in his leisure time, and in 1840 exhibited several of his European landscapes at the Artists' Fund Society of Philadelphia. About 1845 he began devoting all his time to painting and was active as a landscape artist in Philadelphia until 1856. Several of his oil paintings and watercolors, including views of California painted during a visit to the gold mines in 1849, were exhibited during the 1850's at the Pennsylvania Academy of Fine Arts and at the National Academy of Design. In 1857 McIlvaine moved to New York City where, except for Civil War service during 1861-1863, he continued to paint until his death at Brooklyn, on June 16, 1867.

REFERENCES:

Groce, George C. and Wallace, David H. *New-York Historical Society's Dictionary of Artists in America 1564–1860*. New Haven: Yale University Press, 1957, p. 414.
Historical Society of Philadelphia. Cole collection of genealogies (newspaper clippings).
M. & M. Karolik Collection of American Watercolors and Drawings 1800–1875. Boston: Museum of Fine Arts, 1962, vol. I, pp. 230–231.
Pennsylvania Academy of Fine Arts Exhibit Records, 1851–1858.
Philadelphia *Ledger*, June 19, 1867. obit.
St. Mary's Church Register. Burlington, New Jersey.

WILLIAM BIRCH MCMURTRIE (1816-1872), was the eldest son of Dr. Henry McMurtrie, head of the science department of the Central High School in Philadelphia. Undoubtedly William received the best education available in the local schools as well as parental instruction in the natural sciences. He may also have had instruction in drawing and painting, for by 1837 he was exhibiting at the Artists' Fund Society of Philadelphia and by 1845 at the American Art Union.

As a young man-about-town McMurtrie was a free spender and was constantly in debt; being of an adventurous nature he was eager to find employment that would take him out of reach of his creditors and provide some excitement in his life. The United States South Seas Surveying and Exploring Expedition, being organized in 1838, seemed the answer and McMurtrie obtained a position with the scientific and technical corps. At the last moment, however, the corps was reduced in size and McMurtrie's appointment was cancelled. While casting about for some other adventurous connection he pursued an art career interspersed with intervals of employment in minor civil and governmental positions. Finally in 1848 he obtained the position of draughtsman with the Coast Survey and was sent around the Horn to San Francisco. He remained with the survey on the West Coast intermittently until 1858 and after 1859 served on the East Coast. He continued to paint and until 1870 had paintings exhibited at the Pennsylvania Academy of Fine Arts. He died in Washington, D.C., on December 30, 1872, and was buried at Philadelphia.

REFERENCES:

California State Library. California Section. Artist Information File.
Catalogue of Original Paintings, Drawings and Watercolors in the Robert B. Honeyman, Jr., Collection. Compiled by Joseph Armstrong Baird, Jr. Berkeley: The Friends of The Bancroft Library, University of California, Berkeley, 1968, pp. 73–97.
Letters written by Edith M. McMurtrie, Theodora N. McMurtrie, and Hudson O. McMurtrie to Jeanne Van Nostrand. In the Jeanne Van Nostrand Archives of California Artists.
McMurtrie, Alexander David, comp. "The McMurtrie Clan or Family." (Typescript.) In the Jeanne Van Nostrand Archives of California Artists.

Monroe, Robert D. "William Birch McMurtrie, a Painter Partially Restored." Oregon Historical
 Society *Quarterly*, vol. 60, September 1959, pp. 352–374.
Philadelphia *Sunday Dispatch*, January 5, 1873. obit.

FRANCIS SAMUEL (FRANK) MARRYAT (1826-1855), son of the English novelist Captain
Frederick Marryat, was born in London on April 18, 1826. He first attended school in Paris,
then at Wimbledon. At age fourteen he entered the Royal Navy as midshipman and until
1847 was on sea duty. His father died in 1848 and Frank, coming into his inheritance soon
after, used some of the money to finance a hunting trip to California. In California, after
spending the summer and winter of 1850 hunting in the Russian River valley, Marryat
visited the principal inland towns and mining camps of the northern gold regions. He re-
turned to England in 1852 and married. The next year he and his wife came to California
intending to tour Southern California and to see "the Great Salt Desert," but at San Fran-
cisco Marryat suffered a severe attack of yellow fever, forcing an early return to England.
Marryat recovered his health sufficiently to write and illustrate *Mountains and Molehills*, an
amusing and informative account of his California experiences, which was published early
in 1855. A few months after the book appeared Marryat became seriously ill again, and on
July 12, 1855, died at his London residence, aged twenty-nine years.

REFERENCES:

Dictionary of National Biography. London: Oxford University Press, 1921–1960.
Illustrated London News, December 7, 1850; June 10, August 9, 1851.
London *Examiner*, July 21, 1855.
London *Times*, July 16, 1855.
Marryat, Florence. *Life and Letters of Captain Marryat*. London: Richard Bentley & Son, 1872, 2 vols.
Marryat, Francis Samuel. *Gold Quartz Mining in California* . . . London: Smith Elder & Company, 1852.
The Oakland Museum. Art Department. Archives of California Art.
San Francisco *Alta California*, October 4, 1855. obit.

E. HALL MARTIN (1818-1851) has been tardily rescued from oblivion by the recent re-
covery of his remarkable Gold Rush painting, "Mountain Jack and Wandering Miner,"
now a prized item in the Oakland Museum.
 E. Hall Martin was born in 1818 at Cincinnati, Ohio. He began painting in early youth
and in 1846 his name appeared in the first Cincinnati directory under the heading "Paint-
ers." From 1847 to 1849 he lived in New York where he painted portraits and marines and
was an occasional exhibitor at the American Art Union. In February, 1849, he left for
California, possibly as a steerage passenger on the *Panama*. He began painting in San Fran-
cisco but soon relocated in Sacramento. The subjects of his recorded paintings were scenes
and characters related to life in the mines where he evidently spent some time in the summer

of 1849. In December 1851, while on a sketching trip in the mountains, Martin contracted diphtheria and died at Onion Valley.

REFERENCES:

Arkelian, Marjorie. "An Exciting Art Department Find." *Art* (The Oakland Museum), vol. 2, January–February 1974.

Baird, Joseph Armstrong, Jr. and Wysuph, C. L. *Current data on the painting called the Forty-Niner.* (Typescript.) San Francisco: The North Point Gallery, 1973.

Historical Records Survey, New Jersey. *American Portrait Inventory. 1440 Early American Portrait Artists (1633–1860).* (Preliminary volume.) Compiled by the New Jersey Historical Records Section, Works Progress Administration. Newark, New Jersey: The Historical Records Survey, 1940, number 870, p. 173.

Illustrated California News, vol. 1, September 1, 1850.

Index to the 1850 Census of the State of California. Compiled by Alan P. Bowman. Baltimore: Genealogical Publishing Company Inc., 1972, p. 371.

The Oakland Museum *Newsletter,* no. 38, Winter 1974.

Sacramento *Union,* December 23, 1851.

San Francisco *Alta California,* January 7, 16, 1850.

WILLIAM HENRY MEYERS (1815-), was born on February 15, 1815, in Philadelphia. His was a seaman's life that began in 1838 with a voyage on a trading vessel to the West Indies. Sometime prior to 1841 he enlisted in the United States Navy and was a gunner on the *Cyane* in 1842 when Commodore Thomas ap Catesby Jones prematurely seized Monterey. During the War with Mexico Meyers was again on the West Coast as a gunner on the *Dale.* In 1847 he resigned from the navy because of illness. He afterwards worked at the naval laboratory in Washington, D.C., handling fulminating powders, an employment he claimed seriously impaired his health. In 1850 his wife contemplated presenting his case to the authorities at Washington, but the outcome of that visit, if it took place, is not recorded. Nothing more of Meyers' life is known, and it is presumed that his numerous ailments resulted in his early death.

REFERENCES:

American Heritage, vol. 11, October 1960, pp. 30, 34.

Anderson, Charles Roberts, ed. *Journal of a cruise to the Pacific Ocean, 1842–1844, in the Frigate United States. With notes on Herman Melville* . . . Durham, North Carolina: Duke University Press, 1937, appendix C, and pp. 84–86.

Meyers, William Henry. *Journal of a Cruise to California and the Sandwich Islands in the United States Sloop-of-war Cyane by William H. Meyers, Gunner, U.S.N. 1841–1844.* Edited by John H. Kemble. San Francisco: The Book Club of California, 1955.

Naval Sketches of the War in California. Reproducing Twenty-Eight Drawings Made in 1846–47 by William

H. *Meyers . . . Descriptive Text by Capt. Dudley W. Knox, U.S.N.* Introduction by Franklin D. Roosevelt. New York: Random House, 1939.

HENRY MILLER An unknown artist by this name was in California in 1856, traveling over the state taking views of towns, mission ruins, and other scenes that interested him, intending to paint them "on a large scale, to present a complete panorama of California to be exhibited in the Eastern States and Europe." He also intended to publish "an album to contain probably 200 engravings of scenery in California, with short explanatory notes."

REFERENCES:
Drawings attributed to Henry Miller. In The Bancroft Library.
Hayes, Benjamin Ignatius. *Pioneer Notes from the Diaries of Judge Benjamin Hayes, 1849–1875.* Los Angeles: Privately printed, 1929, p. 132.
13 California Towns from the Original Drawings. Introduction by Edith M. Coulter and Eleanor Bancroft. San Francisco: The Book Club of California, 1947.

HEINRICH BALDVIN MOLLHAUSEN (1825-1905), a German artist-naturalist and a friend of the geographer Alexander von Humboldt, made three trips to America. On the first trip he accompanied Prince Paul of Wertenberg in his travels up the Missouri; on the second, in 1853, he served as draughtsman and chief illustrator of the Whipple survey that came into Southern California by way of Cajon Pass and arrived at Los Angeles on March 21, 1854. Möllhausen returned to Germany that year; in 1857, while on a third visit to America, he served as topographical draughtsman on Lieutenant Joseph P. Ives's exploration of the Colorado River. After returning to Germany, Möllhausen became custodian of the royal libraries at Potsdam, in which city he died in 1905.

 Möllhausen's voluminous writings, published in Germany, were based on his travels in the American West.

REFERENCES:
The Artist in the American West 1800–1900. Santa Fé, New Mexico: Fine Arts Museum of New Mexico, 1961.
Barba, Preston A. *Balduin Möllhausen, the German Cooper.* Philadelphia: University of Pennsylvania Press, 1914, pp. 37–45.
Goetzmann, William H. *Army Exploration in the American West 1803–1863.* New Haven: Yale University Press, 1959, p. 310.
Möllhausen, Baldwin. *Diary of a Journal from the Mississippi to the Coasts of the Pacific with a United States Government Expedition, by Baldwin Möllhausen, Topographical Draughtsman and Naturalist to the Expedition.* With an introduction by Alexander von Humboldt, and illustrations in chromolithography. Translated by Mrs. Percy Sinnett. London: Longman, 1858, vol. 1, preface.
Taft, Robert. *Artists and Illustrators of the Old West, 1850–1900.* New York: Charles Scribner's Sons, 1953, pp. 22–35.

THOMAS MORAN (1837-1925), holds an honored place in American art annals for his dramatic pictorial interpretations of western scenery. Born in Bolton, Lancashire, England, on January 12, 1837, he came to America with his family in 1844. At age sixteen he began working as an apprentice wood engraver but soon commenced painting, first in water colors and then in oils. He went to England in 1862 where he came under the influence of Turner, and in 1864 visited the art galleries of France and Italy. His first trip into the American West was as guest artist with F. V. Hayden's expedition to the Yellowstone in 1871. It is said that the exciting watercolors he brought back from that journey helped persuade Congress to establish Yellowstone as the first unit in our national park system.

In 1872 Moran crossed the country by railroad to the Pacific Coast. His "Cascades of Vernal Falls," commemorates his first visit to Yosemite. He visited California again in 1879, and in 1916 established a winter studio at Pasadena. After 1922 he made his home in Santa Barbara, where he died on August 25, 1925. Moran's last painting was of Bridal Veil Falls, Yosemite. His celebrated "Grand Canyon of the Yellowstone," for which Congress paid him ten thousand dollars, hung in the national capitol for many years.

REFERENCES:

The American West. Painters from Catlin to Russell. Text by Larry Curry and foreword by Archibald Hanna. Los Angeles: The Viking Press, Inc., in association with the Los Angeles County Museum of Art, March 21–December 31, 1972, pp. 43–45.

Ewers, John C. *Artists of the Old West*. Garden City, New York: Doubleday & Company, 1965, pp. 174–194.

Fryxell, Fritiof. *Thomas Moran, Explorer in Search of Beauty*. East Hampton, New York: East Hampton Free Library, 1958.

Wilkins, Thurman. *Thomas Moran. Artist of the Mountains*. Norman, Oklahoma: University of Oklahoma Press, 1966.

CHARLES CHRISTIAN NAHL (1818-1878), was born on October 13, 1818, at Kassel, Germany, into a family that had been celebrated in the art annals of Europe for generations. Charles probably received his earliest training in art from his father; as a young man he studied in Paris under Horace Vernet and by 1846 had won a reputation in France and Germany as a gifted painter of classical subjects. In 1849 a difficult family situation caused him to emigrate with his mother, two sisters, and two half-brothers to America. They settled in Brooklyn, New York, but soon succumbed to the raging gold fever. On March 26, 1851, the entire family left for the California gold fields and were in San Francisco by May 23, 1851. Unsuccessful as miners, they settled in Sacramento where Charles found employment first as a sign painter and then as a newspaper illustrator, in between times filling an occasional art commission. He had made a promising start on an art career when, in 1852, a city-wide

fire destroyed his studio and much of his work. He moved his family to San Francisco and began afresh as an illustrator, gradually working into a full-time art career. In addition to a great number of illustrations, he painted portraits, miniatures, genre, and still lifes. In 1867 he acquired the patronage of Judge Edwin Bryant Crocker of Sacramento, for whom he painted a number of canvases illustrative of life in early California.

Charles Christian Nahl died in San Francisco of typhoid fever on March 1, 1878. As one of California's best known nineteenth-century artists he has been the subject of a number of carefully researched studies, a selection of which follows.

REFERENCES:

Baird, Joseph Armstrong, Jr. "Charles Christian Nahl, Artist of the Gold Rush." *American Art Review*, vol. 3, September–October 1976, pp. 56–70.

Ewers, John C. *Artists of the Old West*. Garden City, New York: Doubleday and Company, 1965, pp. 150., ff.

Groce, George C. and Wallace, David H. *New-York Historical Society's Dictionary of Artists in America 1564–1860*. New Haven: Yale University Press, 1957.

Gudde, Erwin G. "Carl Nahl: California's Pioneer of Painting." *The American-German Review*, vol. 7, October 1940, pp. 18–21.

Nahl, Perham W. *Souvenir: Early Days in California*. San Francisco: A. Rosenfeld, 1894.

Neuhaus, Eugen. "Charles Christian Nahl, the Painter of California Life." California Historical Society *Quarterly*, vol. 15, December 1936, pp. 295–305.

Stevens, Moreland L., with the assistance of Marjorie Arkelian. *Charles Christian Nahl, Artist of the Gold Rush 1818–1878*. Sacramento: E. B. Crocker Art Gallery, 1976.

(See also references for Hugo Wilhelm Arthur Nahl.)

HUGO WILHELM ARTHUR NAHL (1833-1889). Overshadowed in the annals of California art by his celebrated half-brother, Charles Christian Nahl, Hugo Wilhelm Arthur Nahl (commonly designated as Arthur), was nevertheless a talented artist in his own right. The development of his artistic ability began while he was still a young lad under the supervision of Charles, fifteen years his senior, and was continued by formal art training in Paris. By 1849, the year he emigrated to America with Charles and other members of the family, Arthur had developed into a competent artist.

The Nahls settled in Brooklyn where Arthur and Charles were soon launched upon promising art careers. These were abruptly terminated in March, 1851, when they set out with their family to make their fortunes as miners in California. Upon arriving at San Francisco on May 23, 1851, they hurried to the mines but in a short while gave up their unsuccessful efforts to 'strike it rich,' and moved to Sacramento. Arthur and Charles took portrait commissions and did newspaper illustrating, and were on their way to making a financial go of their art when in 1852 a city fire in Sacramento destroyed their home and

much of their work. Arthur's pen and ink drawing of the fire, now in the Oakland Museum, is the only known original depiction of that conflagration.

A decision was made to relocate in San Francisco. Fortune was kinder to them there and in due time they became well-known in the field of portraiture, periodical and book illustration, and photography. On his own in 1854 Arthur painted the scenes for four panoramas. His specialty, however, was the depiction of animals.

In April, 1865, Arthur married Annie June Sweeny and the next year, for the sake of her health, moved to Alameda. Except for a trip to Europe on estate business in 1880, he lived and painted in California until his death on April 1, 1889.

REFERENCES:

Arkelian, Marjorie, "A Rare Drawing by Arthur Nahl." *Art*, vol. 6, Jan./Feb. 1978. (A publication of the art guild of the Oakland Museum Association. unp.)
Golden Era, June 1866, p. 399.
San Francisco *Call*, December 29, 1883.
San Francisco Art Association *Catalogs 1874, 1876, 1877, 1879, 1881, 1883, 1885, 1886, 1888.*
Stevens, Moreland L., with the assistance of Marjorie Arkelian. *Charles Christian Nahl, Artist of the Gold Rush 1818–1878*. Sacramento: E. B. Crocker Art Gallery, 1976, p. 51.
Van Nostrand, Jeanne and Coulter, Edith M. *California Pictorial*. Berkeley and Los Angeles: University of California Press, 1948, p. 140.
(See also references for Charles Christian Nahl.)

MRS. A. T. OAKES (fl. 1852-1886), born in New York, was active as a landscape painter in New York City in 1852 and in Boston in 1854. She is believed to have come to California about 1855. In 1857 she exhibited an oil painting of a California landscape at the Mechanics' Institute Fair and may have remained in San Francisco for a number of years. From 1865 until 1886 she was an exhibitor of landscapes and classical subjects at the National Academy of Design. Her views of European scenes indicate she visited Switzerland and France prior to 1870. The only known California painting by this artist is "Ocean Beach, San Francisco," which she offered for sale in 1873. It is now in the California Historical Society's collection.

REFERENCES:

Exhibition Records of the National Academy of Design 1861–1900, vol. 2, pp. 695–696.
Groce, George C. and Wallace, David H. *New-York Historical Society's Dictionary of Artists in America 1564–1860*. New Haven: Yale University Press, 1957.

THOMAS STORY OFFICER (1810-1859), son of John Officer and Mary Storey Officer, was born at Carlisle, Pennsylvania, on August 15, 1810. He studied art under Thomas Sully and in 1847 and 1849 exhibited at the National Academy of Design, of which he was a member.

His early art years were spent painting portraits and miniatures in New York City, Philadelphia, New Orleans, and Mexico City. Later he lived in Australia and then in 1855 went to San Francisco, where he opened a studio. In 1856 he was located in the Vance Building and was associated with the photographer George B. Johnson as a colorist. Officer exhibited portraits and miniatures at the 1858 and 1859 Mechanics' Institute Fairs. He died in impoverished circumstances on December 8, 1859, and was buried in the public plot at Lone Mountain Cemetery.

REFERENCES:

California State Library. California Section. Artist card file.
Frick Art Reference Library, New York City. Artist Information File.
Gibbs Art Gallery, Charleston, South Carolina. Artist File.
Golden Era, December 9, 1855.
National Academy of Design. *Exhibition Record, 1826–1860*. New York: New York Historical Society, 1943.
San Francisco *Alta California*, December 18, 1859.
San Francisco News Letter, September 15, 1923, p. 8.

SAMUEL STILLMAN OSGOOD (1808-ca. 1885), was born on June 9, 1808, at New Haven (?), Connecticut, but was raised in Boston, where he studied painting. His earliest known work is a portrait of David Crockett, painted in 1830 (now in The Alamo, San Antonio, Texas). In 1833 Osgood married the poetess Frances Sargent Locke and went with her to Europe where he studied art for several years. He was an exhibitor of genre paintings at the British Institute in 1838 and 1839, and at the Pennsylvania Academy of Fine Arts in 1849. The Osgoods lived for varying lengths of time at Charleston, Boston, and Philadelphia, but made their permanent home in New York City. Osgood's first visit to California was from June, 1849 to January, 1850. Following his wife's death in 1851 and another trip to Europe Osgood again visited California, staying from early in 1852 until late in 1853. His third visit was in July, 1870 when he stopped over at San Francisco en route for Japan. He is believed to have lived in California for some time before his death in the mid-eighties. His second wife was Sarah Howland. Osgood was an associate member of the National Academy of Design. He exhibited paintings at the New York Metropolitan Fair in 1864 and at the National Portrait Exhibit in London in 1868.

REFERENCES:

California State Library. California Section. Artist Information File.
Exhibit Records of the National Academy of Design 1826–1860.
Frick Art Reference Library, New York City. Artist Information File.
Graves, Algernon. *A Century of Loan Exhibits*. London: A. Graves, 1913.

Groce, George C. and Wallace, David H. *New-York Historical Society's Dictionary of Artists in America 1564–1860*. New Haven: Yale University Press, 1957.
Literary World, vol. 4, June 30, 1849, pp. 556–557.
San Francisco *Alta California*, September 6, 1849; May 26, 1851; March 2, 1852.
San Francisco Municipal Reports 1881–1882. Appendix p. 127.
Weekly Placer Herald, March 26, 1853.

FRANÇOIS EDMOND PÂRÍS (1806-1893), French naval officer and artist, born at Brest, France, received naval training and probably instruction in drawing and painting at a naval training school at Angoulmême. In 1826 he made his first voyage around the world, and from 1830 to 1832 accompanied Captain Cyrille Pierre Thèodore Laplace on a long sea voyage. He joined Laplace again in 1837 as official artist of a round-the-world expedition that visited Monterey, California, in 1839. From 1833 to 1839 paintings by Pârís were exhibited at the Salon de Paris. After retiring from the navy with the rank of admiral, he became director of the Musée de la Marine. He died in Paris in 1893.

REFERENCES:

Bènèzit, E. *Dictionaire critique et documentaire des Peintres, Sculpteurs, Dessinateurs et Graveurs.* (Nouvelle edition.) Paris: Librarie Gründ, 1961.
Beriot, Agnes. *Grands Voiliers Autour du Monde*. Paris: Librarie Robert Laffont, 1963, pp. 240–241.
General Dictionaire des Artistes de l'Ecole Française. Depuis l'origine des Arts du Dessin jusqu'à nos Jour. Paris: Librarie Renouard, 1885.
Letter written November 6, 1964 by the director of the Musée de la Marine, Paris, to Jeanne Van Nostrand. In the Jeanne Van Nostrand Archives of California Artists.

TITIAN RAMSAY PEALE (1799-1885), was born in Philadelphia. His father was Charles Wilson Peale, artist, and proprietor of a natural history museum in Philadelphia. Titian became an artist and a naturalist. His special abilities in those fields admirably fitted him for the life of an expeditionary artist and in that capacity he went on expeditions to Florida, South America, and the country between the Mississippi River and the Rocky Mountains. From 1839 to 1842 he was attached to the United States South Seas Surveying and Exploring Expedition, and while on the Pacific Coast in 1841 made an overland journey from Oregon to San Francisco. After serving with the expedition Titian was associated for a time with his father in the museum and then became an assistant examiner in the United States Patent Office, from which position he retired in 1873. During the last twelve years of his life he divided his time between the Academy of Natural Sciences of Philadelphia, painting, and the writing and illustrating of books on natural history. He died on March 13, 1885.

REFERENCES:

McLanathan, Richard. *The American Tradition in the Arts.* New York: Harcourt, Brace & World, Inc., 1968, pp. 226–227.

Peale, Titian Ramsay. *Diary of Titian Ramsay Peale. Oregon to California Overland Journey September and October, 1841.* Edited by Clifford M. Drury; introduction and bibliography by Carl Dentzel. Los Angeles: Glen Dawson, 1957.

———. "The South Seas Surveying and Exploring Expedition." (Ms.) Washington, D.C.: Smithsonian Institution.

Poesch, Jessie. *Titian Ramsay Peale, 1799–1885, and His Journals of the Wilkes' Expedition.* Philadelphia: The American Philosophical Society, 1961.

Richardson, Edgar. *Painting in America. The Story of 450 Years.* New York: Crowell, 1956, p. 202.

HENRI [JOSEPH?] PENELON (1827-1874), a French artist who settled in Los Angeles about 1853, was that city's first resident-artist and photographer. During the first years he painted portraits of some of the important *Californios* of Southern California, but in the sixties and early seventies specialized in photography. His first associate in photography was Adrien L. Davoust, a Parisian; in 1870 Penelon was associated with Valentin Wolfenstein.

It is believed that Henri Penelon was born in Lyons, France, in 1827. He married Emilia Herriot, a native of San Francisco, in 1854; their daughter Hortense was born November 17, 1871. Penelon is represented at the Los Angeles County Museum of Natural History and at the Charles W. Bowers Memorial Museum, Santa Ana, California.

REFERENCES:

Barrows, Henry D. "Reminiscences of Los Angeles." Historical Society of Southern California *Annual Publication,* 1893, p. 59.

Los Angeles *Star,* December 31, 1870.

Newmark, Harris. *Sixty Years in Southern California, 1853–1913.* New York: The Knickerbocker Press, 1916, pp. 82, 293, opp. p. 400.

Owen, J. Thomas. "The Church by the Plaza." Historical Society of Southern California *Quarterly,* vol. 42, June 1960, pp. 189–192.

Packman, Ana Bégué de. "Landmarks and Pioneers of Los Angeles in 1853." Historical Society of Southern California *Quarterly,* vol. 26, 1944, p. 85.

HENRY CHEEVER PRATT (1803-1880), was born at Orford, New Hampshire, on June 13, 1803. When fourteen years old his artistic ability came to the attention of Samuel F. B. Morse who engaged him first as an unpaid errand boy and then as a paid assistant in return for instruction in painting. Pratt traveled with Morse to Washington, D.C., South Carolina, New Haven, and New York, and collaborated with him on a number of large canvases. After 1827 Pratt had his own studio in Boston and began exhibiting annually at the Boston

Athenaeum. From 1851 to 1854 he traveled as artist with the United States Boundary Commission across the Southwest to California. Afterwards Pratt continued his art career in Boston and except for a trip to California in 1870 was active in his profession at home for more than twenty years.

Pratt died at Wakefield, Massachusetts, on November 27, 1880. He had five children, one of whom was the artist John J. Pratt, who had been taken along as a boy on the 1851-1854 boundary survey.

REFERENCES:

Catalogue of Original Paintings of California and other American Scenery by H. C. Pratt. Boston Art Gallery, 1872.

Hodgson, Alice Doan. "Henry Cheever Pratt (1803–1880)." *Antiques*, vol. 102, November 1972, pp. 842–847.

John Carter Brown Library, Providence, Rhode Island. Papers of John Russell Bartlett.

M. & M. Karolik Collection of American Water Colors and Drawings 1800–1875. Boston: Museum of Fine Arts, 1962, pp. 262, 449.

Personal interview and correspondence with Mrs. Alice S. Robinson, Wakefield, Mass.

JOSEPH WARREN REVERE (1812-1880), a grandson of Paul Revere, was born in Boston on March 17, 1812. He entered the United States Navy in 1822 and followed a naval career for twenty-five years. He was stationed in California from July 1846 to January 1847; in 1848 he returned to California as a government timber agent, with headquarters in Marin County. He remained for a number of years and was a successful claimant for a grant of land in Marin County. From California Revere went to Mexico where he led an adventurous life as a ranchero and soldier of fortune. Later he saw active service in the Civil War and rose to the rank of Brigadier-General.

Revere was the author of two autobiographical books: *A Tour of Duty in California* (1849), and *Keel and Saddle* (1872). He attained some reputation in New Jersey as an artist and fresco painter; his home at Morristown contained many of his oil paintings and frescoes. His death occurred on April 20, 1880.

REFERENCES:

Biographical Genealogical & Descriptive History of New Jersey. Newark: New Jersey Historical Society, 1900.

Flynn, Joseph. *Story of a Parish*. New York City: The Publisher's Printing Company, 1904, pp. 270–272.

Newark *Daily Advertiser*, April 21, 1884. obit.

Revere, Joseph Warren. *Keel and Saddle: a Retrospect of Forty Years of Military and Naval Service*. Boston: James R. Osgood and Company, 1872.

San Jose *Pioneer*, May 8, 1884. obit.

Upham, Samuel C. *Notes of a Voyage to California together with Scenes in El Dorado*. Philadelphia: Published by the author, 1878, pp. 457–458, 591.

ALFRED ROBINSON (1806-1895), born in Boston, was trained from early youth for a business career. He made several commercial trips to the West Indies before going to California in 1829 as clerk of the *Brookline*, a trading vessel belonging to Bryant and Sturgis of Boston. Robinson remained in California for nine years as agent for the firm. In 1836 he married fifteen-year-old Ana-María, daughter of José de la Guerra of Santa Barbara, and the next year took her to Boston to be educated. Robinson was in California again from 1840 to 1842. Between 1842 and 1846, while in the East, he wrote and published anonymously *Life in California*, now a standard reference work for the period 1829 to 1842. Six of the nine illustrations were based on Robinson's drawings. In 1849 he returned to California as agent for the Pacific Steamship Company, and from that time on California was his permanent home. In his later years he handled the sales and management of various large estates, including the extensive Abel Stearns holdings in Southern California.

REFERENCES:

Bancroftiana, Berkeley: The Friends of The Bancroft Library, #60, February 1975, pp. 7–8.

Barrows, Henry D. "Alfred Robinson." Historical Society of Southern California *Quarterly*, vol. 4, 1899, pp. 234–235.

Davis, William Heath. *Seventy Five Years in California*. San Francisco: John Howell, 1929, pp. 3, 243–244.

Robinson, Alfred. *Life in California before the Conquest*. New York: Wiley & Putnam, 1846.

———. Papers. In The Bancroft Library.

———. Statement of recollections on early years of California made by Alfred Robinson, 1878, for The Bancroft Library. In The Bancroft Library.

THOMAS ROSS. This unidentified artist is listed in San Francisco city directories only for the years 1859 and 1862. He painted numerous landscapes of the San Francisco and Sausalito areas, and of Yosemite. Paintings by a Thomas Ross were exhibited at the Mechanics' Institute Fairs of 1872, 1874, 1875-76, 1879-1880, and 1886. In 1886, the last time his name appears as an exhibitor, he won a cash award for one of his paintings.

REFERENCES:

Perret, Ferdinand. (card catalogue.) *The California Section of the Ferdinand Perret Research Library of the Arts and Affiliated Sciences*. Compiled in Los Angeles, 1936–1942. The Oakland Museum. Art Department. Archives of California Artists.

San Francisco *Bulletin*, December 6, 1872, February 5, 1874.

WILLIAM REDMOND RYAN (1823[?]-1855). Very little is known about this English journalist and amateur artist. He is believed to have been associated with the New York press and to have become a naturalized citizen of the United States before enlisting in June, 1847, in Company D of Colonel Jonathan D. Stevenson's First New York Volunteers. He was mustered out at Monterey, California, in 1848, and after an unrewarding visit to the mines worked at house and sign painting at Monterey and then at San Francisco. He left California in August, 1849 because of ill health and died at New Orleans on October 9, 1855, of yellow fever. The two volumes of his *Personal Adventures . . .* are illustrated with twenty-three lithographic reproductions of his drawings. A Dutch edition appeared in 1851 and in 1852 a second English printing was made of this early California 'best seller.'

REFERENCES:

British Quarterly Review, vol. 12, 1850, p. 59.
Clark, Francis D. Marginal notes on Francis D. Clark's copy of Ryan's *Personal Adventures*. California
 Historical Society.
San Francisco *Alta California*, November 15, 1855. obit.
Stevenson, Jonathan D. "Order Book." (Ms.). New York Historical Society.
United States War Department. Office of the Adjutant General. Records.

EMMANUEL SANDELIUS, who called himself "the King's Orphan," i.e., a ward of the Swedish king, and traveled under the name Gustave M. Waseurtz, had visited the East Coast of the United States, lived in Brazil and Mexico, and possibly in Australia as well, before coming to California in 1842. He remained in California a full year, informing himself on the various aspects of life in that part of the world. Sometime before the outbreak of the War with Mexico he was in New Orleans where he is said to have given Colonel Thomas Bangs Thorpe, an artist-journalist, a manuscript of his experiences in California and a portfolio of drawings and paintings. The "King's Orphan" was then seriously ill with tuberculosis and it is assumed his death occurred soon after. Colonel Thorpe later presented Sandelius's manuscript and drawings to Samuel C. Upton, a California pioneer, who in turn gave the collection to the Society of California Pioneers.

REFERENCES:

Bidwell, John. "California, 1844-1848." (Ms.). In The Bancroft Library.
"Journals and Drawings of Gustave M. Sandels." (Ms.). In the Society of California Pioneers.
Rickels, Milton. *Thomas Bangs Thorpe, Humorist of the Old Southwest*. Baton Rouge: Louisiana State
 University Press, 1962, pp. 115, 119.
*A Sojourn in California, by the King's Orphan. The Travels and Sketches of G. M. Waseurtz af Sandels, a
 Swedish Gentleman who Visited California in 1842-1843*. Edited with an introduction by Helen Putnam

Van Sicklen. San Francisco: The Book Club of California in Arrangement with The Society of California Pioneers, 1945.

Upham, Samuel C. *Notes of a Voyage to California together with Scenes in El Dorado.* Philadelphia: Published by the author, 1878, pp. 470–471.

STEPHEN WILLIAM SHAW (1817-1900), whose grandfathers fought in the Revolutionary War, was born on December 15, 1817, at Windsor, Vermont, on his parents' farm. Stephen received a common school education and learned the trade of mechanic. There is no record that he received any training in art, but in his early twenties he was a teacher of penmanship and later a professor of drawing at an academy in Norwich, Vermont. In 1842 he began traveling as an itinerant portrait painter. At Baton Rouge, after the War with Mexico, he painted several portraits of General Taylor, and was commissioned by the City of New Orleans to go to Mexico to paint a portrait of General Persifor F. Smith, the United States military governor of that city. In 1849 Shaw's wanderings brought him to San Francisco. After spending a winter in the mines and then participating in the expedition that discovered and named Humboldt Bay, Shaw settled in San Francisco to paint portraits. He was active in San Francisco as an artist and a teacher of art from 1852 until his death on February 14, 1900.

REFERENCES:

The Bay of San Francisco . . . Chicago: The Lewis Publishing Company, 1892, vol. 2, pp. 254–256.

Catalogue of the Mark Hopkins Institute of Art. San Francisco: San Francisco Art Association, 1902, p. 366.

Catalogue of Paintings in E. B. Crocker Art Gallery. Sacramento, California: E. B. Crocker Art Gallery, 1905.

Fletcher, Robert H. "Memorandum of Artists, 1906." (Typescript.) In the California State Library. California Section.

San Francisco *Call*, February 15, 1900.

WILLIAM SMYTH (1800-1877), was born to English parents in 1800. He entered the Royal Navy in his early twenties and from 1825 to 1827 served as admiralty mate and artist on Captain Frederick William Beechey's expedition to the Far North Pacific which wintered at San Francisco and Monterey, 1826-27. Smyth afterwards sailed on H.M.S. *Samarang* to Callao, and from Callao crossed the Andes in company with Frederick Lowe, a fellow shipmate. On a later voyage he accompanied Sir George Back to the Arctic on H.M.S. *Terror.* Smyth wrote and illustrated *Narrative of a Journey from Lima to Para* (London, 1836), and was the illustrator of George Back's *Narrative of an Expedition in H.M.S. Terror* (London, 1838). Smyth's home was at Tunbridge Wells, England, where he died on September 25, 1877.

REFERENCES:

Bancroft, Hubert H. *Works*. San Francisco: The History Company, 1882–1891, vol. 4, p. 120.

Catalogue of Original Paintings, Drawings and Watercolors in the Robert B. Honeyman, Jr., Collection. Compiled by Joseph Armstrong Baird, Jr. Berkeley: The Friends of The Bancroft Library, University of California, Berkeley, 1968, pp. 133–137.

Correspondence of Edith M. Coulter with Sir Geoffrey Callender, The National Maritime Museum, Greenwich. In the Jeanne Van Nostrand Archives of California Artists.

Proceedings of the Geographical Society, vol. 22, 1878, pp. 321–322.

Public Record Office, Search Department, London. Memorandum concerning Admiral William Smyth. In the Jeanne Van Nostrand Archives of California Artists.

JOHN MIX STANLEY (1814-1872), who became one of the country's foremost painters of Indian portraits, began his art career wandering about in the midwest and into the Indian country in Arkansas and New Mexico as an itinerant painter. In 1845 he joined Colonel Stephen Watts Kearny at Santa Fé as staff artist on the march to California. From San Diego he went on his own to San Francisco and Oregon and made a journey up the Columbia and Snake Rivers before returning to the East Coast in 1850. In 1853 he crossed the western territories to Oregon as chief artist for the Pacific Railroad survey led by Isaac Stevens.

Stanley lived in Washington, D.C., from 1854 until 1863, then moved to Buffalo, and later returned to Detroit where he had lived as a young man. At the time of his death on April 10, 1872 he was working on his celebrated picture, "The Trial of Red Jacket," which now hangs in the Buffalo Historical Society building. Many of his paintings which he had left on deposit at the Smithsonian Institution were lost when a fire destroyed a wing of the building in 1865.

REFERENCES:

Bushnell, David I., Jr. "John Mix Stanley, Artist-Explorer." Smithsonian Institution *Publication 2816*. Washington, D.C.: 1925, pp. 507–512.

Dictionary of American Biography. New York: C. Scribner's Sons, 1928–1936.

Draper, Benjamin P. "John Mix Stanley, Pioneer Painter." *Antiques*, vol. 41, March 1942, pp. 180–182.

Groce, George C. and Wallace, David H. *New-York Historical Society's Dictionary of Artists in America 1564–1860*. New Haven: Yale University Press, 1957.

Pipes, Nellie B. "John Mix Stanley, Indian Painter." Oregon Historical Society *Quarterly*, vol. 33, September 1932, pp. 250–258.

Rasmussen, Louis. "Artists of the Explorations Overland 1840–1860." Oregon Historical Society *Quarterly*, vol. 43, March 1942, pp. 56–62.

HENRY S. STELLWAGON. The meager information at hand about this naval officer establishes Pennsylvania as his native state but does not reveal his birthdate. He may have entered the United States Navy about 1833. The earliest known water color painting executed by

him is a view of "City of New York from below Bedlows," (1841). Other dated watercolors indicate he came around the Horn in 1849 on a tour of naval duty that kept him in the vicinity of San Francisco until the spring of 1850—long enough for him to buy a lot in San Francisco and to paint a number of watercolors from points around the bay and at Sacramento. In fraternizing with the Coast Survey personnel he met—or became re-acquainted with—William Birch McMurtrie who presented him with "a fancy sketch" (a landscape). For at least part of Stellwagon's California duty the *Savannah* was his ship. In July, 1851, aboard the *Savannah* with the rank of lieutenant, Stellwagon was at Valparaiso, where he painted several small views of that city. The following year he was in command of the Coast Survey schooners *Morris* and *Belle*; in 1856 he was captain of the steamer *Connecticut*. The subjects of his non-California paintings indicate visits to China, South America, and Africa.

REFERENCES:

Frick Art Reference Library, New York City. Artist Information File.
United States Coast & Geodetic Survey. *Annual Report of the Director . . .*, Washington, D.C.: Government Printing Office, 1852; 1856.

ALFRED SULLY (1820-1879), was born on May 20, 1820, in Philadelphia, one of nine children in the family of Thomas Sully, the portraitist. Young Alfred inherited considerable artistic talent from his father and received training from him in art. In 1837 he entered West Point and in 1841 graduated with the rank of second lieutenant. His military career began in 1846 with participation in the War with Mexico, at Vera Cruz. In 1848 he was posted to California and in April, 1849, was made chief quartermaster at Monterey. His marriage in 1850 to Manuela Jimeno, the daughter of Doña Augustias Jimeno, of the De la Guerra family, ended in tragedy when the young wife and her infant son died the following year. Sully reluctantly remained in California until transferred in 1853. His life-long army career included service in Minnesota and the Dakotas. He took part in a number of major Civil War battles and rose to the rank of Major General. His last assignment was at Fort Vancouver, where he died on April 27, 1879.

REFERENCES:

Appleton's Cyclopaedia of American Biography. New York: D. Appleton & Co., 1887–1900.
Frick Art Reference Library, New York City. Artist Information File.
The Oakland Museum. Art Department. Archives of California Art.
Ord, Augustias de la Guerra. "Occurencias en California." (Ms.). In The Bancroft Library.
Patten, George W. "Alfred Sully." *1879 Annual Reunion of the Association of Graduates, United States Military Academy*. West Point, New York: 1879, pp. 90–93.
San Francisco *Alta California*, June 3, 1850.

San Jose *Pioneer*, May 17, 1879.

Sully, Langton. *No Tears for the General. The Life Of Alfred Sully 1821–1879*. Palo Alto: The American West, 1974.

Tomás de Suría (1761–), artist-engraver, born in Spain, studied art with Jeronimo Antonio Gil at the Royal Academy of San Fernando, Madrid. In 1788 Suría accompanied his teacher to Mexico, and possibly continued his art studies there before becoming an engraver in the Casa de Moneda, Mexico City. He obtained a leave of absence from the Casa de Moneda in 1791 to join the Malaspina expedition at Acapulco as official artist. At the conclusion of the voyage he returned to Mexico City where he resumed his former employment and completed his expeditionary sketches.

REFERENCES:

"The Art of the Malaspina Expedition of 1791–1792." Oakland Art Museum *Monthly Bulletin*, June 1960.

Cutter, Donald C. "Early Spanish Artists on the Northwest Coast." *Pacific Northwest Quarterly*, vol. 54, October 1963, pp. 11, 150–155.

———. *Malaspina in California*. San Francisco: John Howell–Books, 1960, passim.

Fernandez, Justino. *Tomás de Suría y su viaje con Malaspina, 1791*. Mexico, D.F.: Libraria de Porrua Hermanos y cia, 1939, p. 16.

Museo Naval, Madrid, Spain. Archives.

Van Nostrand, Jeanne. *A Pictorial and Narrative History of Monterey, Adobe Capital of California 1770–1847*. San Francisco: California Historical Society, 1968.

Wagner, Henry R. "Four Early Sketches of Monterey Scenes." California Historical Society *Quarterly*, vol. 15, September 1936, pp. 213–215.

———. "Journal of Tomás de Suría of His Voyage with Malaspina to the Northwest Coast of America in 1791." *Pacific Historical Review*, vol. 5, September 1936, pp. 234–276.

John Sykes (1773-1858), was born in England in 1773, and when ten years old joined the Royal Navy as captain's servant. In 1790 he sailed as master's mate on the *Discovery*, commanded by Captain George Vancouver. During the voyage he kept a journal and executed many drawings and paintings of the Northwest Coast and California. He remained in the navy for the rest of his life, saw action in numerous naval engagements, and shortly before his death in 1858 was raised to the rank of admiral.

REFERENCES:

Catalogue of Original Paintings, Drawings and Watercolors in the Robert B. Honeyman, Jr., Collection. Compiled by Joseph Armstrong Baird, Jr. Berkeley: The Friends of The Bancroft Library, University of California, Berkeley, 1968, pp. 139–152.

Groce, George C. and Wallace, David H. *New-York Historical Society's Dictionary of Artists in America 1564–1860*. New Haven: Yale University Press, 1957.

Marshall, John. *Royal Naval Biography*. London: Longman, 1933, vol. 4, part 1.

Sykes, John. "Log of the Proceedings of His Majesty's Sloop Discovery from December 18, 1790 to February 28, 1795." (Ms.). Public Records Office, London.

Views of the Northwest Coast of America. Portfolio. Hydrographer's Office of the Admiralty, Taunton, England.

JULES TAVERNIER (1844-1889), a gifted French painter, was among the artists flocking to California in the 1870's who preferred the gentler landscape of the Monterey Peninsula to the rugged grandeur of the mountains. Born in April, 1844, in Paris and trained in France at L'Ecole des Beaux Arts, Tavernier began a promising art career in France, but for political reasons emigrated to America in 1871. He worked in New York City as an illustrator for various magazines. In 1874 Harper's commissioned Tavernier and another French artist, Paul Frenzeny, to make a series of illustrations along the route of the transcontinental railroad. They crossed the western territories on horseback and arrived at San Francisco in July of 1874. For some years Tavernier had a studio at Monterey where he painted, exhibited, and gave lessons in art. In 1879 an unfortunate altercation with the local authorities caused Tavernier to close his studio and return to San Francisco. He was eminently successful in the city and his work commanded good prices. Nevertheless, his improvident way of life resulted in an accumulation of debts which he could not pay. In 1884 he escaped his creditors by leaving hurriedly for Hawaii. He became known in Hawaii for his dramatic paintings of the volcanoes. Tavernier, a heavy drinker, died of acute alcoholism on May 18, 1889.

REFERENCES:

Catalogue of Original Paintings, Drawings and Watercolors in the Robert B. Honeyman, Jr., Collection. Compiled by Joseph Armstrong Baird, Jr. Berkeley: The Friends of The Bancroft Library, University of California, Berkeley, 1968, pp. 153–154.

The French in California, One Hundred Years of Achievement 1850–1950. San Francisco: California Palace of the Legion of Honor, November 11–30, 1950.

Hoag, Betty. "Jules Tavernier." Unpublished Master's Thesis, University of Southern California, Los Angeles.

Luquiens, H. M. "Jules Tavernier." Honolulu Academy of Arts *Bulletin*, vol. 2, 1940, pp. 25–31.

San Francisco *Alta California*, January 8, February 3, May 24, 1876; February 25, 1877; January 27, 1879.

Taft, Robert. *Artists and Illustrators of the Old West, 1850–1900*. New York: Charles Scribner's Sons, 1953, pp. 125, 149, 188.

BAYARD TAYLOR (1825-1878), was born in Chester County, Pennsylvania, on January 11, 1825, of Quaker parents and was raised in that faith. When seventeen years old he was apprenticed to a printer but his interests were literary and artistic. He asked John Sartain to

teach him engraving but Sartain was not then taking pupils. Taylor then turned to writing poetry and in 1844 had his first verses published. Shortly afterward he began a lifetime of foreign travels and the writing of travel books. For two years he wandered about Europe gathering material for *Views Afoot* (1846), the first of his numerous books, some of which he illustrated himself. In 1849 he went to California as a roving reporter for the New York *Tribune*. His later travels included a visit to Japan with Perry's expedition. Between journeys he built up a reputation as an entertaining lecturer and in 1859 went to California on a lecture tour.

Taylor was appointed Secretary of Legation to St. Petersburg in 1862 and Minister to Germany in 1878. He died in Berlin that year. He had achieved international fame as a poet, critic, essayist, and author. Three of his European canvases were exhibited in 1860 at the National Academy of Design.

REFERENCES:

Fairman, Charles E. *Art and Artists of the Capitol of the United States of America*. Washington, D.C.: Government Printing Office, 1927, p. 374.
Harper, J. Henry. *The House of Harper*. New York: Harper & Brothers, 1912, p. 455.
Morison, Samuel E. *"Old Bruin" Commodore Matthew Calbraith Perry*. Boston: Little, Brown, 1967.
New York *Tribune*, December 25, 1878. obit.
San Francisco *Alta California*, July 1, 1850; August 13, 1859.
Sartain, John. *The Reminiscences of a Very Old Man, 1808–1897*. New York: D. Appleton & Company, 1900, pp. 228–229.
Taylor, Bayard. *Eldorado, or Adventures in the Path of Empire*. New York: George P. Putnam, 1850.

DOMENICO TOJETTI (1806-1892), came to San Francisco in 1871 from his native Rome where he had received high honors from the Catholic Church and the nobility for his paintings of biblical scenes and the ornamentation of palatial residences. He immediately became active in the growing art world of San Francisco as a teacher of art and decorator of mansions and churches. The altar pieces of St. Ignatius and St. Peter and Paul's Church were from his brush. He remained in San Francisco until his death on March 28, 1892.

From 1872 until 1883 Tojetti exhibited regularly at the San Francisco Art Association. Before the 1906 fire his paintings hung in many of San Francisco's most elaborate houses. The artist specialized in biblical, mythological, and literary themes, but occasionally painted a portrait, or, even more rarely, a California-inspired scene.

REFERENCES:

California State Library. California Section. Artist Information File.
Catalogue of the Mark Hopkins Institute of Art. San Francisco: San Francisco Art Association, 1902.

Comstock, Sophie P. *Painters of Northern California.* 1910. Part I. A lecture read before the Kingsley
 Art Club, E. B. Crocker Art Gallery, Sacramento, California, March 15, 1909.
Mechanics' Institute and Library of San Francisco. *Industrial Exhibition Reports,* 1871, 1874.
San Francisco *Bulletin,* May 10, 1871; March 6, 1879.
San Francisco *Call,* March 29, 1892. obit.

LEON TROUSSET. To date there is practically no factual information about this French
painter. He is believed to have been painting at Santa Cruz in the early 1850's and on the
Peninsula and in the San Francisco Bay Area in the 1870's. His view of the Santa Cruz
Mission (1853[?]), on display at the mission, is the prototype of several later paintings of
that subject. His large oil on canvas of Moss Landing at Castroville (ca. 1873) is the property
of Our Lady of Refuge Catholic Church at Castroville. A landscape believed to represent
Oakland, dated 1875, is in The Oakland Museum. Two retrospective paintings have been
identified as the work of Leon Trousset: "Monterey—Father Serra's Landing Place" (in the
Carmel Mission gift shop), and a watercolor on paper captioned "The Founding of Mission
Monterey—Father Serra Performs the First Mass" (privately owned).

REFERENCES:

Berkeley *Daily Gazette,* November 9, 1950.
California State Library. *News Notes of California Libraries,* vol. 5, July 1910, p. 402.
Catalogue of the Edwin Grabhorn Exhibit. Oakland: The Oakland Museum, March 1957.
The French in California, One Hundred Years of Achievement 1850–1950. San Francisco: California Palace
 of the Legion of Honor, November 11–30, 1950.
San Francisco *Chronicle . . . Supplement,* November 15, 1903.

JEAN JACQUES VIOGET (1799-1855), Swiss sea captain and amateur watercolorist, born at
Cambremont le Petit, Switzerland, ran away from home at the age of fifteen years to join
one of Napoleon's fife and drum corps. A few years later he began a life at sea and by the
1830's had become master of the *Delmira,* a vessel belonging to a South American firm en-
gaged in trading on the West Coast. Vioget first came into San Francisco Bay in the spring
of 1837. In 1839 he built a home and tavern at Yerba Buena and made the first survey of the
village. In 1847 he married María Benevides, a widow, by whom he had two sons. The
Viogets later moved to Las Pulgas Rancho on the Peninsula and then to San José. Vioget
traveled frequently to San Francisco to testify before the Land Commission on behalf of his
old friends whose claims were being adjucated. Becoming discouraged over adverse legal
decisions which he believed to be unjust, Vioget decided to move with his family to France.
They were ready to leave when Vioget suffered a heart attack from which he died on
October 25, 1855.

REFERENCES:

Barry, Theodore A. and Patton, Benjamin A. *Men and Memories of San Francisco in the Spring of 1850*. San Francisco: A. L. Bancroft & Company, 1873, pp. 210–211.

Bowman, James N. "Finding the Grave of Jean Jacques Vioget." (Typescript.) In The Bancroft Library.

Davis, William Heath. *Sixty Years in California*. San Francisco: A. J. Leary, 1889, pp. 379–381.

Peterson, Harry C. A talk given at the Papyrus Club. (Typescript.) In the California State Library. California Section.

San Francisco *Examiner*, September 6, 1896.

Vioget, Jean Jacques. "Diary." (Ms.). In the California State Library. California Section.

EDWARD VISCHER (1809 [1810?]-1878), born in Bavaria on April 6, 1809, [or 1810?], emigrated to Mexico at the age of nineteen and became affiliated with the trading company of Heinrich Virmond of Acapulco and Mexico City. At Virmond's suggestion Vischer made a combined business and pleasure trip to California in 1842, visiting the principal settlements between Yerba Buena and San Diego. In 1849 he returned to San Francisco where he became a merchant, moneylender, and importer.

Although Vischer had long been in the habit of sketching in his spare time his artistic ability remained fairly dormant until the late 1850's when he began in earnest to make drawings of the missions and to sketch scenes and events illustrative of life in California. As cameras came into general use Vischer took up photography and usually created his finished drawings from notes and photographs taken on the spot. The completed pictures were then lithographed and photographs taken of the lithographs. He used this process to prepare for publication his *Mammoth Tree Grove* (1862), *Pictorial of California* (1870), and *Missions of Upper California* (1872).

Vischer died in 1878, in San Francisco. A portfolio of his original drawings is in The Bancroft Library.

REFERENCES:

Bancroftiana. Berkeley: The Friends of The Bancroft Library, #66, February 1977; #68, October 1977, pp. 5–6.

Barry, Theodore A. and Patton, Benjamin A. *Men and Memories of San Francisco in the Spring of 1850*. San Francisco: A. L. Bancroft & Company, 1873, pp. 25–26.

California State Library. California Section. Portfolio of views by Edward Vischer.

"Edward Vischer's First Visit to California." Translated and edited by Erwin G. Gudde. California Historical Society *Quarterly*, vol. 19, September 1940, pp. 193–216.

Edward Vischer original drawings in The Bancroft Library.

Farquhar, Francis P. *Edward Vischer and His "Pictorial of California."* San Francisco: Privately Printed, 1932.

JAMES WALKER (1818-1889), was born in England on June 3, 1818, and was brought to New York by his parents in 1823. He began painting when very young and in the early 1840's took charge of the department of drawing and art in the Mexican Military College at Tampico. At the time of the outbreak of the War with Mexico he was living in Mexico City. Mexican friends helped him to escape from the city and he joined the American forces as an interpreter. He is believed to have made trips to Monterey and San Francisco before returning to New York City in 1848 to resume his art career. Following the Civil War, during which he served as staff artist for the Union Army, Walker went to California, possibly in the late 1860's. In the early 1870's he had a studio in San Francisco.

According to letters written by his grandson, Reginald F. Walker, after the Civil War Walker "again spent considerable time in California, went to Europe in 1878, returned to Washington, D.C. in 1880, and returned to California for the last time in 1884, dying in Watsonville, at the home of a brother, on August 29, 1889."

James Walker's most celebrated painting, "Battle of Chapultepec," (1862),was painted for the United States Capitol. Walker was also the artist of other historical canvases depicting battles of the Civil War. His California paintings depict scenes of life in California during the Mexican period and the early years of the American period.

REFERENCES:

Fairman, Charles E. *Art & Artists of the Capitol of the United States of America*. Washington: Government Printing Office, 1927, p. 55.

Groce, George C. and Wallace, David H. *New-York Historical Society's Dictionary of Artists in America 1564–1860*. New Haven: Yale University Press, 1957.

Letters written by Reginald F. Walker, October 23, 1945; November 29, 1952. In the California Historical Society.

McNaughton, Marion R. "James Walker, Combat Artist of Two American Wars." *Military Collector and Historian*, vol. 9, Summer 1957, pp. 31–35.

San Francisco *Call*, September 4, 1889. obit.

Taft, Robert. *Artists and Illustrators of the Old West, 1850–1900*. New York: Charles Scribner's Sons, 1953, p. 303.

JUAN BUCKINGHAM WANDESFORDE (1817-1902). From the time this artist settled in San Francisco in 1862 until his death in 1902 his exceptional ability as a versatile artist and teacher of art was an inspiration to his fellow artists. Born in England on June 24, 1817, Wandesforde began the study of art early in life. In the 1850's, after some years of foreign travel and art study, he became one of the leading watercolorists of New York City. In 1862, upon becoming a resident artist of San Francisco, he began painting landscapes based on visits to Mount Shasta, the Trinity Mountains, Clear Lake, and other scenic areas of the

state. From 1864 on he regularly exhibited his work at the fairs of the Mechanics' Institute, and after 1872 at the newly organized San Francisco Art Association. Wandesforde excelled as a teacher of art and a number of his young pupils became successful artists.

During his last years Wandesforde made his home in Hayward, California, dying there on November 18, 1902.

REFERENCES:

Avery, Benjamin P. "Art Beginnings on the Pacific." *Overland Monthly*, vol. 1, August 1868, p. 113.
California State Library. California Section. Artist Information File.
Groce, George C. and Wallace, David H. *New-York Historical Society's Dictionary of Artists in America 1564–1860*. New Haven: Yale University Press, 1957.
Mechanics' Institute and Library of San Francisco. *Industrial Exhibition Reports*, 1872, 1874, 1875.
The Oakland Museum. Art Department. Archives of California Art.
Oakland *Tribune*, November 19, 1902. obit.
San Francisco *Alta California*, June 5, 1870; January 15, 1871; December 11, 1873; February 13, 1875.

FREDERICK WHYMPER, an imperfectly known artist and author, states in his *Travel and Adventure in the Territory of Alaska* (1869), that he repeatedly visited San Francisco from 1862 to 1867. It is known that on July 10, 1865, he sailed from San Francisco as artist for the Russian-American Telegraph Exploring Expedition and was one of the party that worked in and around Nulato in Russian America (Alaska) and along the Anadyr River. Sketches and a map by Whymper illustrating those explorations were published in 1868 in the *Journal* of the Royal Geographic Society. The next year at San Francisco Whymper exhibited two water color views of Alaska at the Mechanics' Institute Fair. The paintings were praised in the September 25, 1869 issue of the *Illustrated San Francisco News* as being the work "of an artist of distinguished ability." Whymper was at that time on a Pacific Coast assignment for the *Illustrated London News*. Sketches by Whymper published in that periodical included views taken from points along the Pacific railroad route, which suggests that his 1869 journey to California was made over the newly completed Pacific railroad. During the early seventies Whymper was actively engaged in painting at San José, Oakland, Berkeley, and San Francisco. He attended the first meeting of the San Francisco Art Association in March, 1871, and was a charter member of the Bohemian Club.

No further information about this artist is at hand except that his book, *The Fisheries of the World*, was published in 1884.

REFERENCES:

Bohemian Club, San Francisco. *The Annals*, vol. 1, 1872.
————. *The Annals of the Bohemian Club* . . . San Francisco: Press of the Hicks-Judd Co., 1898, p. 18.

The Graphic Club, San Francisco. *Album*, vol. 1, July 1873, p. 107.

Illustrated San Francisco News, September 25, 1869.

Mechanics' Institute and Library of San Francisco. *Industrial Exhibition Reports*, 1869, 1874.

The Oakland Museum. Art Department. Archives of California Art.

San Francisco *Alta California*, June 5, 1870.

Whymper, Frederick. *Travel & Adventure in the Territory of Alaska* . . . New York: Harper & Brothers, 1869, p. 299.

VIRGIL WILLIAMS (1830-1886), a descendant of Roger Williams, was born on October 29, 1830, at Dixfield, Maine, but spent his childhood in Taunton, Massachusetts. His art training began in New York City with instruction from the artist Daniel Huntington, and was continued from 1853 to 1860 in Rome. An initial art career in Boston (1860-1862) was interrupted when Robert B. Woodward, proprietor of a San Francisco hotel, commissioned him to design art galleries for a proposed amusement park in Mission Valley. Williams went to California and laid out the galleries; he was then sent by Woodward to Italy to buy Italian paintings and upon returning to San Francisco to paint California landscapes for the galleries. In all, seventy-four paintings were assembled for Woodward's Gardens, over half of which were by Williams.

In 1866 Williams returned to Boston where for five years he had a studio and also taught drawing at Harvard University and the Boston School of Technology. Upon returning to California in 1871 he was active in organizing the San Francisco Art Association. In 1874 he became the first director and a teacher in the association's School of Design, a position he held until his death on December 18, 1886, at his ranch near Sonoma.

REFERENCES:

Avery, Benjamin Parke, "Art Beginnings on the Pacific." *Overland Monthly*, vol. 1, August 1868, p. 114.

California Historical Society *Courier*, vol. 26, May–June, 1974, pp. 1, 7.

California State Library. California Section. Artist Information File.

Mechanics' Institute and Library of San Francisco. *Industrial Exhibition Reports*, 1864, 1875, 1876.

The Oakland Museum. Art Department. Archives of California Art.

Oakland *Tribune*, January 13, 1965.

San Francisco *Chronicle*, December 21, 1886; July 4, 1889.

Index